W9-DJM-544

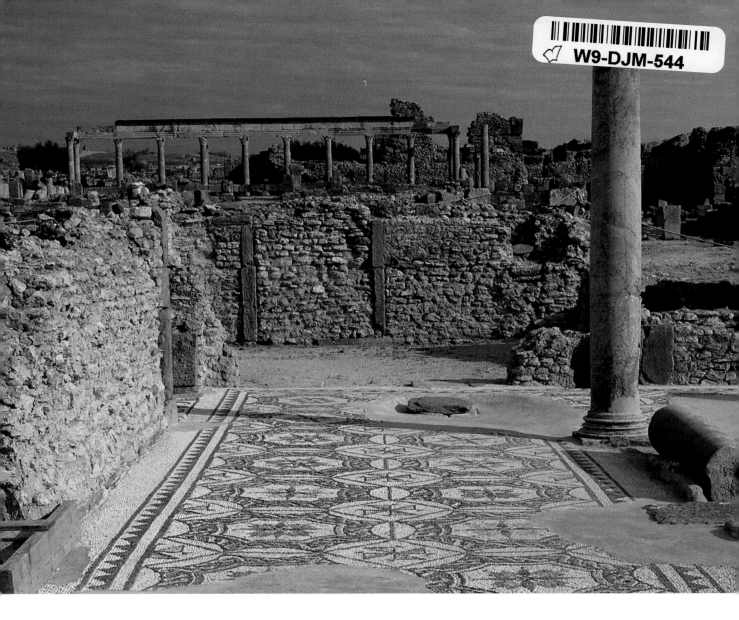

Tunisian Mosaics

TREASURES FROM ROMAN AFRICA

Aïcha Ben Abed

Translated from the French by Sharon Grevet

The Getty Conservation Institute
Los Angeles

The Getty Conservation Institute

Timothy P. Whalen, *Director*
Jeanne Marie Teutonico, *Associate Director, Programs*

The Getty Conservation Institute works internationally to advance conservation and to enhance and encourage the preservation and understanding of the visual arts in all of their dimensions—objects, collections, architecture, and sites. The Institute serves the conservation community through scientific research, education and training, field projects, and the dissemination of the results of both its work and the work of others in the field. In all its endeavors, the Institute is committed to addressing unanswered questions and promoting the highest possible standards of conservation practice.

This is the seventh volume in the Conservation and Cultural Heritage series, which aims to provide information in an accessible format about selected culturally significant sites throughout the world. Previously published are *World Rock Art* (2003); *El Pueblo: The Historic Heart of Los Angeles* (2002); *Cave Temples of Mogao: Art and History on the Silk Road* (2000); *Palace Sculptures of Abomey: History Told on Walls* (1999); *The Los Angeles Watts Towers* (1997); and *House of Eternity: The Tomb of Nefertari* (1996).

© 2006 The J. Paul Getty Trust
Getty Publications
1200 Getty Center Drive, Suite 500
Los Angeles, California 90049-1682
www.getty.edu

All photographs by Bruce White, Guillermo Aldana, and Elsa Bourguignon are © The J. Paul Getty Trust.

Mark Greenberg, *Editor in Chief*

Tevvy Ball, *Series and Book Editor*
Vickie Sawyer Karten, *Series and Book Designer*
Anita Keys, *Production Coordinator*
Sylvia Lord, *Copy Editor*

Printed by CS Graphics, Singapore
Separations by Professional Graphics, Rockford, Illinois

Library of Congress Cataloging-in-Publication Data

Ben Khader, Aïcha Ben Abed.
 Tunisian Mosaics : Treasures from Roman Africa / Aïcha Ben Abed; translated from the French by Sharon Grevet.
 p. cm. — (Conservation and cultural heritage)
 ISBN-13: 978-0-89236-857-0 (pbk.)
 ISBN-10: 0-89236-857-8 (pbk.)
 1. Mosaics, Roman—Tunisia. 2. Mosaics—Tunisia. 3. Tunisia—Antiquities, Roman.
I. Title. II. Series.
NA3770.B44 2006
738.5'209397—dc22

2006006996

FRONT COVER
Portrait of a Nereid (a nymph and daughter of the sea god Nereus) traveling through the water, accompanied by a great sea horse and two playful dolphins. Third century.
El Jem Museum.
Photo: Bruce White, 2005.

TITLE PAGE
The peristyle of the House of Neptune in Thuburbo Majus. Third century.
Photo: Elsa Bourguignon, 2002.

CONTENTS PAGE
Mosaics from Roman Africa often portray daily life, as in this detail of a depiction of fishermen in a sea teeming with fish. Third century.
Sousse Museum.
Photo: Bruce White, 2005.

BACK COVER
The Capitol at Dougga. Second century.
Photo: Bruce White, 2005.

i-29952

To the memory of
Noureddine

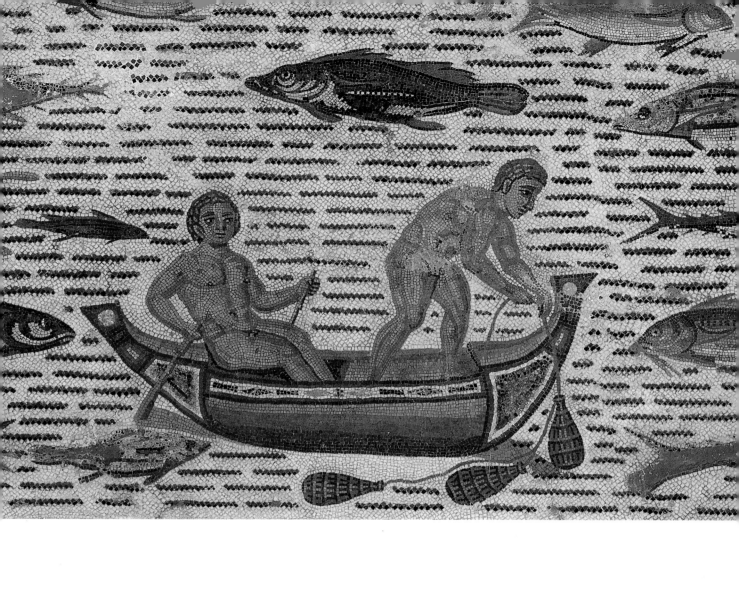

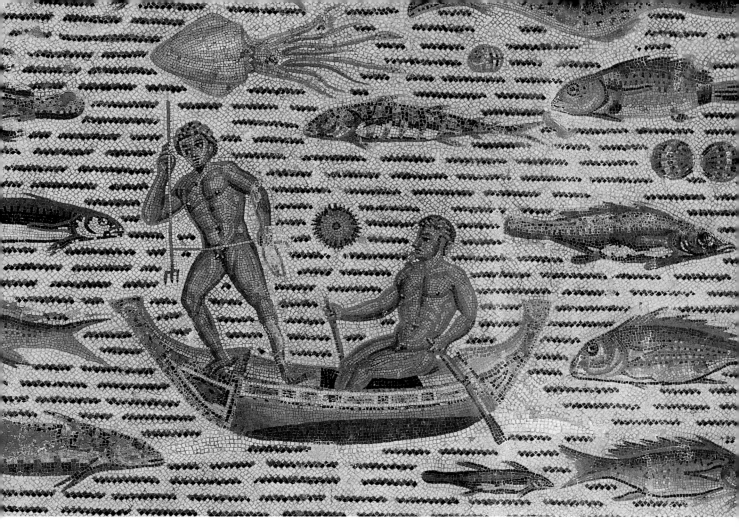

Contents

AN ANCIENT ART

Mosaics are undoubtedly one of the most accomplished expressions of ancient Mediterranean art. Practically all of the countries of the Mediterranean basin played a role, and each of the region's peoples contributed its particular genius to the birth and technical development of this art form (FIGURE 1.1).

FIGURE 1.1

Detail of a mosaic from a house at El Jem. This tableau depicts Aeon, or absolute time, at the center of a pavement that also depicts Luna and Sol and the four seasons. This subject evokes time in all of its aspects: day and night, the seasons, and eternity. Because of their highly symbolic connotation, themes relating to time were often represented in mosaics. The succession of days and nights and of the seasons regulated human life and nature, renewing the universe in an infinite progression. The concept of time and its cycles was adopted early in imperial symbolism, starting in the reign of Augustus. The empire was often likened to the universe, and the accession of a new emperor to the throne was considered a new era during which stability and harmony would triumph. Third century.

El Jem Museum.
© Cérès Éditions, Tunis.

2

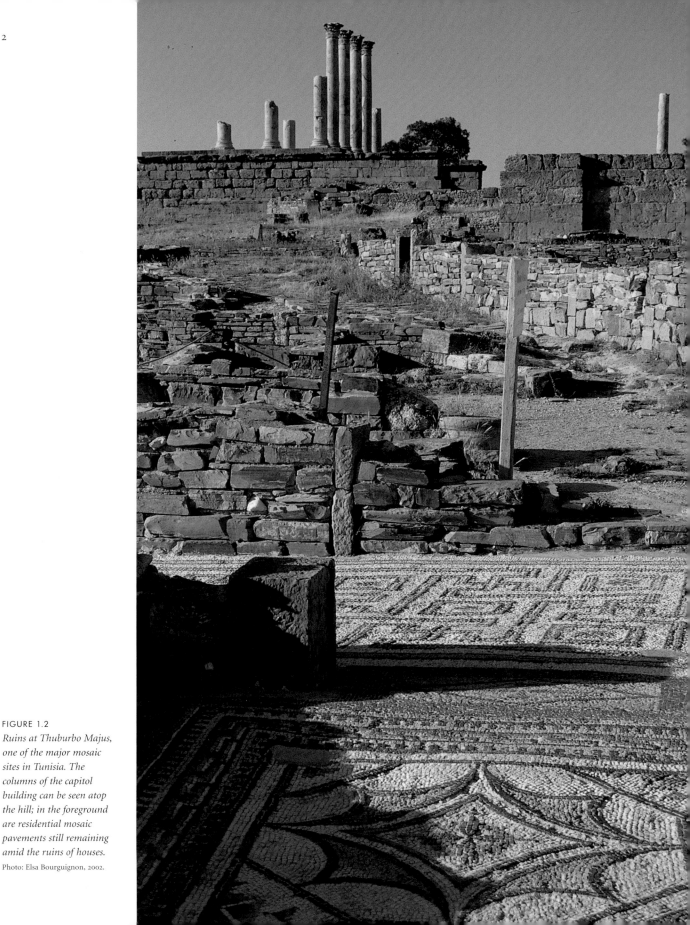

FIGURE 1.2
Ruins at Thuburbo Majus, one of the major mosaic sites in Tunisia. The columns of the capitol building can be seen atop the hill; in the foreground are residential mosaic pavements still remaining amid the ruins of houses.
Photo: Elsa Bourguignon, 2002.

However, we should not lose sight of the fact that what is now defined as art was not necessarily considered art fifteen or twenty centuries ago. In antiquity, making mosaics was part of the business of everyday life, like building as solid a house as possible and tiling its floors with a practical, fairly waterproof surface that could withstand constant washing. With the passage of time and with the evolving mastery of technique, mosaic developed into a preferred medium for conveying ever richer and more sophisticated themes, until it finally reached the heights of artistic refinement and took its place among the supreme arts of the ancient world. Nowhere did this art reach a higher pinnacle of expression than in the Roman colonies of northern Africa.

Yet mosaic artisans and artists rarely received the honors and recognition accorded to painters and sculptors, whose signatures were well known. Their virtuosity and genius were part of a collective effort, in which the patron, the mosaic artisan, the designer, the mosaic workers, and their apprentices all contributed to the finished product. This is probably why we find so few signatures of mosaicists — at least where we would most expect them. Their wages were not among the highest mentioned in the Edict on Maximum Prices dating from the reign of the Roman emperor Diocletian. This humble status, which we find so surprising today, made mosaic art very much a part of daily life, with its grandeur and its limitations.

As Rome, after having defeated its great rival Carthage in the second century BCE, expanded its African settlements in the early centuries of the common era, thousands of mosaic pavements were fashioned to adorn townhouses, country estates, and baths (FIGURE 1.2). Magnificent images were created from small polychrome stones, usually gathered from surrounding quarries and

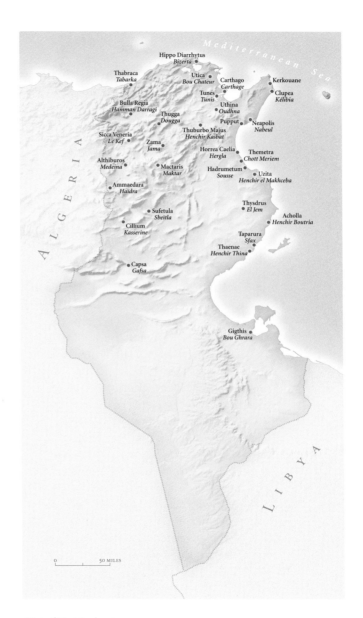

Map of Tunisia showing important archaeological and historical sites. When two names are given for a site, the ancient name is given first, the modern name second.

patiently cut to size. Commissioned by citizens to adorn their homes, mosaics express, more than any other ancient artistic medium, the common aspirations of a people. Mosaic art was a far cry from the official art of Roman imperial ideology, and it thus reveals myriad details of the people's everyday lives.

The figurative mosaics, with their illustrations of daily life and classical mythology, have long attracted the attention of scholars (FIGURE 1.3). In addition, African mosaicists created increasingly complex geometric and floral compositions, which came to characterize the Mediterranean mosaic landscape. As the centuries passed, an African style was forged, defined by its shapes, its movement, and, especially, its shimmering colors. From the second to the sixth centuries CE, the African mosaic school would radiate throughout the Mediterranean basin, its influence extending to Italy, Spain, Gaul—even as far away as England.

Tunisia possesses one of the richest and most varied collections of mosaic art in the Mediterranean basin. Its archaeological sites and museums document more than ten centuries of mosaic production. Thousands of pavements recount the journey of an ancient civilization through its landscapes and its beliefs, its dreams and its daily routine. They also reveal how what began as a simple technique developed into a major art.

Today Tunisia is confronting the challenges of preserving and presenting these treasures of universal art. Since these works are obviously quite fragile, the international scientific community is involved in an ongoing and multifaceted effort to save these priceless traces of the past. Tunisia, with the support of the international community, has the responsibility of preserving and displaying its vast number of mosaic pavements, so that future generations may appreciate this magnificent legacy.

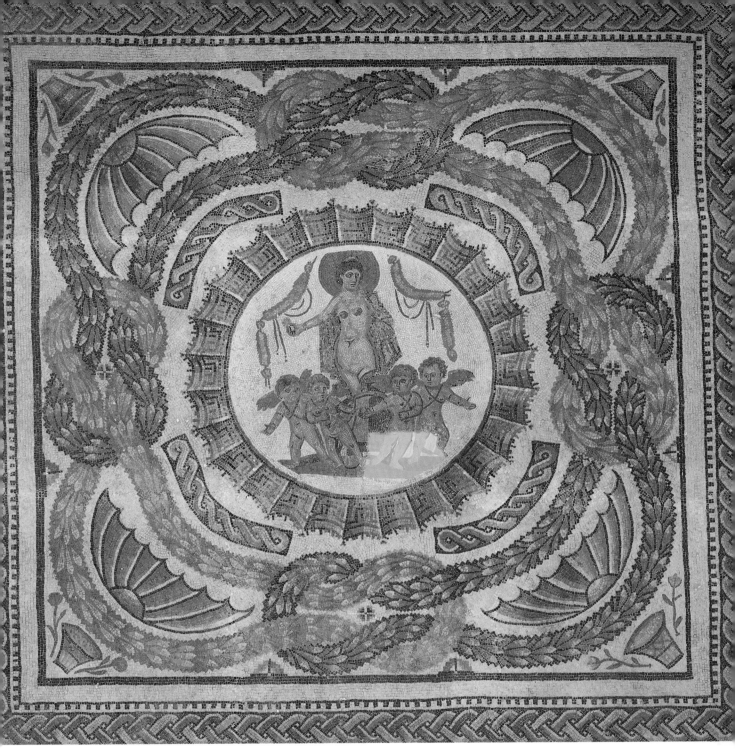

FIGURE 1.3

*Mosaic from the House of the Chariot of Venus, in the western quarter at Thuburbo Majus.
In an elaborate framework of interwoven laurel garlands, the goddess Venus stands on a
chariot drawn by four cupids. The haloed head and nude body of the goddess of beauty stand
out against her green mantle. The marine origin of the goddess is suggested by the four
large seashells near the four corners of the tableau. Second half of the fourth century.*

Bardo Museum.
Photo: Jerry Kobylecki/GCI.

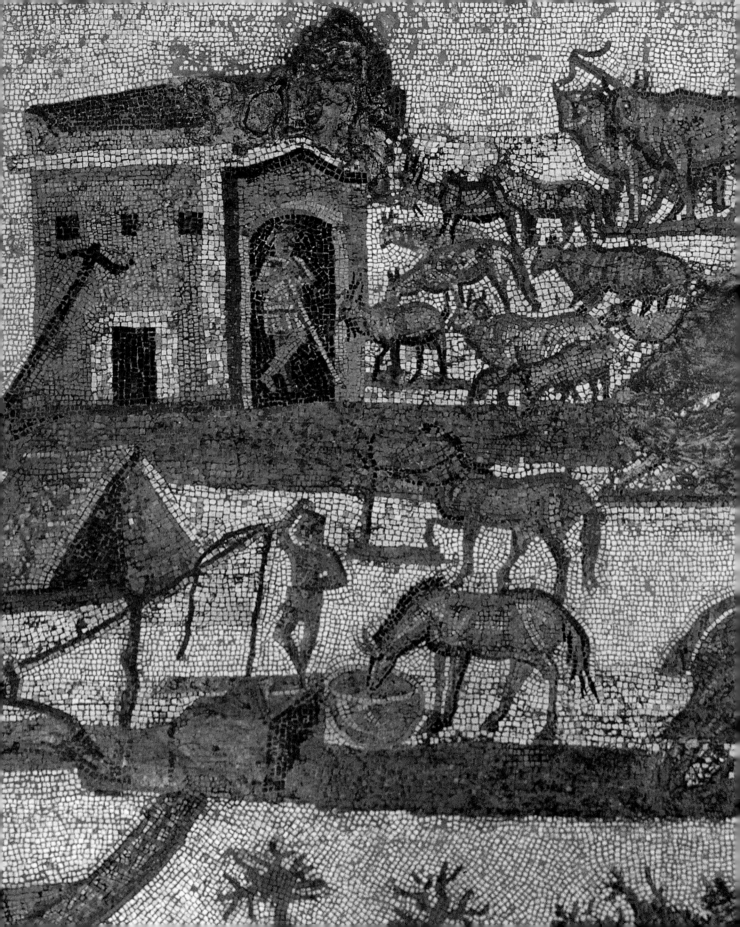

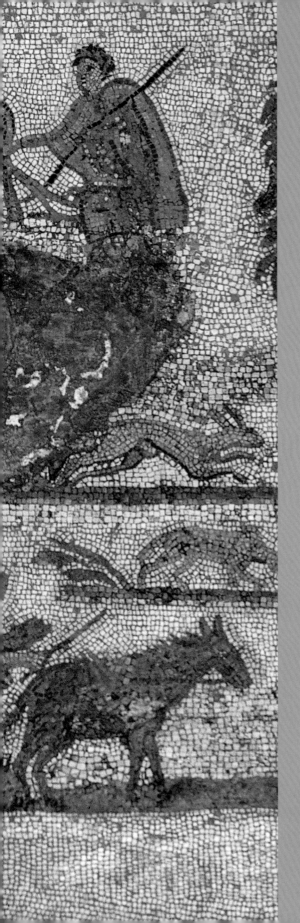

ANCIENT TUNISIA

The country that is today known as Tunisia, situated at the north-ernmost tip of Africa, has its roots in African soil, but it also reaches north toward Europe and east toward Asia. Much of the land is bathed by the sea. With its gentle, varied terrain and long coastline, Tunisia has been a crossroads and place of settlement for the many civilizations that have passed through the Mediterranean since ancient times (FIGURE 2.1).

FIGURE 2.1
Detail from a mosaic showing scenes of rural life, from the so-called House of the Laberii at Oudhna. Mosaics provide important historical information about life in ancient North Africa.
Bardo Museum.
Photo: Jerry Kobylecki/GCI.

The earliest human settlement dates to the prehistoric era. Brilliant civilizations developed both in the north, at sites such as Sidi Zine, in the vicinity of Le Kef, and in the south, around what is today the city of Gafsa. Near Gafsa, at El Guettar, a particularly interesting monument has been unearthed. The Hermaion of El Guettar, a cairn composed of silex, limestone, and bone shards, was built close to a spring more than forty thousand years ago. Now restored and on display at the Bardo Museum in Tunis, it is thought to be the oldest known cult monument in the world, testifying eloquently to the early human presence in this region. Much later, between the eighth and sixth millennia BCE, what is known as Capsian culture developed around Gafsa. This culture is known for its principal sites, called shell mounds—archaeological deposits consisting of a refuse mound composed of ash and snail shells.

The Tunisian Neolithic period—between 5000 and 2000 BCE—is represented by a multitude of sites. Findings of obsidian at several coastal locations suggest that this era witnessed early contact between peoples of the northern and southern coasts of the Mediterranean. North Africa was settled over the course of the fifth millennium BCE, largely by Libyan tribes, ancestors of the Berbers, whom the Greek historian Herodotus called the Libu. Throughout the country, at major sites such as Dougga (ancient Thugga) and Bulla Regia, ruins from this ancient Berber culture have been found, in the form of burial chambers, or *haouanets*, dolmens, and mausoleums.

Tunisia entered the historic era with the arrival of the Phoenicians, at the end of the second millennium BCE. The Phoenicians built and based their power around cities such as Tyre and Sidon in the Levant, on the eastern Mediterranean coast around what is today Lebanon. The Phoenicians played a very important role in the ancient imagination. Intrepid sailors and traders, they were great shipbuilders, and their power was based on their prowess as seafarers. Their civilization reached its zenith in the eleventh century BCE. Navigation and trade, in such goods as metals and textiles, were the driving forces behind the dissemination of their culture, particularly their alphabet, throughout the Mediterranean, including much of the Greek world (FIGURE 2.2).

As they traveled in search of silver mines in Spain and other sources of wealth, the Phoenicians founded trading posts *(emporia)* all along the coast of North Africa. One of the most famous was Utica. According to legend, it was founded in 1101 BCE. Carthage, their most prestigious colony, was established in the late ninth or the eighth century BCE as an outpost supplying ships trading in the western Mediterranean; according to ancient legend, Carthage was founded by a Phoenician princess in 814 BCE. The founding of Carthage marked the beginning of the systematic settlement of the Tunisian coast. From this encounter between Phoenician civilization and the indigenous Berber population, Punic civilization was born (FIGURE 2.3).

Carthage developed into the major metropolis of the Punic world. From around the sixth century to the fourth century BCE,

FIGURE 2.2 (OPPOSITE)
Mounted panel, or emblema, from El Jem, depicting a sailor rowing a single-masted sailboat. Second century.
Bardo Museum.
© Cérès Éditions, Tunis.

I. BCE

1110 BCE	1101 BCE	814 BCE	Late 8th century BCE
Beginning of Phoenician expansion in the western Mediterranean	Traditional date of the founding of Utica	Traditional date of the founding of Carthage	*Tophet* (shrine) of Salammbô and ancient tombs of Carthage

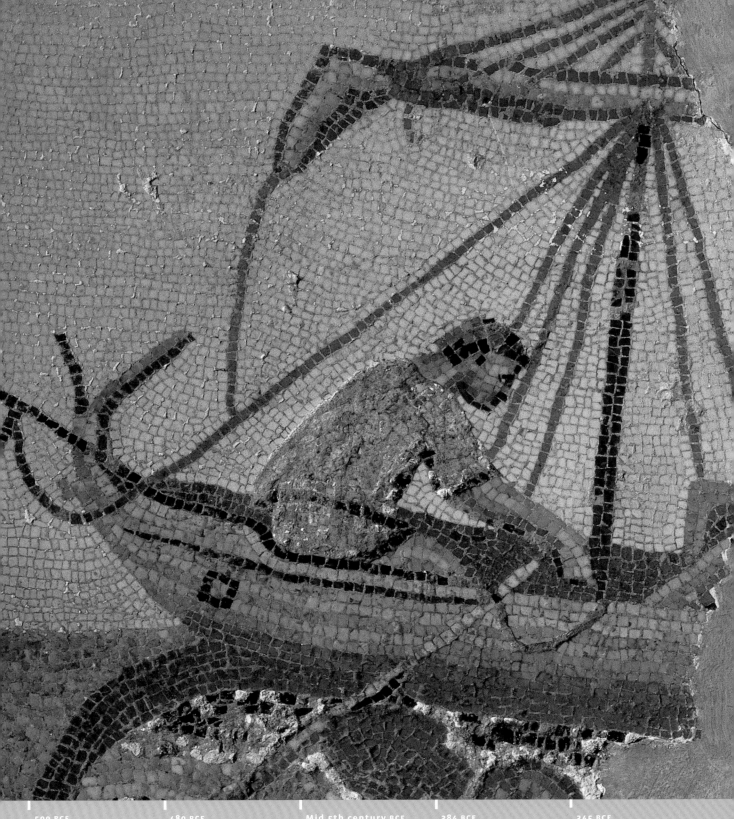

The Legend of Carthage

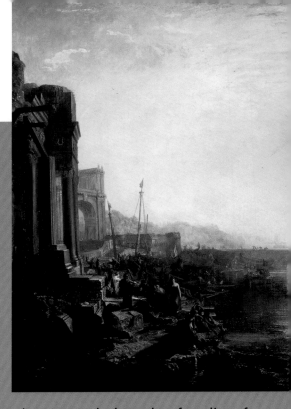

FIGURE 2.3

J. M. W. Turner, Dido Building Carthage, *or* The Rise of the Carthaginian Empire. *The subject of the founding of Carthage fascinated generations of artists and writers. The legend recounts that a princess named Elissa left Tyre, fleeing her brother, King Pygmalion, who had already killed her husband. The princess left with her treasures and her followers to search for a new home. She landed on the coast of Africa after a long period of wandering, which earned her the Latin name Dido, "the wanderer." The new city she founded was named* Qart Hadasht, *or Carthage. Oil on canvas.*

© The National Gallery, London.

The legend of Carthage dates to around the fourth century BCE, with texts of ancient authors from the Phoenician city of Tyre. According to legend, a Phoenician princess named Elissa, who became known as Dido in the Latin tradition, fled Tyre. After wandering for a while in the Mediterranean, she arrived in North Africa in 814 BCE and settled with her court at the magnificent site of Carthage (from the Phoenician *Qart Hadasht,* or New City, which in Latin became Carthago). The legend was later taken up by the Roman poet Virgil, the eulogist of Roman culture, who opened the *Aeneid,* his epic poem on the legendary founding of Rome, by evoking the tragic love of Dido for the poem's hero, Aeneas. This romantic encounter was intended to reconcile the traditional enemies, Carthage and Rome, once and for all. Over the centuries, the love story of Dido and Aeneas was to leave a lasting impression. For example, in his *Confessions,* Saint Augustine tells us that as a child he wept for their ill-starred passion.

Thus popularized by Virgil, the myth of Carthage became established and would reverberate throughout Western culture for many hundreds of years. Among the more celebrated treatments is *Salammbô* (1862), a historical novel by the French writer Gustave Flaubert. Focusing on the title character, a Carthaginian princess and priestess, at the time of the First Punic War, the novel is responsible for perpetuating some of the myths about Punic Carthage, such as that of child sacrifice. Flaubert attempted to fix what he called "the mirage" of ancient Carthage; his fictional re-creation of the city was purely imaginative, as were the paintings by J. M. W. Turner, who was similarly fascinated by the myth of the Punic city-state.

289 BCE

Third treaty between Carthage and Rome

279–278 BCE

Fourth treaty between Carthage and Rome

264 BCE

Roman intervention against the Carthaginians at Messina, triggering the First Punic War (264–241)

260 BCE

Naval victory by the Romans at Mylae (modern Milazzo)

237–229 BCE

Conquest of part of Spain by Hamilcar and creation of a "kingdom" there

it was the most important city-state in the western Mediterranean. It had a splendid harbor, a powerful fleet, and a stable oligarchic political system that was greatly praised by Aristotle. Situated on a peninsula between two lagoons, protected by high, thick walls and dominated by the hilltop acropolis of Byrsa, it was home to several hundred thousand people. There were magnificent temples and palaces. Residential neighborhoods were located on the waterfront and on the hillside of Byrsa (FIGURE 2.4). Wealthy merchants, grown rich on the city's abundant trade, lived in luxurious, many-storied townhouses. These dwellings contained some of the earliest mosaics; the floors were covered with red concrete, inset with decorative white cut stones (FIGURE 2.5).

As the wealth and power of Carthage grew, Punic culture spread over all of North Africa, as well as across the Mediterranean into Sardinia, western Sicily, and several cities in Spain and the Balearic Islands. Because the supremacy of Punic civilization was based largely on the sea, the planning of port areas in Carthage was very important. The city's military and commercial ports, renowned throughout the ancient world, were described in plentiful detail by Appian, the second-century historian of Rome:

> The harbours had communication with each other, and a common entrance from the sea seventy feet wide, which could be closed with iron chains. The first port was for merchant vessels, and here were collected all kinds of ships' tackle. Within the second port was an island, and great quays were set at intervals round both the harbour and the island. These embankments were full of shipyards which had capacity for 220 vessels. There were also magazines for their tackle and furniture. Two Ionic columns stood in front of each dock, giving the appearance of a continuous portico to both the harbour and the island. On the island was built the admiral's house, from which the trumpeter gave signals, the herald delivered orders, and the admiral himself oversaw everything.[2]

The Carthaginian system of governance consisted of the Council of Elders (a sort of senate), a popular assembly, and two magistrates, or *sufetes*, appointed each year to manage the city's affairs. Carthage was considered to combine the best elements of the

228 BCE

Death of Hamilcar; Hasdrubal, his son-in-law, succeeds him

226 BCE

Punic-Roman treaty limits Punic expansion in Spain

219 BCE

Hannibal takes Sagunto in Spain; Rome declares war on Carthage

218 BCE

Start of the Second Punic War (218–201); Hannibal leads an army across the Pyrenees and the Alps and gains two victories over the Romans at Ticino and Trebbia

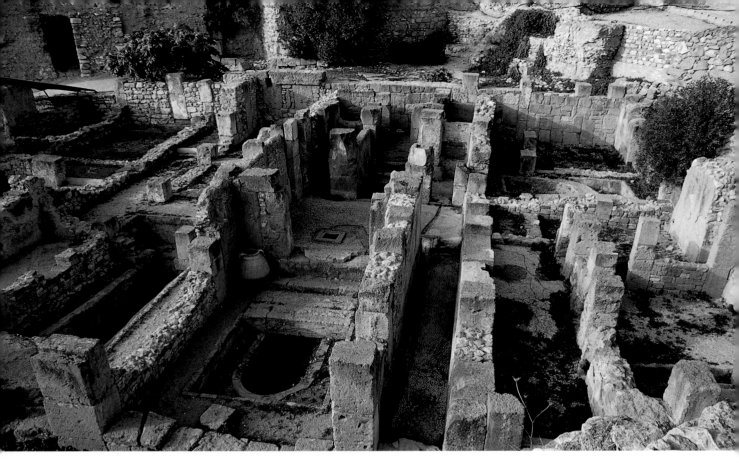

FIGURE 2.4
*Ruins of a Punic residen-
tial quarter on Byrsa Hill
at Carthage. These houses
were built around an open
central courtyard. They
had a sophisticated water
supply and disposal
system. The floors were
covered with* pavimenta
punica, *a concrete pave-
ment roughly inlaid with
cut stones — a type of*
opus signinum. *Third to
second century* BCE.

Photo: Corpus des mosaïques
de la Tunisie.

three great political systems of antiquity —
monarchy, aristocracy, and democracy.

The Carthaginian pantheon was ruled
by the god Baal and his consort, Tanit.[3] Baal
was the supreme deity of Carthage's main
shrine, or *tophet*. This shrine has long been
the subject of some controversy. Our knowl-
edge of ancient Carthage derives largely
from ancient Greek and Roman sources,
who often pursued their own interests when
describing the culture and society of their
great western rival. Although some ancient
accounts indicate that child sacrifice was
carried out in this sacred place, recent
research suggests that even if such sacrifices
were enacted for a time, they were quickly
replaced by symbolic animal sacrifices. It

appears that the Greeks and Romans greatly
exaggerated the phenomenon of child sacri-
fice in order to discredit the Carthaginians.
According to certain scholars, the *tophet* was
a sort of burial ground for stillborn infants.
The truth, obscured in the mists of the past,
may well be complex.

The economy of Carthage was based on
agriculture, trade, and various forms of fine
craftwork. An agronomist from Carthage
named Magon wrote a famous agricultural
treatise that presented techniques for wine
making and many other activities; it is one
of the few Carthaginian texts to have sur-
vived. The fine goods of Carthage were not
intended solely for internal consumption
but were also widely exported. They were

217 BCE	216 BCE	212–211 BCE	209 BCE	202 BCE
Hannibal defeats Romans at Trasimeno	Hannibal defeats Romans at Cannae in southern Italy	Defeat of the Punic fleet at Sicily; victory over the Romans by Hasdrubal, brother of Hannibal, in Spain	Romans take Carthage	Battle of Zama and defeat of Hannibal by Scipio and Massinissa

abundant and diverse, consisting predominantly of work in ceramic, glass, and metal, including gold and silver (the Carthaginians were great jewelers), as well as bronze (FIGURE 2.6). The silks and embroidery of Carthage were also much prized. Carthaginian merchant ships carried these goods throughout the Mediterranean world.

With its power spreading, Carthage soon found itself confronting the western Greek world in a series of conflicts with the tyrants of Syracuse and other Sicilian Greek cities throughout the fifth and fourth centuries BCE. Then, in the third and second centuries BCE, in one of the great conflicts of antiquity, Carthage would defend its interests against the vast ambitions of imperial Rome, when the two powers became fierce rivals for supremacy in the western Mediterranean. The confrontations between Rome and Carthage resulted in the three Punic Wars, which reverberated throughout the Mediterranean region. The first, which occurred in the years 264–241, resulted in a victory for Rome. The second was fought throughout the region in the years 218–201. This conflict is renowned largely for the feats of the great Carthaginian general Hannibal. Hannibal had been raised in Spain, where he grew up hating the domination of imperial Rome. Once Carthage had rebuilt its army from the defeat of the First Punic War, it resumed hostilities against Rome. Hannibal invaded Europe from Spain, crossing the Pyrenees and the Rhone River. Then, in a now-legendary feat, he took his army, including elephants, across the Alps and invaded northern Italy, defeating the Romans in battle after battle and striking fear into

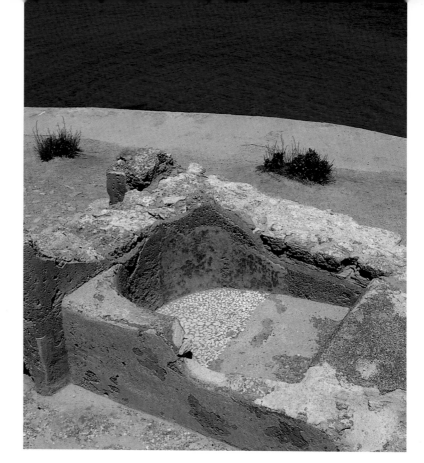

FIGURE 2.5
Remnants of a bathtub in a Punic house at Kerkouane. The bottoms of the bathtubs in each house contain examples of early opus signinum. Fourth century BCE.
Photo: Elsa Bourguignon, 2002.

FIGURE 2.6
Punic coin depicting the figure of a woman who is often interpreted as the embodiment of Carthage.
Photo: Bibliothèque Nationale de France.

201 BCE
Peace treaty between Carthage and Rome

195 BCE
Hannibal exiled to the east

174–172 BCE
Massinissa takes possession of seventy cities in central Tunisia

149 BCE
Start of the Third Punic War (149–146), a war of siege

146 BCE
Romans destroy Carthage; formation of the first Roman province of Africa

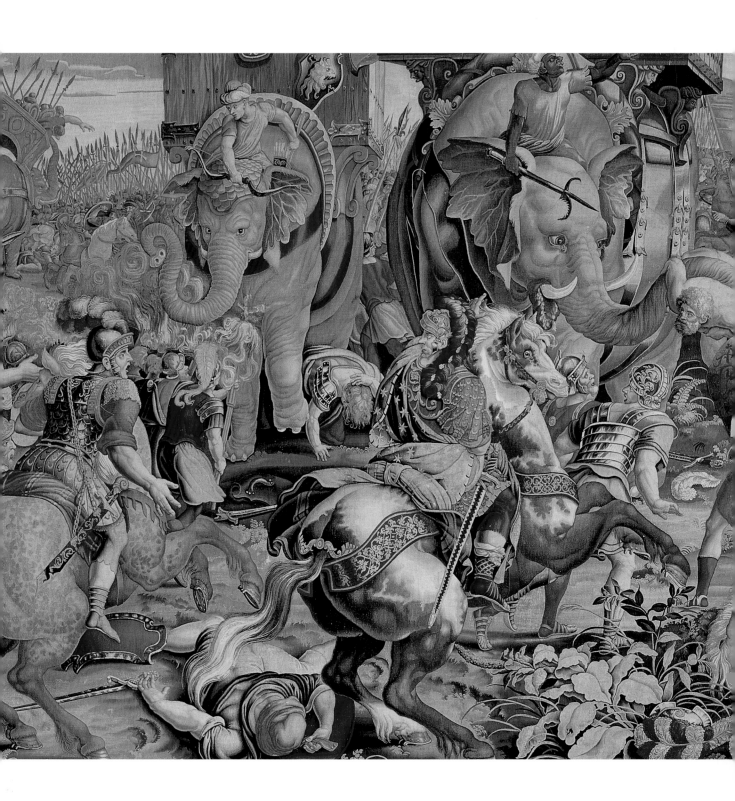

their hearts in his relentless march on their capital.

Even so, and although the campaign in Italy lasted more than fifteen years, Hannibal never managed to conquer Rome. Finally, when Roman forces landed in northern Africa and began laying waste to the region, he was obliged to return from Italy to face them. The Battle of Zama proved decisive: some twenty thousand Carthaginian soldiers were killed, and almost all the rest were captured, ending the war with another Roman victory (FIGURE 2.7). Carthage began paying a fifty-year indemnity to Rome.

The rivalry between the two powers continued, and from Rome came increasing calls for the complete destruction of Carthage, incited by the politician Cato the Elder, who had grown up in the time of Hannibal's triumphs. In speeches to the Roman Senate, Cato repeatedly issued his famous dictum *Carthago delenda est*— "Carthage must be destroyed." The third and last of the Punic Wars, which began in 149 BCE, resulted in Rome's definitive victory three years later. The Roman army invaded northern Africa and encamped on the Carthage isthmus, laying siege to the city. Although Carthage defended itself mightily, the Romans ultimately penetrated its defenses and put the city and its inhabitants to fire and sword (FIGURES 2.8 AND 2.9).

The fall of Carthage was one of the cataclysmic events of antiquity. Basing his text on the accounts of earlier historians, Appian described the conflagration in great and terrible detail, as Roman soldiers torched the grand city:

> *The fire spread and carried everything down, and the soldiers did not wait to destroy the buildings little by little, but pulled them all down together. So the crashing grew louder, and many fell with the stones into the midst of the dead.*

FIGURE 2.7
Late-seventeenth-century tapestry depicting the Battle of Zama of 202 BCE, in which Hannibal was defeated by Roman forces. The Punic Wars would echo down through the centuries, fascinating artists for millennia to come. This work was based on a drawing by Giulo Romano (1499–1546).

Photo: Arnaudet.
Réunion des Musées
Nationaux/Art Resource, NY.
Louvre, Paris.

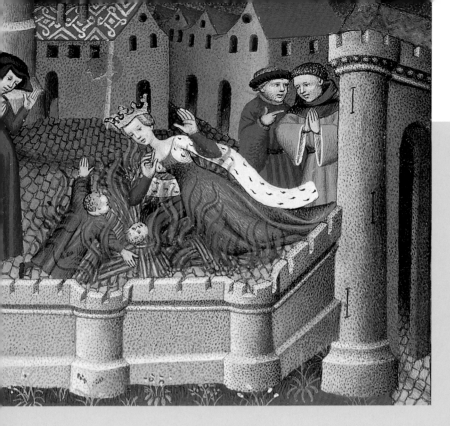

The Fall of Punic Carthage

From *The Histories,* by the Roman historian Polybius

The Roman accounts of the fall of Carthage present, not surprisingly, a decidedly pro-Roman point of view. However, they are the only contemporary written accounts available. This passage by Polybius, who was Greek by origin and who accompanied the Roman armies, is perhaps the best. He describes the final phase of the battle, after the long siege and after Roman forces conquered the harbors and the marketplace, leaving only the fortified Byrsa citadel, where the last Carthaginian forces were holding out.

FIGURE 2.8
*Medieval illuminated
manuscript depicting the
suicide of the queen of
Carthage, who threw
herself into the fire.*
Photo: Bibliothèque Nationale
de France.

Having got within the walls, while the Carthaginians still held out on the citadel, [the Roman general] Scipio found that the arm of the sea which intervened was not at all deep; and upon Polybius advising him to set it with iron spikes or drive sharp wooden stakes into it, to prevent the enemy crossing it and attacking the mole [constructed of huge stones to block up the mouth of the harbor], he said that, having taken the walls and got inside the city, it would be ridiculous to take measures to avoid fighting the enemy. . . .

[The Carthaginian commander] Hasdrubal threw himself on his knees before the Roman commander, quite forgetful of [the] proud language [he had used earlier in defiance of the invaders]. . . . When the Carthaginian commander thus threw himself as a suppliant at Scipio's knees, the proconsul with a glance at those present said: "See what Fortune is, gentlemen! What an example she makes of irrational men! This is the Hasdrubal who but the other day disdained the large favors which I offered him, and said that the most glorious funeral pyre was one's country and its burning ruins. Now he comes with suppliant wreaths, beseeching us to spare life and resting all his hopes on us. Who would not learn from such a spectacle that a mere man should never say or do anything presumptuous?" . . . And just at this moment Hasdrubal's wife, seeing him seated in front of the enemy with Scipio, advanced in front of the deserters, dressed in noble and dignified attire herself, but holding in her hands,

on either side, her two boys dressed only in short tunics and shielded under her own robes. . . . She asked Hasdrubal how he had had the heart to secure this favor from the Roman general for himself alone, and, leaving his fellow-citizens who trusted in him in the most miserable plight, had gone over secretly to the enemy? And how he had the assurance to be sitting there holding suppliant boughs, in the face of the very men to whom he had frequently said that the day would never come in which the sun would see Hasdrubal alive and his native city in flames. . . . [She then threw herself and her children off the parapet.]

At the sight of the city utterly perishing amidst the flames, Scipio burst into tears, and stood long reflecting on the inevitable change which awaits cities, nations, and dynasties, one and all, as it does every one of us men. This, he thought, had befallen Ilium, once a powerful city, and the once mighty empires of the Assyrians, Medes, Persians, and that of Macedonia, lately so splendid. And unintentionally or purposely he quoted—the words perhaps escaping him unconsciously—

**"The day shall be when holy Troy shall fall
And Priam, lord of spears, and Priam's folk."**

And on my asking him boldly (for I had been his tutor) what he meant by these words, he did not name Rome distinctly, but was evidently fearing for her, from this sight of the mutability of human affairs. . . . Another still more remarkable saying of his I may record. . . . [When he had given the order for burn-

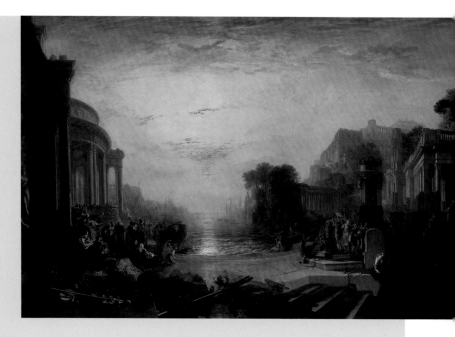

FIGURE 2.9
J. M. W. Turner, Decline of the Carthaginian Empire, *exhibited 1817. Oil on canvas. Tate Gallery, London. The great British painter was fascinated by the story of Carthage. He saw the rise and fall of great empires as a historical inevitability.*

Photo: © Tate London, 2004.

ing the town] he immediately turned round and grasped me by the hand and said: "O Polybius, it is a grand thing, but, I know not how, I feel a terror and dread, lest someone should one day give the same order about my own native city." . . . Any observation more practical or sensible it is not easy to make. For in the midst of supreme success for one's self and of disaster for the enemy, to take thought of one's own position and of the possible reverse which may come, and in a word to keep well in mind in the midst of prosperity the mutability of Fortune, is the characteristic of a great man, a man free from weaknesses and worthy to be remembered.

From Polybius, *The Histories of Polybius,* trans. Evelyn S. Shuckburgh (London: Macmillan, 1889), vol. 2, pp. 528–30.

*Others were seen still living, especially
old men, women, and young children who
had hidden in the inmost nooks of the
houses, some of them wounded, some
more or less burned, and uttering horrible
cries. Still others, thrust out and falling
from such a height with the stones,
timbers, and fire, were torn asunder into
all kinds of horrible shapes, crushed
and mangled.[4]*

The city was razed and plowed over, its pos-
sessions destroyed, and its ruins were aban-
doned to the curse of the Roman gods for
approximately a century.

The devastation was so complete that
it was not until the excavations begun in
the mid-nineteenth century that the world
rediscovered the physical attributes of Punic
civilization. Archaeologists, who were then
able to unearth the vestiges of Carthaginian
homes dating from the fifth through the
second century BCE, found that they were
adorned with *cocciopesto* — crushed brick
concrete, sometimes inlaid—and mosaic
pavements, some simple and some embel-
lished with geometric patterns.

With Carthage destroyed, the rest of the
country remained in the hands of Numidian
kings such as Massinissa, who had sided with
Rome in the war. Most of the territory of
Carthage was declared the public domain of
the people of Rome *(ager publicus populi
romani),* and as a consequence, all the terri-
tory's cities, with the exception of the seven,
such as Utica, that had sided with Rome
against Carthage, were forced to pay a trib-
ute. The land of Carthage went into decline.
Rome, however, did not long remain blind
to its fertility and wealth. In around 123 BCE,
Rome under the Gracchi attempted to colo-
nize Carthage, without much success. It was
not until the reign of Julius Caesar that a
new Roman colony, Colonia Iulia Concordia
Carthago, was founded, and it fell to his
adopted son Augustus to build on the site
the new capital of the Roman province of
Africa. The province of Africa encompassed
most of present-day Tunisia and eastern
Algeria. Africa was placed under the author-
ity of a proconsul chosen by the Roman
Senate.

Carthage remained the capital of the
new province, and Roman Carthage would
become one of the great cultural hubs of late
antiquity. It was a center of education and
law and a capital of Western Christianity. At
its heart were monuments exalting Rome
and Roman ways—lavish bathhouses and
a massive forum and basilica, rivaling in
splendor those of Rome itself. Inland were
lands of remarkable richness and fertility.
Here, great estates growing wheat, olives, and
wine grapes were developed (FIGURE 2.10).
This process of Romanization, which would
continue for several centuries, was sup-
ported by a policy of sending colonists or
veterans, usually of Italian origin, to the
rich inland territories. The newcomers, who
set up colonies modeled on Rome and pro-
moted contact with the local populations,
disseminated Roman civilization inland
into Africa. A priority of Roman policy was
organization of city life, followed by the

122 BCE

Gaius Gracchus, tribune of the people and
agrarian reformer in Rome, unsuccessfully
attempts to found a Roman colony at
Carthage

47 BCE

Julius Caesar lands in
Africa to eliminate one of
the last bastions of resist-
ance against his power

47–46 BCE

African War and decisive
victory by Caesar at
Thapsus in 46

44 BCE

Death of Caesar and
implementation of
his plan to resurrect
Carthage

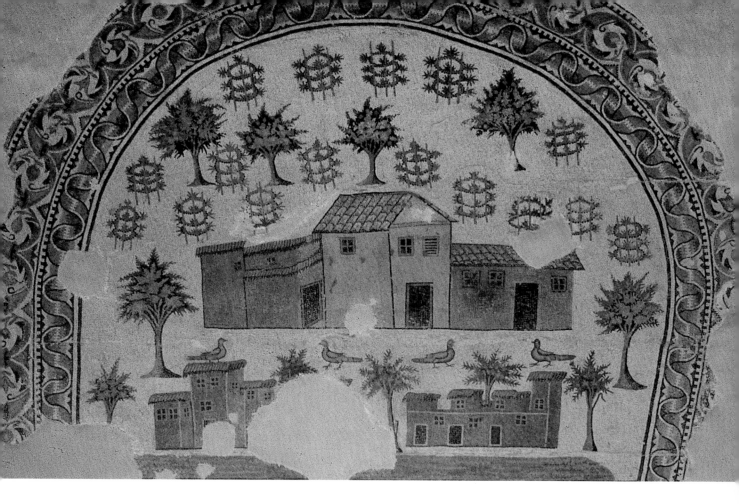

implementation of a system of privileges for the local bourgeoisie, to encourage them to become Romanized.

The cities were also subject to a legal statute that compensated citizens based on how well they adhered to the values of Roman civilization. The Roman cities with the highest legal status were called colonies. Their citizens had the same rights and duties as the inhabitants of Rome. The Roman emperors, beginning with the Julio-Claudians and the Flavians in the first century CE and, in particular, the Antonines in the second century, worked toward the economic and social development of a pacified Africa,

which had become one of the richest provinces of the empire. It was legendary as the breadbasket of Rome. The policy favorable to the Africans reached its zenith when the Severans, a dynasty of African origin from Leptis Magna in Tripolitana (now the region surrounding the city of Tripoli in western Libya), ruled the Roman Empire from 193 to 235.

During that period, Roman colonial urban centers, generally of Punic or Libyan origin, were covered with monuments modeled on those of Rome, evidence of their belonging to Roman civilization. Typically, traffic arteries made it possible to traverse an

FIGURE 2.10

Mosaic from one of the apses of a trifolium in a house at Tabarka, showing views of a large rural estate. The tableau illustrates buildings on the estate amid a landscape with grapevines and olive trees. This type of representation of estates became widespread in African mosaics in the last half of the fourth and the first half of the fifth century. Fifth century.

Bardo Museum.
Photo: INP.

II. CE

29 BCE

Emperor Augustus reinforces the colony of Carthage, which takes the name of Colonia Iulia Concordia Carthago

128

Voyage of Hadrian to Africa and start of construction of the Zaghouan aqueduct at Carthage

193

Septimius Severus, an African from Leptis Magna, becomes Roman emperor and founds a dynasty that rules the Roman Empire until 235

Late 2nd century/early 3rd century

Rise of Christianity in Africa

The Founding of Roman Carthage
From Appian's *Roman History* 8.20.136

"In the tribunate of Gaius Gracchus, uprisings occurred in Rome on account of scarcity, and it was decided to send 6,000 colonists into Africa. When they were laying out the land for this purpose in the vicinity of Carthage, all the boundary lines were torn down and obliterated by wolves. Then the Senate put a stop to the settlement. At a still later time it is said that Caesar, who afterwards became dictator for life, when he had pursued Pompey to Egypt, and Pompey's friends from thence into Africa, and was encamped near the site of Carthage, was troubled by a dream in which he saw a whole army weeping, and that he immediately made a memorandum in writing that Carthage should be colonized. Returning to Rome not long after, and while making a distribution of lands to the poor, he arranged to send some of them to Carthage and some to Corinth. But he was assassinated shortly afterward by his enemies in the Roman Senate, and his son Augustus, finding this memorandum, built the present Carthage, not on the site of the old one, but very near it, in order to avoid the ancient curse. I have ascertained that he sent some 3,000 colonists from Rome and that the rest came from the neighboring country. And thus the Romans took Africa away from the Carthaginians, destroyed Carthage, and repeopled it again 102 years after its destruction."

entire city. At the heart of each city was the requisite monument complex: forum, capitol, temples to the major Roman deities, civic monuments, and public squares adorned with fountains and nymph sanctuaries. The residential neighborhoods were laid out in a grid of streets, which changed over the centuries along with the fortunes of the owners of the houses. The residents were eager to display their social success, and in certain cities, such as Carthage, El Jem, and Bulla Regia, some villas comprised more than five thousand square feet. These homes were carefully decorated and had floors of opus sectile (a paving technique using slabs of cut marble inlaid in geometric or floral compositions) or opus tessellatum (a technique using tesserae—small, hand-cut pieces of stone, ceramic, or glass). As a result, mosaic workshops abounded.

Wealthy Africans—totally caught up in the Romanization system—dreamed of acquiring Roman citizenship for themselves, for their families, and for all of the inhabitants of their cities. Traces of this Romanization are still visible in the many Roman cities that now dot Tunisia, such as Utica, Oudhna (ancient Uthina), Henchir Kasbat (Thuburbo Majus), Dougga (Thugga), Hammamet (Pupput), and Nabeul (Neapolis) in Proconsular Africa (the northern half of present-day Tunisia) and Sousse (Hadrumetum), El Jem (Thysdrus), Sbeïtla (Sufetula), and Haïdra (Ammaedara) in Byzacene (the southern half of the country).

The society that constituted the wealth and prosperity of the Roman province of Africa was composed of a vast majority of free citizens and a minority of slaves. The

203

Martyrdom of Saint Perpetua and Saint Felicitas in Carthage; voyage of Septimius Severus to Africa

238

Revolt at Thysdrus (El Jem) against tributes levied by Emperor Maximinus; assassination of the procurator of the treasury; and Proconsul Gordian proclaimed emperor. Defeat of Gordian I and Gordian II; fall of Maximinus; Gordian III proclaimed emperor (238–244)

249

Cyprian elected bishop of Carthage

250

Persecution of the Christians under Emperor Decius

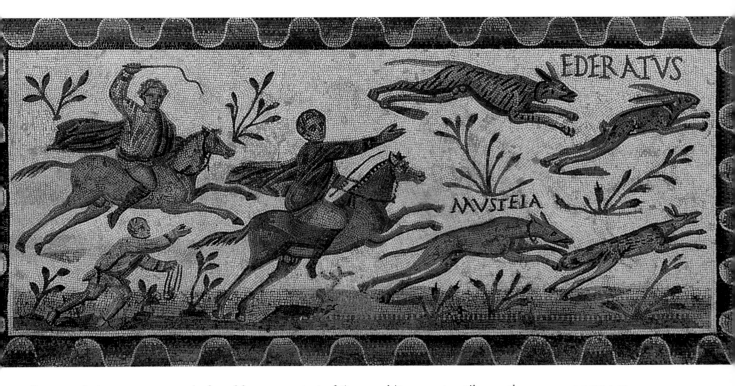

free population was composed of wealthy property owners who held high municipal positions and derived their fortunes from farming their domains. The leisure activities of this category of citizens were many and varied. Large mosaic tableaux depict some of these pleasures, such as various types of hunting (FIGURE 2.11).

The second category of the population was composed of artisans, shopkeepers, and the various trades that formed the mainstay of an African city. The lowest rung was occupied by the working masses, who labored hard to survive. This disadvantaged class did not leave much of a mark on the archaeological landscape until a few decades ago. Their humble dwellings were not built to stand the

test of time, and it was not until recently that archaeologists uncovered even the slightest traces of their lives. Favorite mass entertainments included the circus, which featured chariot races and other events (FIGURE 2.12). Despite its rigidity, African society allowed its most enterprising members some measure of upward mobility, as was the case with the tillerman of Mactar, whose epitaph, dating from 260–270, recounts the biography of a peasant of very modest circumstances who, through hard work and sacrifice, ended his days as a wealthy man.

The economy of ancient North Africa was based on agriculture. Wide-scale cultivation of cereal grains predominated, which

FIGURE 2.11
Threshold mosaic from the reception room, or oecus, of the so-called House of the Laberii at Oudhna. The tableau depicts a hunt in which two mounted horsemen, accompanied by a servant following on foot, chase two hares, which are tracked by two hounds, whose names are given as Ederatus and Mustela. Fourth century.
Bardo Museum.
Photo: Jerry Kobylecki/GCI.

258	Late 3rd century	303–305	308–311	308
Martyrdom of Saint Cyprian	Major administrative and military reforms by Diocletian in Africa	Violent persecution of the Christians under Diocletian	Rebellion of Domitius Alexander, vicar of Africa; proclaimed emperor by the troops. Carthage pillaged by troops	Beginning of the Donatist crisis

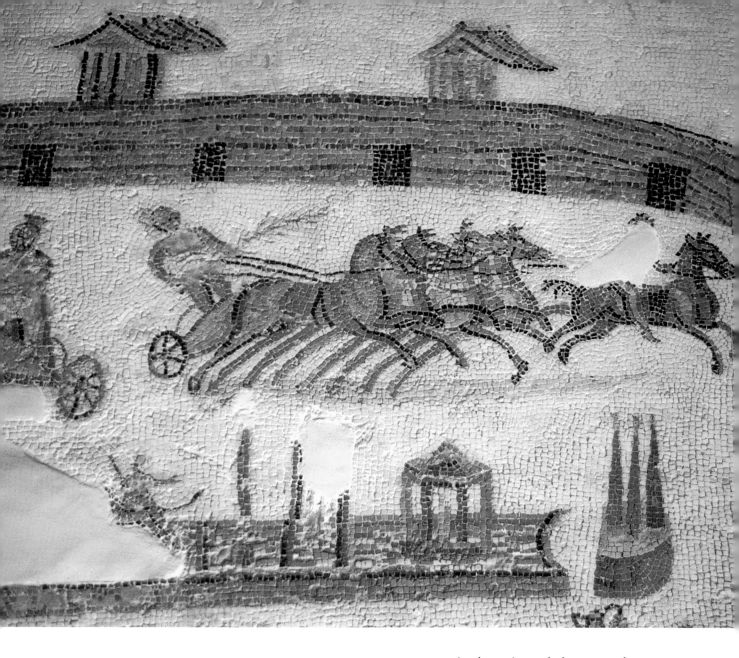

FIGURE 2.12

Detail of a mosaic found at Carthage, depicting a circus where a chariot race is taking place. The interior architecture of the circus is shown. On the right, there are doors to the bleachers. At the center of the structure is a raised median, which divides the track in half. At its ends are posts, around which the chariots turned. Circus games were very popular in Africa, as in the rest of the Roman world, particularly as of the fourth century. The winning charioteers were considered celebrities, as were the winning horses. Third century.

Bardo Museum.
Photo: CMT.

is why grain symbols were used to represent the summer season in dozens of African mosaics. The second major crop of Africa is the olive, particularly in the Sahel region beginning at Sousse. Large oil mills dating from the Roman period have been discov-

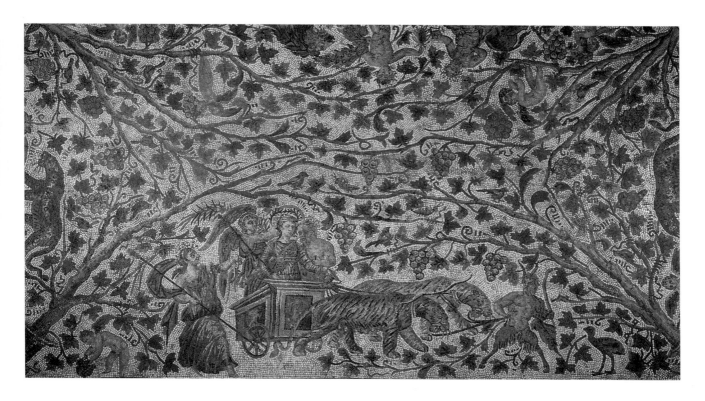

ered throughout the Roman territories, proving that olive oil was a source of wealth for the African bourgeoisie. Furthermore, the city of El Jem —with its splendid amphitheaters and residential neighborhoods—owed its prosperity to the role it played in collecting olive oil from all of the inland cities of the Sahel region and transporting it to the capital of Byzacium. Sousse was able to ship a great deal of it, thanks to its port. Indeed, olive oil has long been emblematic of Tunisia; a well-known passage from *The Confessions of Saint Augustine,* for example, alludes to the abundance of olive oil in Africa. In fact, Augustine, an African for whom olive oil was widely available, was

shocked during his travels in Italy by how sparingly his hosts used oil lamps.

Grapes and wine also occupied an important place among the sources of income of wealthy Africans. Along with oil mills, archaeological excavations have unearthed winepresses. We find echoes of this wealth of grapes and wine in the multitude of mosaic pavements illustrating all aspects of this topic. Bacchus, the god of wine, was the master of the universe, in the incarnation of the Pantocrator, god of the seasons, fertility, life, death, and eternal renewal (FIGURE 2.13).

This state of grace lasted in Roman Africa until the third century, when a major military, political, economic, and religious

FIGURE 2.13
Mosaic from El Jem portraying a triumph of Bacchus. The lush grapevine composition contains a Dionysian procession. The richly dressed god Bacchus rides his chariot, drawn by a team of tigers. He is being crowned by Victory, who stands behind him. Silenus, the god Pan, a maenad, and—on the opposite side of the mosaic—satyrs, cupids, and fauns can also be seen. Second half of the third century.
Bardo Museum.
Photo: Jerry Kobylecki/GCI.

429

The Vandals land in Africa

430

Death of Saint Augustine in Hippo; Hippo besieged by the Vandals

431

Roman army of Boniface beaten by Genseric and the Vandals

439

Genseric takes Carthage and founds a Vandal kingdom

455

Genseric and the Vandals occupy and pillage Rome

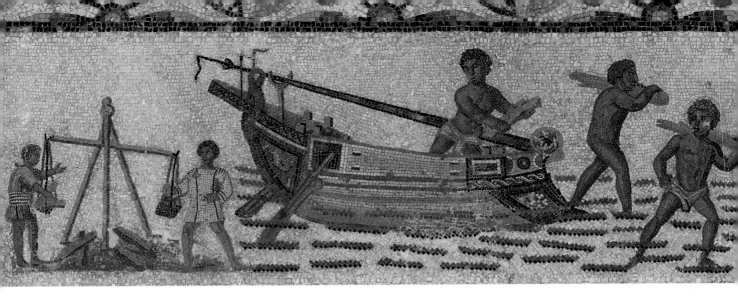

FIGURE 2.14
*Threshold panel from
Sousse showing a com-
mercial boat being
unloaded at port, sug-
gesting the vitality of
trade in third-century
Roman Africa. The sailor
hands wooden bars to
the two figures who are
carrying them to shore.
On the left, two other
men weigh the merchan-
dise. Third century.*

Bardo Museum.
Photo: Bruce White, 2005.

crisis shook the foundations of the Roman Empire. Unstable at home, the empire was under attack from without, as various Germanic tribes raided its eastern borders. Although the ripple effects of the crisis slowed the process of African urbanization, they were not as serious here as in other provinces of the empire. In recent decades, archaeological research has shown that the great crisis of the third century spared the African cities in comparison to its impact on the rest of the occidental Roman world (FIGURE 2.14).

The region recovered over the course of the fourth century. This recovery is visible in the plethora of restoration and embellishment work undertaken on public monuments, particularly the public baths, where inscriptions extol the reconstruction. In the area of domestic architecture, we note additions to houses and numerous reception halls, as well as care given to their decoration and mosaic decor. Demand for these services resulted in a revival of workshops and of artistic freedom. The resumption of urban renewal in the area of domestic architecture reveals the existence of a prosperous bourgeoisie that had the wherewithal to spend on comfort and to indulge in the fashion of the

day. This prosperity was particularly evident in Carthage, Thuburbo Majus, Bulla Regia, and Dougga.

In this receptive atmosphere, Christianity developed further as well. The religion, which appeared in Africa toward the end of the second century, underwent several periods of persecution under Commodus, Septimius Severus, and Diocletian. Some of the famous martyrs included Felicitas and Perpetua, both of whom died in Carthage in 203. In the fourth century, Christianity became the state religion under Emperor Constantine.

In the fourth century, under Constantine, a schism developed within the African Church as the new movement of Donatism emerged. Donatism was periodically persecuted by Catholicism, which became the official religion of the Roman Empire. Yet it was not until the early fifth century, in 411, that Orthodox Catholicism definitively triumphed at the famous Council of Carthage, whose most notable figure was Saint Augustine. During the entire period when African Christianity was in constant upheaval with respect to dogma and ritual, the construction of churches multiplied, and some pagan temples were converted to Christian

476
Fall of the last Western Roman emperor, replaced by powerful barbarian royalty

525
Peace with the Catholic Church and severe Vandal defeats by the Berbers

533
Defeat of Vandals and Byzantine reconquest of Africa under the leadership of General Belisarius

563–571
Berber insurrections and numerous setbacks to the Byzantine army

647
First Muslim attack on Africa

places of worship, as was the case in Carthage and Thuburbo Majus. Churches abounded everywhere, even in the smallest rural centers, such as Sidi Jdidi, located approximately ten kilometers inland from Pupput. Today, chance discoveries often bring to light the vestiges of Christian basilicas, with their characteristic pavement designs decorated with symbols of the Christian faith. These discoveries also often reveal tombs of the faithful, covered with traditional mosaic designs (FIGURE 2.15).

During the first half of the fifth century, the African territories fell under the domination of the Vandals, who took possession of Carthage in 439. Led by their king, Genseric, approximately eighty thousand Vandals arrived from Spain, after crossing all of North Africa. To consolidate their power, the Vandals confiscated the territories for their people and persecuted the Catholic Church. History has accorded the Vandals a reputation for wanton destruction, but it now appears that historians of centuries past greatly exaggerated their wrongdoings, largely because the primary sources are Victor of Vita and Procopius, two Catholic historians, one a Roman and one a Byzantine. Admittedly the persecutions were real, but these were not uncommon for the period.

Archaeological excavations in recent decades show that the fifth century was consistent with the previous period. It is very difficult to recognize a Vandal church or the home of a Vandal notable. The figurative peristyle house found in Pupput, dated to the mid-fifth century, has the same features as other residences of the fourth- and fifth-century bourgeoisie. The mosaic workshops

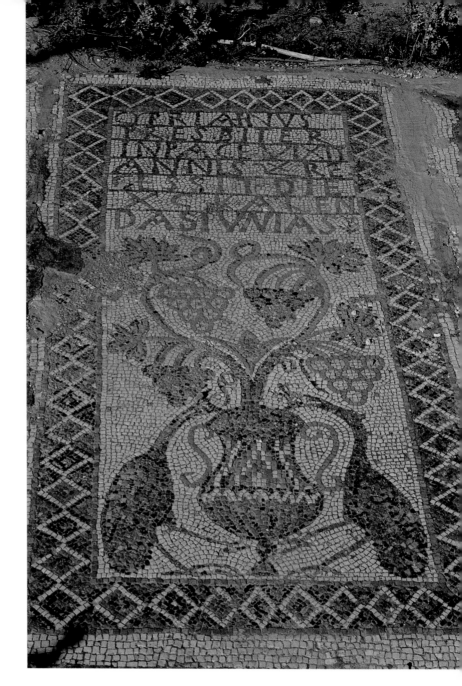

FIGURE 2.15

Tomb mosaic from Sidi Jdidi (ancient Aradi), which covered the tomb of Father Cyprian, as the inscription indicates. The bottom of the tableau is decorated with a krater from which grapevines branch and peacocks drink. These were standard themes in paleo-Christian iconography. The mosaic is in its original setting. Sixth century.
Photo: Michel Fixot.

665	670	695	698	800
Second Muslim attack	Founding of Kairouan by the Muslims	Taking of Carthage by the Muslims	Final fall of Carthage	Founding of the Aghlabid dynasty

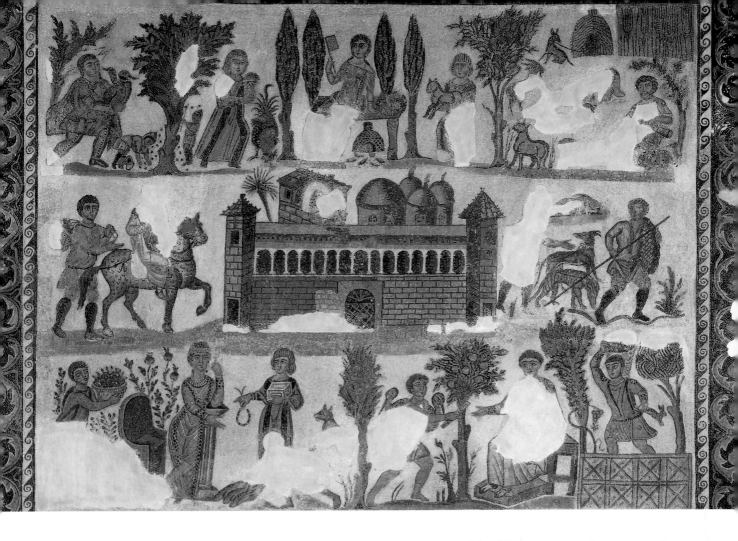

FIGURE 2.16

Mosaic from Carthage depicting the Estate of Lord Julius. One of the most celebrated mosaics in the Bardo Museum, this tableau portrays the life of a lord and lady on their great estate. The mosaic is dominated by a palatial home. Behind the house is a small complex with cupolas — probably the baths—along with common buildings. The masters of the domain are shown several times: in the top and bottom registers, among servants and peasants, they receive offerings such as ducks and a lamb; in the middle register, the lord, at left on horseback, and servants leave for the hunt. Fifth century.

Bardo Museum.
Photo: Jerry Kobylecki/GCI.

of the fifth century continued to produce the same types of carpet mosaics and to deal with the same themes as in the previous century. The Vandals gradually assimilated into highly Romanized African society, and the comforts of African life, over time, permanently subdued their bellicose spirits. Then, barely more than a century after the Vandals took Carthage, the Byzantine army arrived at their doorstep. The Byzantine reconquest of Africa in 533 was accomplished in a spirit of revenge against the Vandals by the Byzantine Empire, the heir and continuator of the Roman Empire. This victory was

909	916	1535	1574	1574–1609
Founding of the Fatimid dynasty	Founding of Mahdia	Conquest of Tunis by Charles V; Spanish protectorate	Turkish victory over the Spanish troops; Tunisia becomes an Ottoman province	Turkish period

seen by the Byzantines as a restoration of legitimacy after the period of Vandal usurpation. However, reconquered Africa became an impoverished province, torn by schisms. The cities were increasingly abandoned in favor of rural domains, as the mosaics from the Estate of Lord Julius and those from Sidi Ghrib illustrate so well (FIGURE 2.16). Public monuments, such as capitols, were fortified (as was the one at Ksar Lemsa, for example) or converted to other uses, as in Thuburbo Majus, while homes were increasingly scaled down or abandoned. The only major undertakings involved rebuilding and enlarging the ancient churches and repaving them with mosaics bearing the stamp of a new style.

In the seventh century, the new religion of Islam spread west into northern Africa from the capital of the caliphate in Damascus. When in 647 the Muslim armies made their first raid at the capital of the Byzantine Roman Empire, the old Roman town of Sufetula (now Sbeïtla), some 250 kilometers southeast of Carthage, they met with little resistance on the part of an African population weakened and jaded by centuries of dissension and misery. While the Arabs eventually departed, their armies were soon to return. In 670 the Arab conqueror 'Uqbah ibn Nāfi' crossed the deserts from Egypt and on the site of one of his army encampments founded Kairouan, some 50 kilometers southwest of Sousse. Kairouan grew into prominence as the region's new political and religious capital. It would become known as one of Islam's holiest cities, and the new Muslim province of Ifriqya would succeed the wealthy and prosperous ancient province of Africa (FIGURE 2.17).

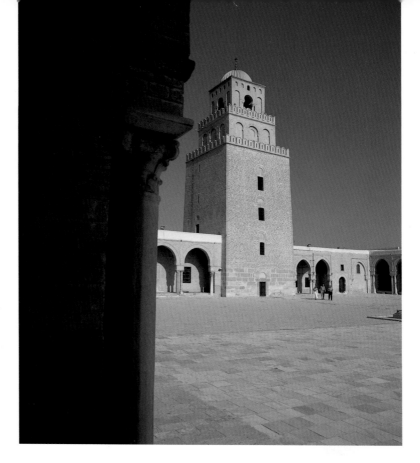

NOTES

1 Little was known about the physical layout of the city of Carthage until 1974, when international archaeological excavations undertaken under the aegis of UNESCO provided important new information. Residential neighborhoods were excavated on the waterfront and on the hillside of Byrsa. Prior to these excavations, our knowledge of Punic Carthage was based on funerary archaeology dating to the nineteenth century. Tombs in crypts abounded with objects of daily life, such as ceramics, terra-cotta figurines, vitreous paste objects, jewelry, coins, and other furnishings. In particular, the UNESCO campaign made it possible to build our knowledge of traffic arteries and domestic architecture.

2 Appian, *Roman History* 8.14.96.

3 In addition to the divine couple, other gods, such as Astarte, Melqart, and Eshmun, populated the Carthaginian pantheon.

4 Appian, *Roman History* 8.19.129.

FIGURE 2.17
The Mosque of Kairouan, the first Islamic African capital, built in the early ninth century. There were several restorations and additions to the structure over the centuries. The magnificent prayer room is remarkable for its decor and particularly for the reuse of material from Roman ruins, including hundreds of ancient columns. Today the Mosque of Kairouan remains one of the jewels of Islamic architecture. Eighth century.

Photo: Bruce White, 2005.

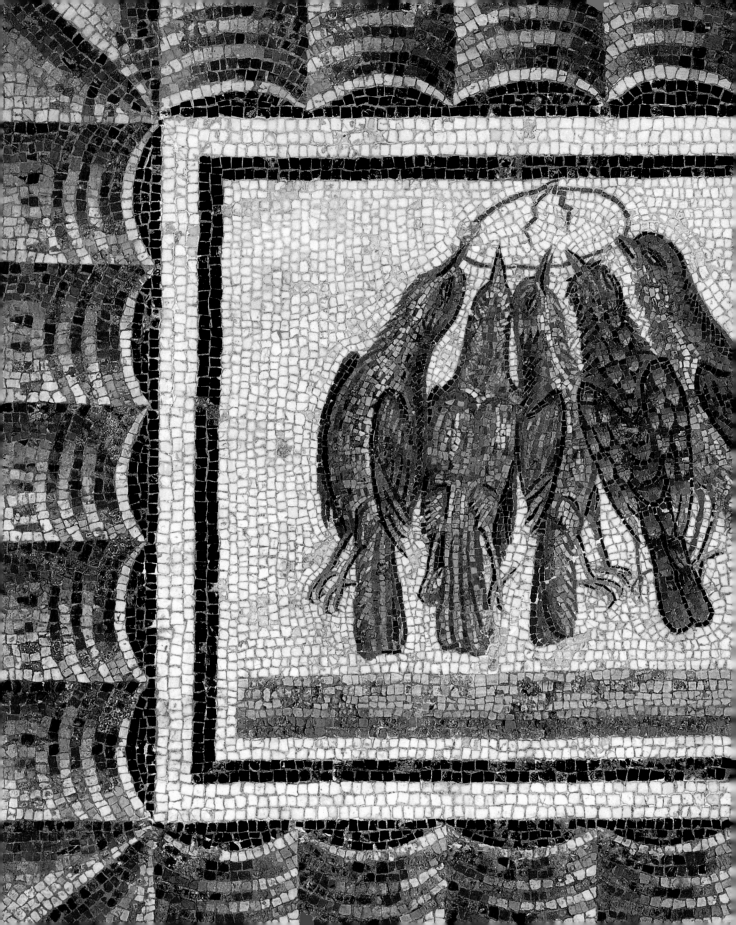

THE DEVELOPMENT OF MOSAIC ART

Tunisia's central geographic location and the openness and hospitality of its people have made it a point of confluence and, over time, assimilation of various influences from throughout the Mediterranean region. Largely for these reasons, over the course of its history Tunisia has fostered the development of a wealth of artistic styles and techniques (FIGURE 3.1).

FIGURE 3.1
Detail of a xenia, or still life, triclinium pavement mosaic from El Jem, depicting a string of thrushes. Third century.
Bardo Museum.
Photo: Bruce White, 2005.

One of the most important of these is the art of decorative mosaic flooring. For those who commissioned them, mosaic pavements served as a prestigious display of their classical culture. The mosaics' iconography was also believed to have the power to ward off evil and to attract the goodwill of spirits who protect the living. Some mosaics were intended to commemorate important events, such as spectacles organized by the wealthy for the masses — as was the case with the mosaic of Magerius from Smirat now on exhibit at the Sousse Museum (SEE FIGURE 6.6). Most of these mosaics were installed in private homes or in public baths. Aside from the baths, public monuments were rarely paved with mosaics but were, instead, usually paved with slabs of luxurious marble, whose value depended primarily on its rarity. In this respect, Tunisia was not very different from Rome itself, where the principal monuments were paved with opus sectile, formed of marble slabs inlaid in geometric or floral designs.

In contrast to public statuary, which illustrated the supremacy of Roman ideology, these pavements show how Africans lived and thought over the centuries. Thus they constitute historical records of prime importance, invaluable figurative archives of antiquity. They depict the country's natural environment—the land, the sea, the plants and animals. They also reveal the structure of African society — its beliefs, culture, practices and customs, leisure activities, and living environment. In fact, scholars of antiquity are increasingly emphasizing the value of the information provided by these mosaics (FIGURES 3.2 AND 3.3).

Mosaic apparently originated in the Mediterranean basin, where pebble mosaics, especially in the Greek world, date to the fifth century BCE. The Carthaginians, particularly in the city of Carthage itself, appear to

FIGURE 3.2
Detail of the celebrated Sacrifice of the Crane mosaic from Carthage. It presents a tableau showing men setting off on the hunt and the hunt itself. Hunting — an activity beloved by the African aristocracy — is often glorified in mosaics. Late fifth to early sixth century.
Bardo Museum.
Photo: Jerry Kobylecki/GCI.

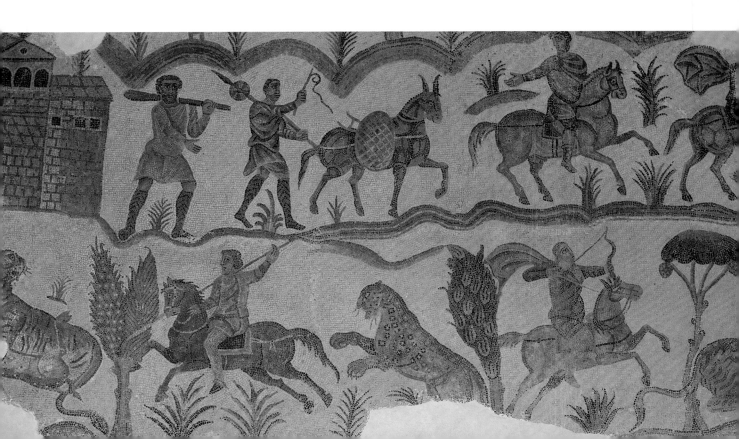

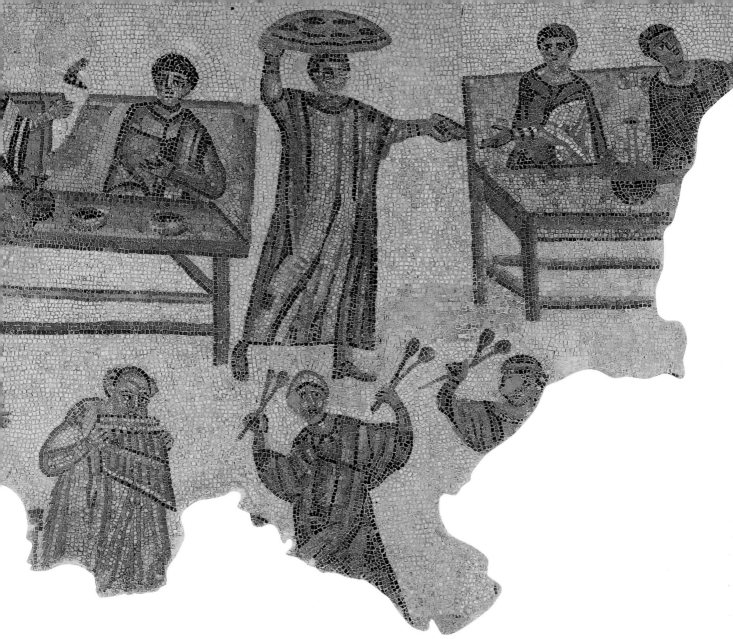

have participated actively in the development of the opus tessellatum technique, in which individual tesserae — small, hand-cut pieces of stone, ceramic, or glass — are embedded in a homogeneous surface. This finding has been borne out by the international excavations carried out in Carthage since the 1970s. This period also featured the development of the opus signinum technique — pavements consisting of lime concrete, sand, and large quantities of crushed terra-cotta, scattered with tesserae (FIGURES 3.4 AND 3.5). The archaeological strata dated between the fifth and third centuries BCE have revealed mosaic

fragments that, while usually undecorated, sometimes contain a few colored elements (FIGURE 3.6). A small fragment of opus tessellatum was also found during an archaeological excavation undertaken in 1965 at the Punic city of Kerkouane, located on the Tunisian Cap Bon peninsula. More recently, a chance discovery at Carthage brought to light a threshold panel with a precise polychrome geometric motif.

The art and craft of Hellenistic mosaics spread throughout Greece, Asia Minor, Alexandria, and Italy, and even to Ampurias in Spain. One of the technique's character-

FIGURE 3.3
The Banquet mosaic from Carthage, which probably paved two apses. Tables are arranged around the periphery of the mosaic. Behind them are guests, eating and drinking. Servants laden with platters circulate among the tables; musicians and singers provide entertainment for the feast. Fourth century.

Bardo Museum.
Photo: Gilles Mermet/Art Resource, NY.
© Cérès Éditions, Tunis.

FIGURE 3.4

Pavement mosaic from a house in the residential quarter of the Punic city of Kerkouane. The technique shown here—opus signinum inlaid with tesserae—was probably the precursor of opus tessellatum. Fourth century BCE.

Photo: Elsa Bourguignon, 2002.

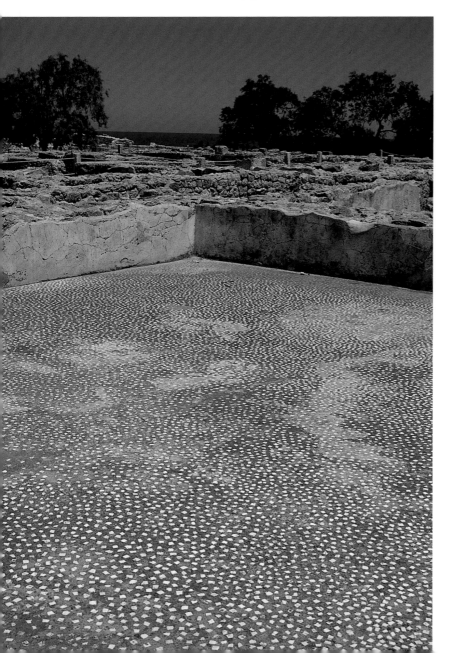

istics was the use of lead strips for outlining. This period also saw the dissemination of emblemata—figurative representations in opus vermiculatum, created with tesserae only a few millimeters in size—each mounted in a separate frame that could be inserted into an existing pavement.

What we know as Italian mosaics developed in the late second and the early first century BCE, in the form of *crustae* floors, consisting of fragments of marble set in mortar. Under the Julio-Claudian dynasty, Italian mosaic art blossomed and gained recognition for its originality. For example, the site of Pompeii provides a host of motifs that were widely disseminated throughout the Roman Empire. The pavements of this period are characterized by simple, uncluttered, and subdued compositions, either entirely in black and white or highlighted with polychrome touches. This style, which evolved during the early second century CE, gave birth to the vegetal patterns magnificently exemplified at the Villa Hadriana in Tivoli, Italy. Apart from the emblemata, the figures are either black-and-white silhouettes or polychrome elements, such as those seen in aquatic scenes. Mosaic art continued to evolve and diversify during the third century. Yet in the late third and the fourth century, Italian mosaic lost its originality and became widely influenced by trends from other provinces, such as Africa.

Constructions from the first century BCE to the first century CE are quite rare, and Africa has not yet yielded any mosaics that can be specifically dated to that period. The first few examples we have of elaborate floors do not appear until the second half of the first century, in Carthage and Utica. There are too few such examples, however, to permit any significant conclusions.

It appears that the flooring of that period either continues the Punic tradition or copies what was then being done in Rome. The floors are covered with a thick layer of opus signinum. Their surfaces are scattered with tesserae, sometimes in a geometric pattern, forming motifs such as grids. While such opus signinum floors are found later, their patterns are less elaborate, and there is no random scattering of tesserae.

As far as we know, true opus tessellatum was not used consistently until the end of the first century CE. Here again, we find the earliest examples in Carthage, as well as in Utica. Like those from the same period found in Rome, these pavements often consist of simple frameworks, formed by traceries of fine black lines, on dominant white backgrounds. The lightness of the traceries and the careful arrangement of the background tesserae give these pavements a feeling of spare elegance. Such is the case with the mosaic pavement from the House of the Cryptoporticus at Carthage, dated to the

FIGURE 3.5
Detail of a pavement mosaic from a house at Kerkouane containing a symbol called a sign of Tanit, which served a protective purpose. The decoration, set into a background of inlaid opus signinum, is in its original location. Fourth century BCE.
Photo: INP.

FIGURE 3.6
Early mosaic from Punic Carthage, an example of the beginnings of the opus tessellatum technique. Ca. third century BCE.
Photo: Bruce White, 2005.

A Heritage Lost and Found

Abandoned at the end of antiquity, the great cities and estates of ancient Tunisia began to fall into ruin in the late sixth century. The mosaics, murals, and other art they housed were exposed to decay and destruction from the elements and human interventions. The abandonment of these places by the Arab conquerors has not been extensively studied, so the process is not yet fully understood. Sometimes the new masters of the region built camps and towns near the ancient cities, such as with Fahs, three kilometers (five miles) south of Thuburbo Majus. The abandoned ancient cities themselves gradually fell into ruin.

For centuries the ruins of Roman Carthage remained impressive. The eleventh-century Arab chronicler El-Bekri noted that the great Roman amphitheater at Carthage, with its "circle of arcades supported by columns topped by other arcades, was of the first rank. On the walls [were] depictions of animals and other figures who symbolize the winds." Another edifice, he said, which we now believe to be the Antonine Baths, "was several stories high, with great marble columns white as snow and brilliant as crystal." Struck by the abundance of marble, he noted that someone visiting Carthage would every day find a new marvel that he had not noticed before.[1] Visitors in the twelfth century would also note the splendor of the amphitheater, the cisterns, and the aqueduct, which traversed, one noted, "an infinite number of bridges of stone arches, one of the most remarkable works that one could possibly see."[2]

However, this observer also noted: "since the fall of [Carthage] there have been continual excavations of its ruins ... to remove all sorts of marble. Marble is exported throughout the country and no one leaves Carthage without loading a good quantity onto ships."[3] Indeed, during the Middle Ages, the ancient ruins at Carthage and elsewhere throughout the region would serve as raw material for new buildings. Thus the capital of the Muslim land of Ifriqya and its great mosque were constructed with blocks and architectural elements taken from ancient sites. The Hall of Prayer of

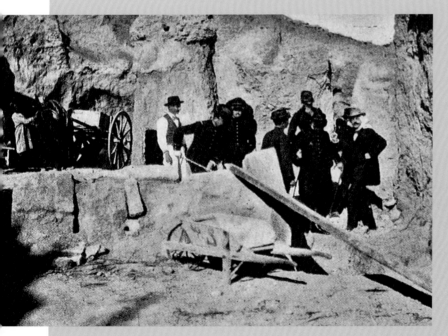

FIGURE 3.7
Excavations of the ruins of Carthage in the late nineteenth century.
Photo: Bibliothèque Nationale de France.

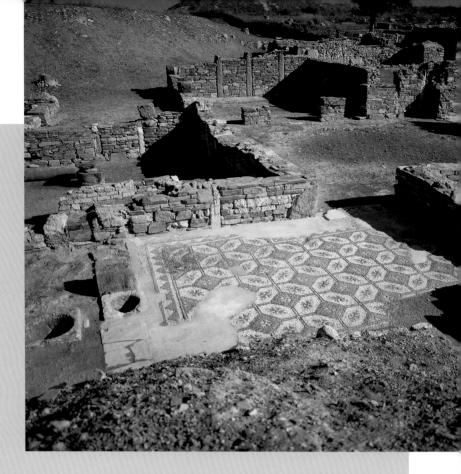

the Great Mosque of Kairouan alone used several hundred ancient columns and capitals taken from sites in central Tunisia. Similarly, the great Ez Zaitouna Mosque of Tunis was built in the ninth century with materials from the ruins of Roman Carthage. Crusaders from Europe took structural elements away to build castles and cathedrals. In the late sixteenth century, when the region came under the control of the Ottoman Empire, material was removed for construction at Constantinople. Material was also taken to Italy, the seat of Roman antiquity, and used in cathedrals in such cities as Pisa and Genoa.[4]

With the Renaissance, Europe rediscovered antiquity and the splendors of its heritage. Not until the mideighteenth century, however, was a passion for antiquity transformed into a scientific quest for the rediscovery of such ruins. The process that began with the excavations at Pompeii and Herculaneum in the mid-eighteenth century reached Tunisia in the midnineteenth century, with the excavation of Punic Carthage, a city that never ceased to fascinate the world since it was tragically sacked by the Romans (FIGURE 3.7). European researchers, practicing the nascent discipline of archaeology, arrived to excavate the long-lost Punic and Roman cities.

With the colonization of Tunisia by France in 1881, when the country became a French protectorate, the interest in Carthaginian antiquities increased— and became increasingly influenced by political aims. The French occupation

of North Africa justified its historical legitimacy by citing its mission to rescue Western antiquity, which they regarded at least in part as their own patrimony.

Among the most important treasures to be discovered were thousands of mosaic pavements (FIGURE 3.8). For the most part, very little remained of the structures in which they were originally housed, and a practice developed of removing what were considered the most valuable mosaics and placing them in museums. More recently, however, interest in the original sites has grown; this increased attention to information regarding the contexts in which the mosaics were created and enjoyed is yielding valuable insights into the role of mosaic art in ancient Romano-African architecture and society.

FIGURE 3.8
A mosaic among the ruins of a house at Thuburbo Majus.
Photo: Bruce White, 2005.

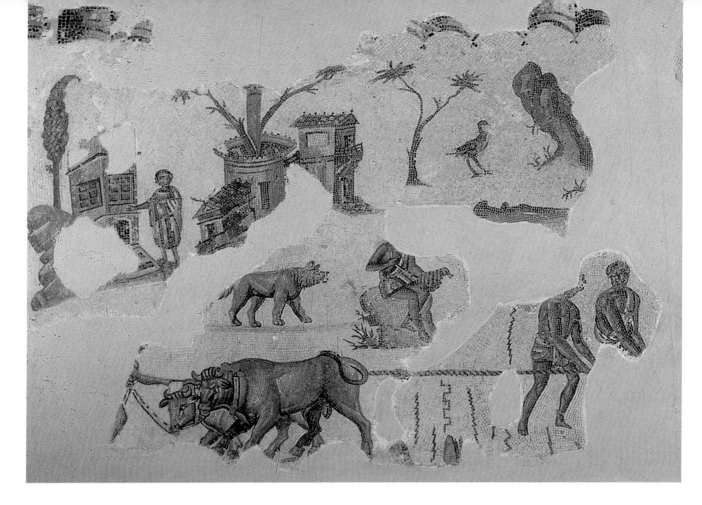

FIGURE 3.9

*Mosaic from El Alia,
near El Jem, representing
daily activities amid a
Nilotic landscape — one
suggesting the land of
Egypt along the banks of
the Nile. Second century.*

Bardo Museum.
© Cérès Éditions, Tunis.

first century, which has a beautiful grid of large and small black and white stones. These motifs are also found at Utica.

The tracings and combinations of these frameworks, as well as their arrangement, are reminiscent of the designs of mosaic floors in Italy during the first century CE. However, while figurative black-and-white mosaics dated to this period are found in Italy, they are practically nonexistent in Africa. Those that have been found in Africa are of relatively poor quality and would appear to be of much later date.

It was not until early in the first half of the second century that polychrome touches were added to pavements as highlighting. These highlights, which first appeared in the borders, gradually came into use in the central fields as well. Color was at first used very discreetly—in a few tesserae or lines in guilloche strands, for example, or to fill in compositional elements. The geometric patterns

were also simple—grids, intersecting circles, and honeycombs. They were surrounded by very common, simple borders, such as guilloches, Greek key patterns, lines of triangles, and meanders.

These early polychrome mosaics are found scattered throughout Africa, both in the Proconsular district around Carthage and in the Byzacene district around Sousse. Color was certainly introduced relatively early at certain sites, such as Proconsular Carthage, Uthina, and Utica, as well as at Byzacene Sousse and El Jem (FIGURE 3.9). It is not until several decades later that color is found in towns relatively remote from the major centers, such as Thuburbo Majus and Dougga.

This early period gave us the exceptional mosaics from the so-called Baths of Trajan in Acholla, now dated to the last half of the second century. The themes, compositions, style, and execution of these mosaics are

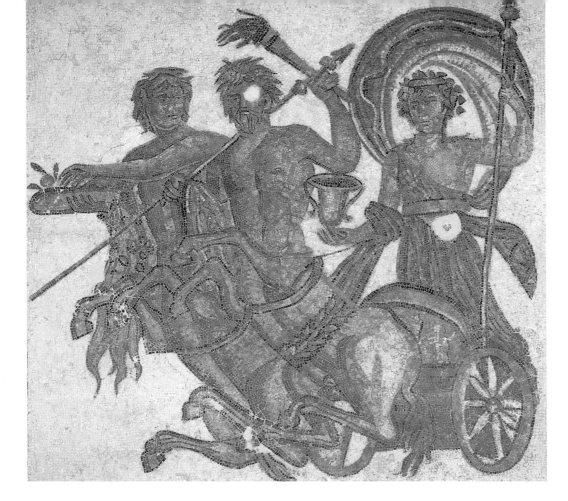

FIGURE 3.10
Detail of a mosaic from the frigidarium of the Baths of Trajan at Acholla, depicting the triumph of Bacchus. The crowned god is standing on his chariot, holding a thyrsus with one hand and a krater with the other. His chariot is drawn by two centaurs. Second century.
Bardo Museum.
Photo: Mohamed El Ayeb.

FIGURE 3.11
Pavement mosaic from a house at El Jem. An elegant vegetal design surrounds a medallion depicting the child Bacchus astride a tigress. Third century.
El Jem Museum.
© Cérès Éditions, Tunis.

similar to those of mosaics in the Hellenistic tradition of the period. Mythological subjects, intimately bound up with Dionysian ritual and prized throughout antiquity by African mosaicists, are developed in a particularly spectacular manner (FIGURE 3.10). The details of the luxuriant borders, the layout of the scenes, and the execution of the figures are certainly the work of a great mosaic workshop whose quality was subsequently long imitated in the region.

The last half of the second century and the early third century were marked by an upsurge in geometric frameworks and a clear interest in polychromy (FIGURE 3.11). At this point a style arose that would come to enjoy great success (FIGURE 3.12). It featured vegetal patterns replete with decorative motifs that branched out and conformed to the overall rhythm of the pavement. Figurative motifs consisting of animals of the land or sea, as well as objects of daily life, such as masks or

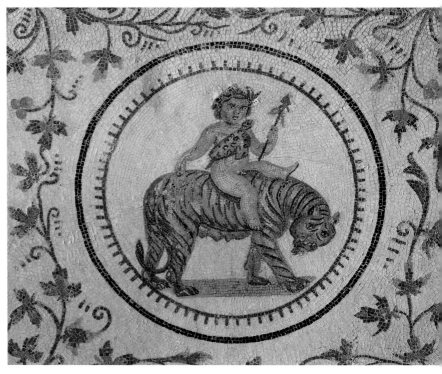

The Mosaic Workshops

We know very little about how mosaics were actually made in antiquity, as there are neither literary works nor inscriptions to tell us how mosaic workshops operated. A single bas-relief found at Ostia has been identified as a depiction of a mosaic workshop. The instruments shown are a compass for tracing the field, a ruler, and other tools. Mosaicists rarely signed their work. The most famous of these artists, known through literature, is Sosos of Pergamon, who lived in the second century BCE and whose works were much celebrated and copied. Later—in late antiquity—the name of the originating workshop *(ex officina)* was indicated on mosaic pavements. Even so, to this day, no single place has been clearly identified as a workshop where mosaics were produced.

There are indications suggesting that mosaicists worked on site. At several locations, including Thuburbo Majus, in the foundations of a mosaic from the House of the Protomes, a large quantity of tesserae and polychrome stone chips—the residue from the cutting of tesserae at the site—have been found. Other places, such as Nabeul, have yielded similar clues. These remnants of the stonecutting process prove that mosaics were laid on site and that teams of mosaic artisans traveled from building to building, from one site to the next. These workshops generally consisted of a master—the artist, or *pictor*—who interacted with the patron to determine the theme and principal components of the decor. The mosaic was then fashioned with the help of assistants whose contributions were probably codified in a hierarchy of seniority and virtuosity.

We know the wages paid to mosaicists, thanks to an important document dating from the fourth century, the Edict on Maximum Prices, which gives wages and the costs of foodstuffs under the Roman Empire. This text specifies two categories of mosaicists: the *musivarius,* whose wages were as high as sixty deniers, and the *tessellarius,* who was paid only fifty deniers per day. Some scholars believe this difference in pay reflected the level of specialization: the *musivarius* was the master who executed the figures, while the *tessellarius* would do the journeyman labor of setting the tesserae.

FIGURE 3.12

Amid a dense composition formed by a geometric design of intersecting circles and a vegetal motif of curved, interwoven forms, are xenia of fish and fowl. Third century.

Sousse Museum.
© Cérès Éditions, Tunis.

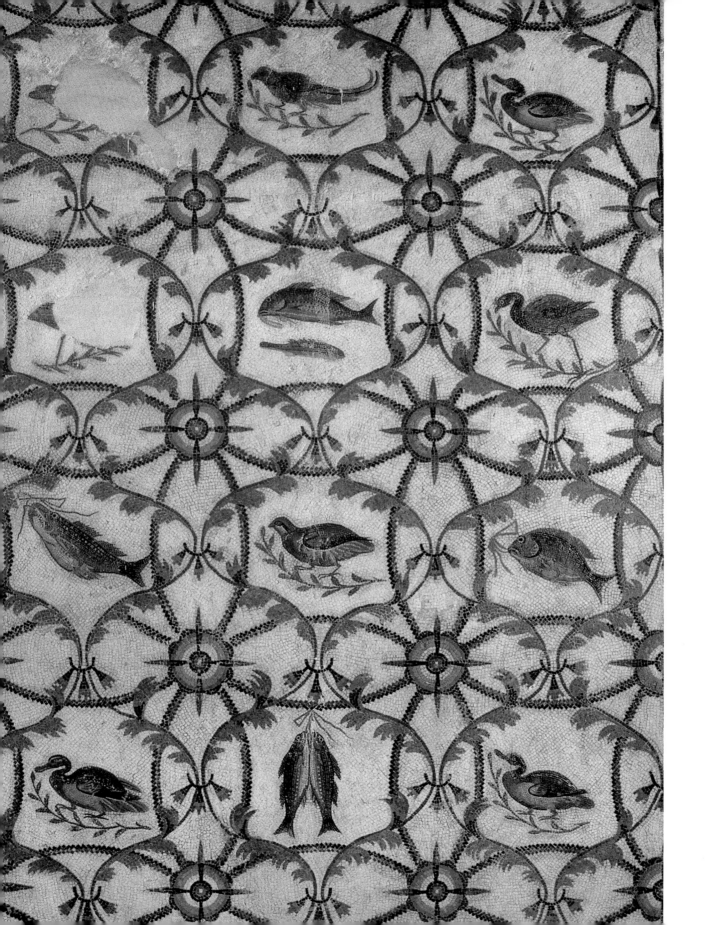

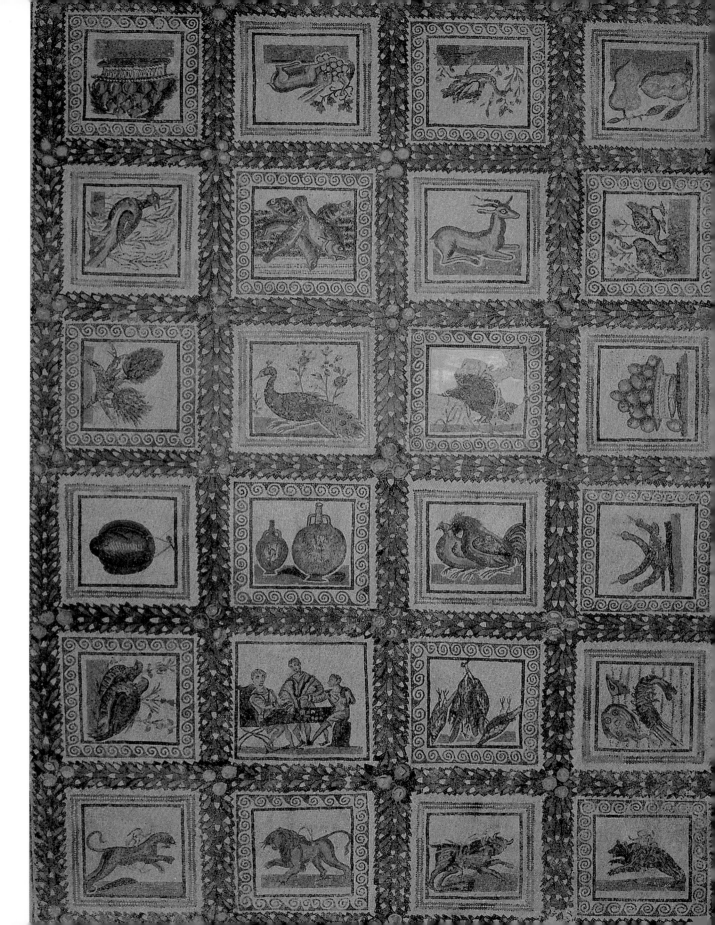

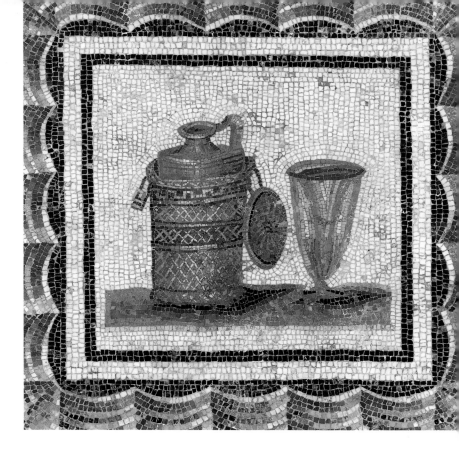

musical instruments, were often placed within compositional elements. Such mosaics were designed like beautiful carpets. With their deftly arranged colors and their sinuous shapes, they were created for the sole purpose of pleasing the eye and contained vague allusions to an ancient—and by now purely decorative—symbolism.

The art and technique of mosaic continued to develop throughout the first part of the third century, becoming more elaborate and diversified. At that time borders became increasingly common, both surrounding the central field and within compositional elements. At the same time, the Africans seemed to develop a taste for florets, which eventually became major components of their mosaics. Classic florets with four lanceolate petals or leaves gave way to myriad shapes and combinations that became veritable floral compositions. A site such as Thuburbo Majus is a good illustration of this process. In order to decorate and completely fill the paved floor space, mosaicists freely used their imagination and creativity with regard to shapes and colors, as evidenced by mosaics from the House of Neptune and the Community House, to name just two examples.

Figurative representations dating to this period were still strongly integrated into geometric patterns, as evidenced by mosaics from El Jem. Figures continued to serve as decorative fill elements. The preferred themes were mythological, especially those related to Dionysian ritual. Imagery also celebrated nature and the environment, in the form of still lifes of marine animals, fruits and vegetables, and fowl. Several extraordinary mosaic pavements from El Jem are masterpieces of this type of ancient art (FIGURES 3.13 AND 3.14).

During the same period of economic, social, and cultural prosperity in Roman Africa, at a time when the region was enjoy-

ing the Pax Romana, the African mosaic school became recognized as one of the most important sources of artistic creation in the Mediterranean basin. Its influence spread to the majority of the Roman provinces, from Italy to Spain and Gaul. From the third through the fifth century, there were few Roman cities whose mosaics did not reflect African influence.

This influence strengthened and expanded throughout the fourth century. Carthage now took the lead in creating and disseminating mosaics throughout the Proconsular region. Large figurative compositions, designed to cover vast areas, became more numerous and increasingly diverse; these works gave rise to some of the masterpieces that now fill Tunisian museums. Property owners commissioned works according to their personal taste and to the fashion of the day, and mosaic artists gave free rein to their imaginations when carrying out these commissions.

For example, the Roman Villas quarter in Carthage offers a particularly spectacular

FIGURE 3.13 (OPPOSITE)
Dice-Game mosaic from El Jem. This triclinium pavement mosaic is composed of a grid formed by a thick laurel garland. Each square is adorned with a xenia motif. One of the squares depicts a dice game, in which two men are seated face-to-face, under the watchful eye of a standing figure. Note that the last row of squares contains animals used in amphitheater combat spectacles. Third century.
Bardo Museum.
© Cérès Éditions, Tunis.

FIGURE 3.14 (ABOVE)
Detail of a triclinium pavement mosaic from El Jem, representing a xenia of a flask in a woven cover and a footed glass. Third century.
Bardo Museum.
Photo: Bruce White, 2005.

Mosaics in the Rest of Roman North Africa

In addition to Proconsular Africa, which covered the eastern edge of Algeria as well as the country that is now Tunisia, ancient North Africa comprised the provinces of Numidia and Mauretania Caesariensis in the area around Cherchell (formerly Iol, then Caesarea) in what is now Algeria, and Mauretania Tingitana, in what is now northern Morocco. A distinction should be made between Algerian and Moroccan mosaics. The former are much larger, more varied, and numerous, and they are greatly similar to those designed and executed in Proconsular workshops. It appears that mosaicists from the major Proconsular centers were the dominant trendsetters in the field of mosaics, since the same trends are found in

FIGURE 3.15
Mosaic depicting the Four Seasons, from Libya. Tripoli Museum.
Photo: Scala/Art Resource, NY.

Algerian mosaics—but only after a certain time lag. For example, the oldest mosaics from Timgad and Djemila date to the late first or early second century.

However, during the first half of the third century, the famous workshops of Timgad and Lambaesis (now Tazoult-Lambese) arose, with their magnificent and characteristic acanthus leaf compositions, which spread as far as Cherchell, where the mosaicists created a marvelous "strewn" pavement. The floor is entirely covered with branches on a black background. During the same period, figurative mosaics depicted mythological themes, as in the famous Mosaic of the Nereids from Lambaesis. The Greek inscription on this artwork—one of the most accomplished African mosaic works—indicates that it is a reproduction of the "Sea Monsters by Aspasios." The existence of the Mosaic of the Nereids is proof that there were first-rate workshops in this region of Africa. Another similarly crafted tableau, depicting the marriage of Thetis and Peleus, comes from the coastal town of Choba.

Mosaic pavements with mythological themes were also produced during the third century in Sétif and Djemila. Two exceptional examples of such pavements are the Indian Triumph of Bacchus mosaic from Sétif, dated to the late third century, and the Thetis and Peleus mosaic from Cherchell, from the second half of the fourth century. In fact, beginning in the second half of the fourth century, there was a spectacular flowering of Algerian mosaics.

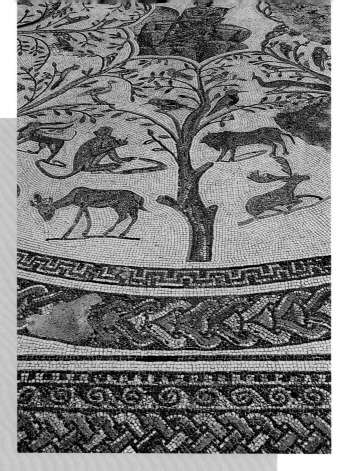

The grand private homes of Djemila and Sétif were paved with striking compositions, particularly in the early part of the fifth century. These include the *Asinus Nica* (victorious donkey) mosaic from Djemila and the Grape Harvest mosaic from Cherchell. Christian cult monuments began to replicate the decor of secular edifices, especially in their geometric compositions and floral and animal motifs. Inscriptions extolling generous donors and builders of churches multiplied.

Production of mosaic pavements became increasingly rare in the late fifth century, and very little is known about Algerian mosaics of the sixth century—or even if there was production of any magnitude. In Mauretania Tingitana, in what is now northern Morocco, Roman mosaics have primarily been found at two important sites, Banasa and Volubilis, although other sites have yielded a few, such as the Orpheus mosaic from Tangier and the mosaics of the Three Graces, Helios, and the god Oceanus from Lixus (present-day Larache). The pavements from Banasa and Volubilis have been dated to the second half of the third century. Their mythological themes include the Labors of Hercules, the death of Hylas, Orpheus (FIGURE 3.16), Bacchus, and a host of others. Marine, animal, geometric, and floral imagery are quite present in these themes. Although rich and varied, Moroccan mosaic production has few similarities to the African styles found in Tunisia and Algeria. Morocco seems much more oriented toward Spain—with respect to the inspiration, technique, and execution of its pavements—than it is toward the rest of North Africa, especially the east.

When we observe the development of mosaics in antiquity, the important role played by Tunisia, with its many important centers, is striking, compared to the rest of North Africa, particularly to the west. Tunisia played a fundamental role not only in perfecting a sophisticated flooring technique but also in creating and developing an art that grew from a minor to a major form of artistic expression. The workshops that developed at the principal sites created and set the styles for the rest of North Africa, as well as for the other western provinces, including Sicily, Italy, Gaul, and Spain.

FIGURE 3.16
A mosaic showing Orpheus among the animals, from a villa in Volubilis, Morocco. Third century.

Photo: Eric Lessing/Art Resource, NY.

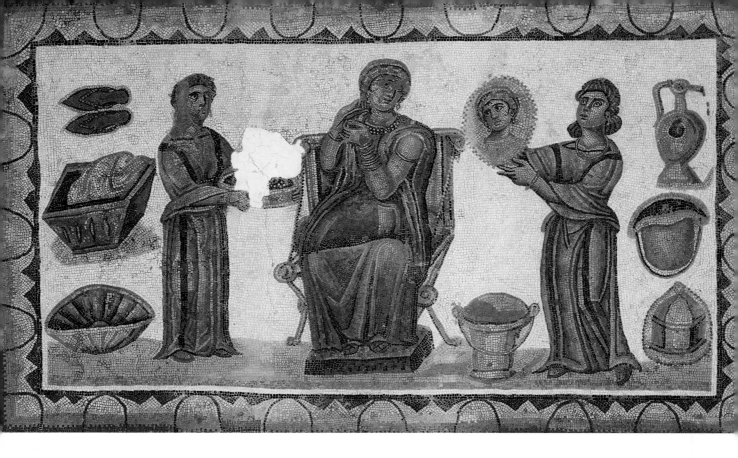

FIGURE 3.17
*Mosaic from the baths
at Sidi Ghrib. The lady
of the estate is shown
at her toilette, attended
by two servants. Fifth
century.*

Carthage Museum.
Photo: Bruce White, 2005.

FIGURE 3.18
*Detail of a mosaic from
the frigidarium of
private baths at Sidi
Ghrib, depicting a
Nereid seated on the
coiled body of a sea
monster. A cupid drinks
from a seashell extended
to him by the goddess.
First half of the fifth
century.*

Carthage Museum.
Photo: CMT.

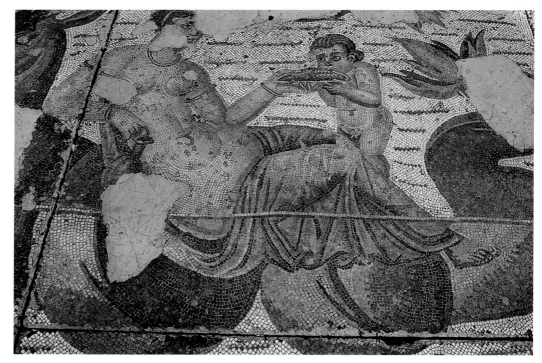

collection of mosaics, most dated to the fourth century. Such pavements include those that covered the floors in the House of the Aviary and the House of the Cryptoporticus. Another example is the rich mosaic decor of the House of the Triconch on the grounds of the Antonine Baths, showing the preeminence of great frescoes designed and executed on extensive surfaces without the use of geometric patterns as guides (one example of this is the mosaic in the vestibule of the triconch). Such large-scale compositions are found at sites such as Thuburbo Majus, notably in the House of the Protomes, the House of the Chariot of Venus, and the House of Bacchus and Ariadne. The town of Dougga also contributed to the profusion of creativity, as evidenced by magnificent representations of the Cyclopes' lair in the Baths of the Cyclopes. The mosaics from the House of the Nymphs in Nabeul (Neapolis) also constitute stellar examples of the technical mastery and creativity of African workshops during the fourth century. These examples show the degree of sophistication achieved by the African bourgeoisie and mosaic artists in the design and execution of ambitious iconographic programs.

This trend continued during the first half of the fifth century, with works such as those that decorated the baths at Sidi Ghrib. The iconographic program centered on a representation of the *dominus,* or master of the estate, leaving for the hunt, an essential ritual among the African aristocracy. Side by side with the image of the *dominus* is the *domina* at her toilette, as befits a lady of her station (FIGURE 3.17). An aquatic procession illustrating Neptune and Amphitrite, the god and goddess of the sea—part of the African mosaic tradition from its inception—adorns the immense floor of the frigidarium, or cold room (FIGURE 3.18). The mosaics from the Estate of Lord Julius at Carthage and

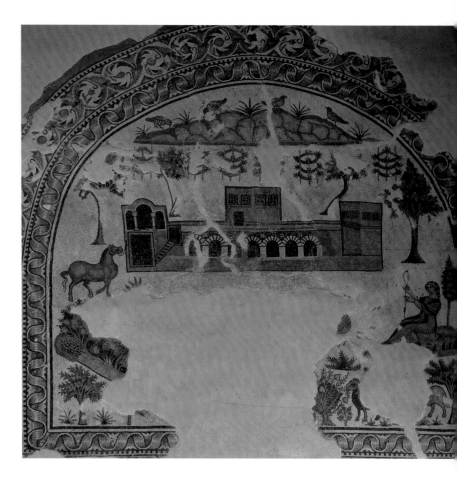

the representations of the villas at Tabarka also fall in this category (FIGURE 3.19). These tableaux give us an idea of the lifestyle of the African bourgeoisie in late antiquity. This period also saw the emergence of paleo-Christian mosaics, identified not by their style but by their presence in Christian sanctuaries or tombs, which are recognizable by their formulaic inscriptions and symbolic figurative repertoire. Because of the increasingly numerous discoveries of tomb mosaics in Tunisia, scholars are arriving at a better understanding of the African Christian community in the early centuries of the first millennium (FIGURE 3.20).

The late fifth century and the first half of the sixth century were marked by the

FIGURE 3.19
Panel from a trifolium apse at Tabarka. This mosaic depicts an estate; in the center is a building with an arcaded gallery and two square towers. The farm is framed at the top by a hill on which birds have alighted. Between the hill and the building are grapevines mounted on hoops. Fruit trees can be seen at the bottom of the tableau. To the right, a woman concentrates on her spinning. Late fourth or early fifth century.
Bardo Museum.
© Cérès Éditions, Tunis.

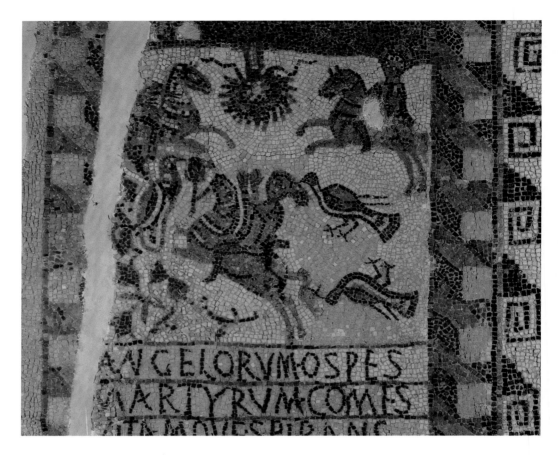

FIGURE 3.20
Detail of a tomb mosaic from Tabarka. The upper part contains a meadow landscape, symbolizing paradise, where a hunting scene is taking place. The deceased, the deacon Crescentinus, is likened to a martyr. Fifth century.
Bardo Museum.
© Cérès Éditions, Tunis.

coexistence of two artistic trends in mosaic production. One was the continuation of traditionalism, with its ancient repertoire of basic geometric frameworks such as grids, intersecting circles, and hexagons in all possible combinations, with their relatively simple decoration of geometric motifs such as Solomon's knots, palmettes, and florets. Polychromy, which had been one of the dominant features of African mosaics, declined considerably. The palette was reduced to a few basic colors, such as red, yellow, and green, along with black and white. Nuances of color and sophisticated halftones became rare; they were replaced by abrupt and graceless contrasting tones.

Alongside this continuity of the traditional mode, a new, Byzantinesque style

surfaced. This new style was totally unrelated to the ancient classical style and featured much more complex geometric patterns, with twisting motifs and intersecting tracery. It appeared several years after the Byzantine reconquest and was part of the artistic and urban renewal that took place in Africa immediately after the province was retaken from the Vandals. The new style is also recognizable by its bright colors, dominated by the use of reds and greens (FIGURE 3.21). The African mosaicists also produced impressive mosaic baptismal fonts, such as the one from Kélibia (SEE FIGURE 5.20) and the more recent find from Tébourba, which is in an exceptional state of preservation. This distinctive style, whose origins still intrigue scholars, seems to have had a relatively

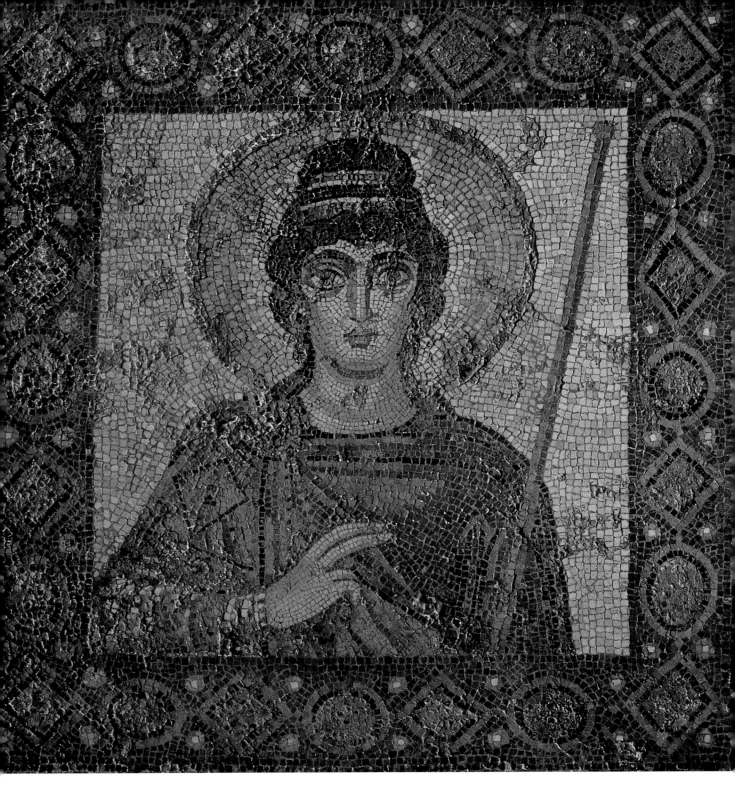

FIGURE 3.21

Mosaic of the so-called Lady of Carthage from a house in Carthage. Much has been written about this enigmatic figure of a haloed woman in a hieratic pose. She is gesturing with her index and middle fingers and holds a scepter in her left hand. She has been interpreted as an archangel, a genie, and the personification of Carthage. Some believe her to be Theodora, the wife of Emperor Justinian. However, the Lady of Carthage has not revealed her secret. Sixth century.

Carthage Museum.
© Cérès Éditions, Tunis.

FIGURE 3.22
Portrait of the Greek author Xenophon from a house in Sbeïtla. Fifth century.
Photo: Mohamed El Ayeb.

limited distribution in the Mediterranean basin and was concentrated in Africa and northern Italy, with a few other sporadic occurrences in Cyrenaica and the Balearic Islands.

Until a few decades ago, scholars believed that mosaic production was in the process of disappearing from Africa on the eve of the Muslim conquest. However, since that time, there have been numerous discoveries, particularly in inland Byzacium, a region little noted for its mosaic production. Although known for the discovery of mosaics in the region of Sbeïtla, including a portrait of the Greek author Xenophon in a residence dated to the fifth century, central Tunisia had never been considered a major mosaic production site—even less a center of stylistic innovation (FIGURE 3.22). Over the past few years, there have been numerous discoveries of mosaics in that region, both at Kasserine and around Sbeïtla, including the Venus of Ouled Haffouz and

the Mosaic of the Nereids, as well as the Hunters Pavement, inlaid with the names of heroes. The style of these mosaics is entirely original, and it is difficult to relate them to previously existing traditions in the African province. They are dated no earlier than the seventh century. The themes and technique of these mosaics call to mind the great frescoes found in Syria, probably of the same period. The discovery of these numerous pavements in the region appears to prove that African mosaic production continued well after the Muslim conquest, and it sheds light on the discovery of the Islamic mosaic in Mahdia (at Kasr El Kaiem), dated to the ninth or tenth century (FIGURE 3.23). As research continues on the late archaeological strata—corresponding to the early Islamic period in Tunisia—it is likely to provide further details about the evolution of mosaics in late antiquity and the early High Middle Ages.

NOTES

1 Cited in Azedine Beshaouch, *La légende de Carthage* (Paris: Editions Gallimard, 1993), 38.
2 In Beshaouch, *Légende de Carthage*, 41.
3 In Beshaouch, *Légende de Carthage*, 42.
4 This phenomenon was not specific to North Africa, since the same thing happened in western Europe during the Middle Ages. There, churches and castles used ancient ruins extensively in new construction.

FIGURE 3.23
Detail of an Islamic mosaic from a palace at Mahdia. Ninth or tenth century.

Mahdia Museum.
Photo: Mohamed El Ayeb.

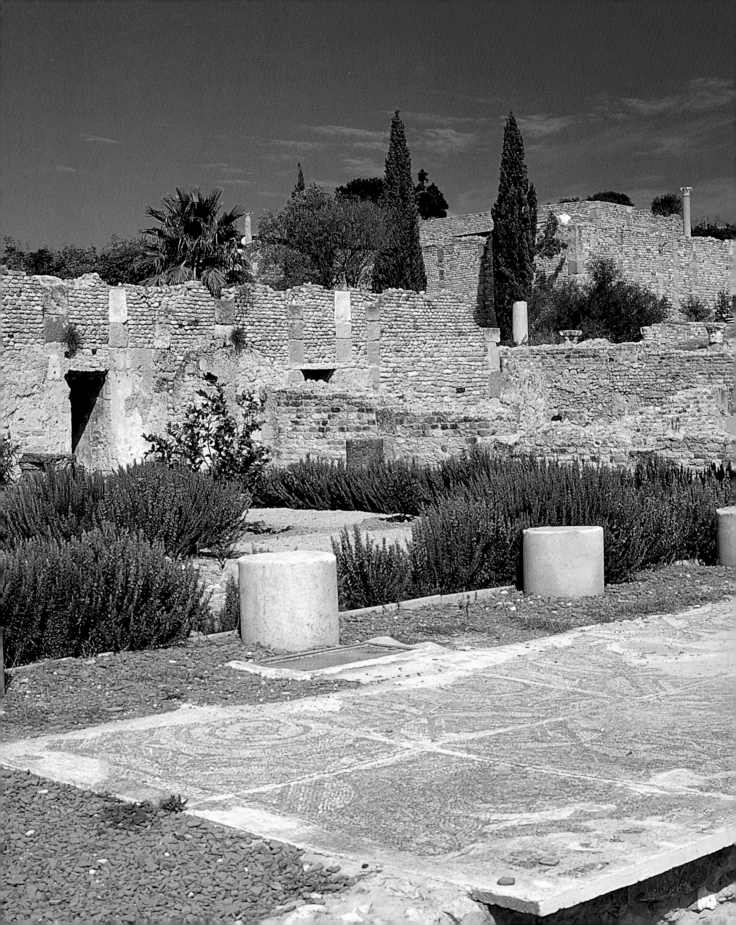

MOSAICS IN THEIR ORIGINAL SETTINGS

Almost all of the mosaic works we see displayed on the walls or floors of museums were, in ancient times, floor pavements in their original buildings. Few wall or ceiling mosaics have come down to us from the Roman period, probably because these were both more rare and more fragile than pavements. When a building was destroyed or fell into ruin, ceilings and walls were generally damaged first; floors usually proved more durable (FIGURE 4.1).

FIGURE 4.1
The House of the Cryptoporticus in the Roman Villas quarter of Carthage.
This large house, which was inhabited between the second and sixth centuries,
was built around a peristyle, one of whose galleries opens onto a cryptoporticus,
or covered gallery. Late fourth or early fifth century.
Photo: Guillermo Aldana, 1993.

It is important to consider the context of the original settings of these mosaics in order to fully understand them and their place in Roman art and architectural history.

For several decades and up until quite recently, archaeologists and art historians engaged in studies focused primarily on works with figurative motifs; geometric and floral mosaics were considered of only passing interest. Techniques for removal were developed in order to transport the works considered worth preserving and exhibiting in museums. The highly valued figurative works were taken to museums, while geometric and floral mosaics were left in their original settings, exposed to bad weather and deterioration. Occasional attempts were made to stabilize them with mortar made from modern cement. The damage and losses from these practices have been considerable; most such pavements have disappeared, and of those that remain, very few have escaped damage from weather and poor maintenance.

This attitude changed several years ago, when scholars discovered the important contribution geometric and floral mosaics can make to our knowledge of the evolution of mosaic history, on the one hand, and of ancient art history, on the other. Since then, numerous publications focusing specifically on pavements with geometric and floral motifs have appeared. That is the case with the *Corpus* publications—the *Corpus des mosaïques de la Tunisie* in particular.[1] These studies present the mosaic along with its context, as a fundamental component of a complex whole. In this approach, emphasis is placed on the presentation of archaeological and architectural information. This volume also emphasizes contextual data. The dating of individual mosaics is usually based on evidence external to the artworks themselves; comparisons and stylistic evidence are cited only when archaeological findings are lacking.

To contribute to the understanding of mosaic floor pavements in their original context, this chapter presents examples from sites representative of African mosaic production, where pavements in situ have been preserved despite the ravages of time (FIGURE 4.2). Most of the examples come from private residences, where such mosaics are most abundant; they reveal the tastes and sensibilities of the upper class, which had the material means, as well as the cultural sophistication, to commission ambitious decorative works from the stylish and accomplished mosaic workshops of Tunisia.[2]

FIGURE 4.2

A mosaic in its original location, a house in Bulla Regia. The partially nude body of the goddess Amphitrite stands out delicately against her mantle, while her crowned head is haloed. Amphitrite is seated on the hindquarters of two sea monsters. Cupids bearing a laurel wreath flutter above her head. Early third century.

Photo: Mohamed El Ayeb.

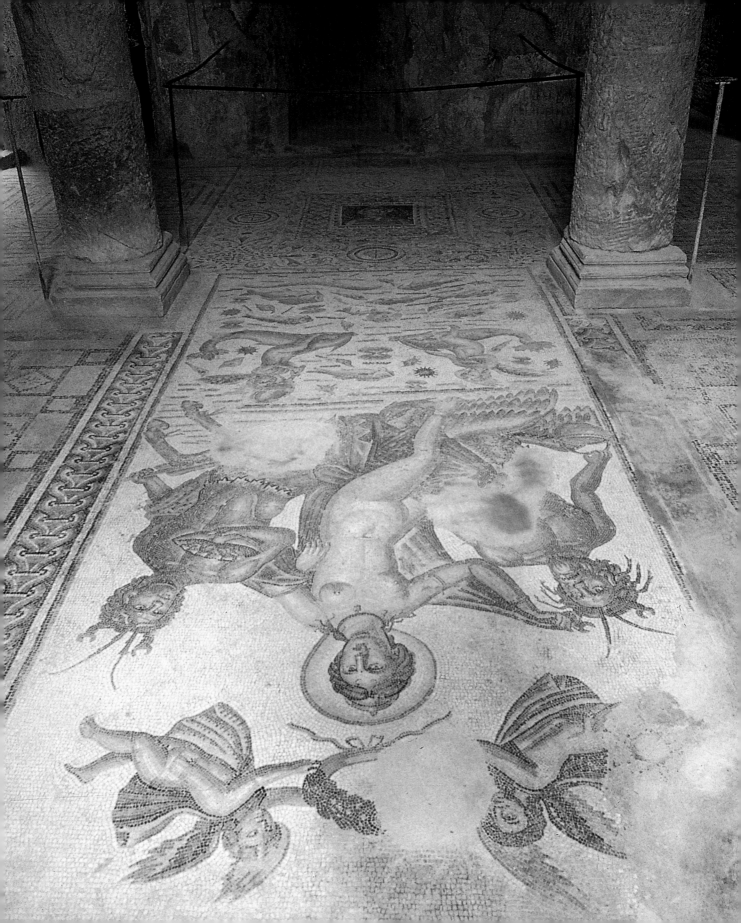

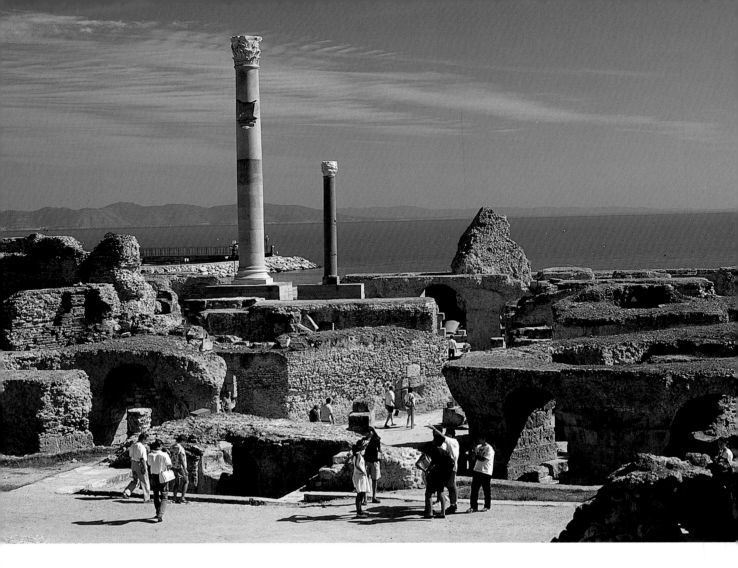

Carthage

FIGURE 4.3
The remains of the large Antonine Baths at Carthage, which were among the largest bath complexes in the Roman Empire. They date to the reign of Antoninus Pius, who ruled from 138 to 161 CE. Today the ruins consist of some of the foundations, as well as the columns, which were righted in the 1970s. Second century.

Photo: Guillermo Aldana, 1993.

One of the most renowned sites in Africa, Carthage, the Punic metropolis that became the capital of Africa Romana, was a major center for the development, production, and distribution of mosaics. In fact, Carthage, which was called *splendidissima*—most splendid—was one of the most important cities of the Roman Empire. It was built on a grid pattern, whose center was at the summit of Byrsa Hill, the acropolis of Punic Carthage. The intersection of the east-west and north-south arteries formed *insulae,* the island-like areas where the city of Carthage developed. Carthage was also an important port and played a vital role in the prosperity of Africa, particularly because of the continent's commercial dealings with Ostia, the port city situated near Rome, at the mouth of the Tiber River.

In the second century, Carthage became the major urban center of Roman Africa, due to the pro-African policies of the Antonine and, especially, Severan emperors. The forum was constructed on Byrsa Hill, along with the capitol, library, and other monuments, including the Metroon, the temple of the mother of the gods, and the Temple of Caelestis. Today there are very few vestiges of these buildings that are still visible. Down the hill to the east, on the seacoast, were the

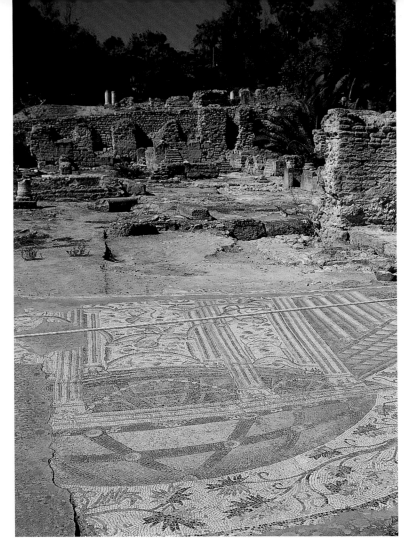

Antonine Baths, among the largest public baths in the Roman Empire. Other public monuments adorned the city in the second century—the theater; the circus, where gladiators fought; the odeum, where poetry and music were performed; and the amphitheater, the remains of which are still visible. Residential quarters formed an important part of Carthage's complex urban fabric. For example, near the odeum there was a profusion of opulent urban villas, such as the House of the Aviary, the House of the Rotunda, and the House of the Cryptoporticus. Similarly, in the vicinity of the Antonine Baths, less spectacular but nonetheless relatively affluent homes were built, and their floors were paved with mosaics.

Scholars have often used the mosaic production of Carthage as a basis for their studies of African mosaics in particular and of Roman mosaics in general. Yet very few structures are preserved with their mosaic pavements intact. Destruction began with the ravages of antiquity, followed by the losses of the Middle Ages, when the ruins of Carthage were pillaged to provide material for the construction of cathedrals, mosques, and other structures. Finally, modern urbanism has taken its toll. Nonetheless, the mosaics that have been discovered give us an idea not only of mosaic production in the African capital but also of the remarkable wealth of styles and variety of mosaic workshops operating in Carthage between the first and seventh centuries. The Antonine Baths and the Roman Villas quarter, for example, still contain several buildings that once were in continuous use over at least four centuries and whose floors today still retain some mosaics (FIGURE 4.3).

On the grounds of the Antonine Baths, two edifices are particularly representative of the structures preserved in this area. The first is the House of the Triconch (FIGURES 4.4A AND 4.4B). When it was discovered in 1953, it was thought to be a *schola* of the imperial cult

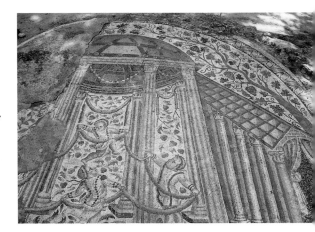

FIGURES 4.4A AND 4.4B
A distinctive mosaic at the House of the Triconch, in its original location in the Antonine Baths at Carthage. Occupying one of the apses of the house's trifolium, the lively pavement mosaic depicts a kiosk flanked by two arcades. Around the pavilion, in a space adorned with roses, cherubs are dancing while holding a garland. Early fifth century.

Photos: Guillermo Aldana, 1993.

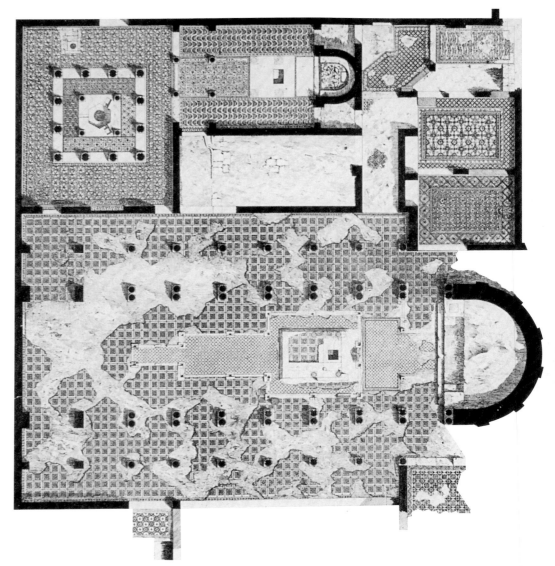

FIGURE 4.5
Design of the Basilica of Dermech 1 at Carthage. The plan comprises the basilica itself, which has an apse and five naves paved with mosaic panels that are good examples of sixth-century Byzantine style. To the north are additional areas, including a baptistery and a chapel. The floors of all of these rooms are covered with geometric and polychrome mosaics characteristic of the style of the first half of the sixth century. Many of these pavement mosaics are still in their original locations. Sixth century.
Photo: INP.

(that is, a building dedicated to the worship of the emperor), but the work conducted for the *Corpus des mosaïques de la Tunisie* shows that this was indeed a Romano-African home. This lavish residence underwent numerous changes in design and mosaic decor over a period of at least two centuries. It is located below the grand Basilica of Dermech 1, from which it is separated by a street. The original house was designed around an oblong peristyle with a fountain basin and pools covered with marble. The

rooms, some of which are paved with opus sectile, open directly onto arcades on the north side and served as classical reception spaces. The *cubicula,* or bedrooms, are more subdued and paved with black-and-white geometric mosaics, sometimes with polychrome highlights. The peristyle itself is enhanced with marble-clad pools and a fountain basin whose elaborate structure is quite sophisticated. This phase of the house is dated to the late second or early third century, as indicated by the archaeological

materials found in core samplings taken throughout the residence.

The second phase of the house's life involved a significant transformation from the original design. The restructuring appears to have been based on the new owners' activities, which probably focused on leisure and entertaining. The shape of the peristyle was totally transformed by the construction of a large central basin and two reception spaces—an apse room and a triconch room. The floors were covered with mosaic pavements, including a particularly interesting tableau in the south apse of the triconch, which represents a kiosk topped with a cupola and two arcades. Cupids are dancing around this circular pavilion. This distinctive mosaic continues to fasci-

nate scholars. This second phase of the residence's existence is dated to the first half of the fifth century.

A second large building occupies the northwest part of the grounds of the Antonine Baths park. It is the large Christian Basilica of Dermech 1 (FIGURE 4.5). The archaeological researches undertaken in the early 1990s have made it possible to reexamine one of Carthage's best-known Christian monuments. Excavated for the first time in the late nineteenth century, as well as several times since then, the Basilica of Dermech 1 is undoubtedly one of the most studied buildings in the Christian metropolis of Carthage. The final stage of this imposing basilica can be dated to the first half of the sixth century. The floor of the main body

FIGURE 4.6
Nave pavement mosaics from the Basilica of Dermech 1 in Carthage. The panels appear to have undergone several ancient restorations. The mosaics remain in their original location. Sixth century.
Photo: CMT.

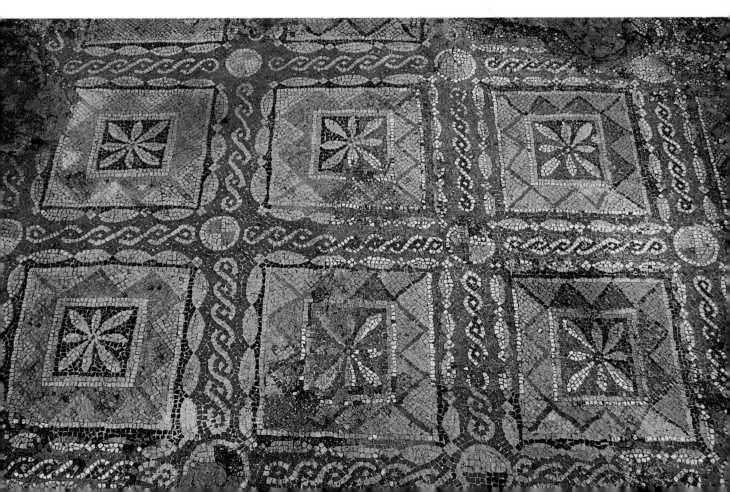

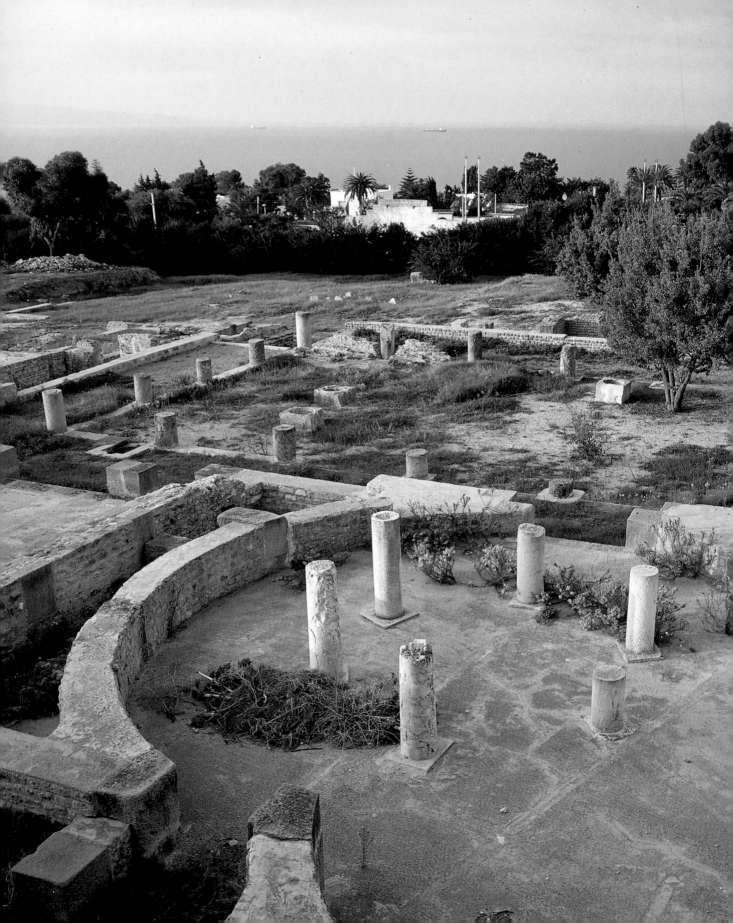

of the church is covered with a mosaic formed of more than a thousand medallions; the pavement's multiple restorations bear witness to the ravages of time and attest to the high foot traffic in certain areas of the church (FIGURE 4.6). The main basilica opens onto a baptismal complex on one side and a chapel on the other. The floors of these two annexes are also covered with geometric and floral mosaics in the same style as those of the basilica. Moreover, all of the pavements, which are dated to the early or mid-sixth century, shed light on the Byzantinizing style that spread through certain parts of the Mediterranean world during the first half of the sixth century. Complex, sinuous compositions, vivid red and gray colors, and thick outlines characterize the pavements of this period. Work on these pavements revealed an earlier geometric and floral mosaic stage, with a composition of meanders of interlocking triple-key swastikas and squares, formed of a two-stranded guilloche. Vestiges of this mosaic remain only in front of the apse in the central basilica. Archaeological research dates this earlier pavement to the first half of the fifth century, a determination supported by the work's composition, execution, and characteristic vegetal pattern. The mosaic, with its classical features, illustrates one of the dominant styles of the fifth century.

Another quarter, located in the area of the Carthage Odeum—the Roman Villas quarter—contains several dwellings, some with exceptional mosaics (FIGURE 4.7). This Roman residential quarter was built on top of a Punic cemetery. Among the homes, which are terraced into the western slope of the hill, there is one that attracted the attention of researchers because of its design and mosaic decor. This is the House of the Aviary, which owes its name to the theme of the mosaic that adorned its peristyle. The house's design is particularly complex. The

FIGURE 4.7
The remains of the Roman Villas quarter at Carthage.
Photo: Bruce White, 2005.

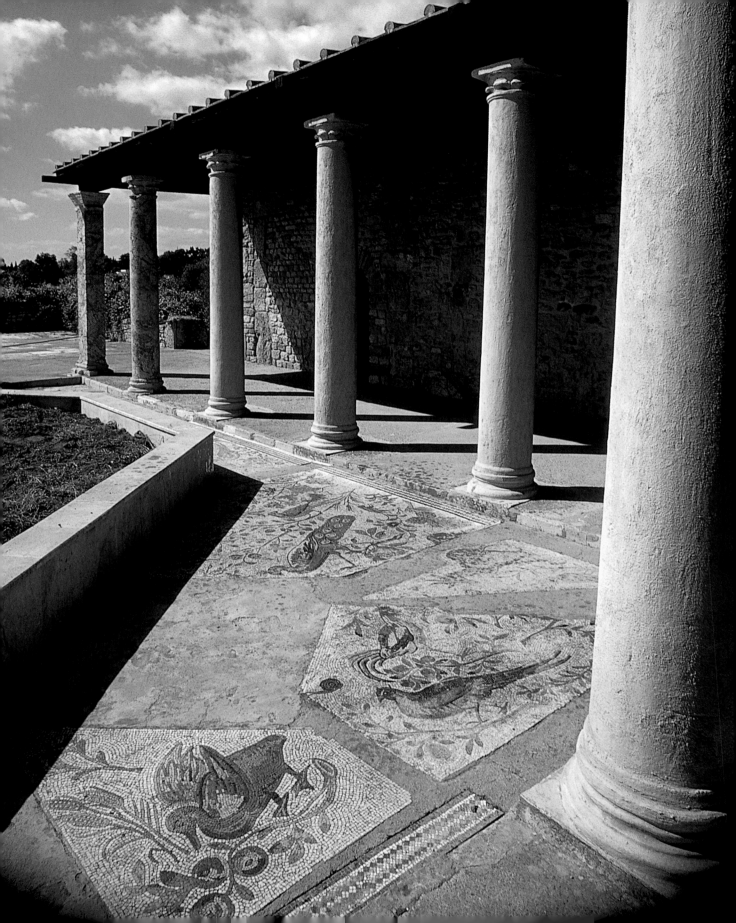

largest area is the peristyle, built around an
octagonal garden set in a square whose cor-
ners are decorated with a magnificent pave-
ment strewn with branches on which are
arranged flowers and fruits, several four-
legged creatures, and a wide variety of birds
(FIGURE 4.8). The general composition and
the charming arrangement of the figures
amid the branches are designed to persuade
viewers that they are enveloped in the sights
and sounds of pastoral life—an ideal of
the period. To the north of the peristyle is a
series of rooms that were paved with geo-
metric and floral polychrome mosaics, most
of which are now gone and which are known
only through documentation from the time
of their discovery early in the twentieth
century.

The east wing of the structure houses
an oecus, a large reception room, paved with
opus sectile, surrounded by areas whose
floors are covered with geometric and floral
mosaics (FIGURE 4.9). The oecus faces a
colonnade also covered with mosaics, which
opens onto a passage paved with opus sec-
tile, which ends in a platform stage inset
with semicircular and rectangular niches,
clearly intended to hold statuary. The sur-
faces between the niches are decorated with
marble or with floral mosaics. Beyond this
platform stage are three tiers of seats whose
walls are decorated with mosaics depicting
marshland fishing and hunting scenes.
Although the House of the Aviary is a reno-
vation of a building constructed earlier, the
design of its last phase and these exception-
ally fine decorations can be dated to the first
half of the fourth century.

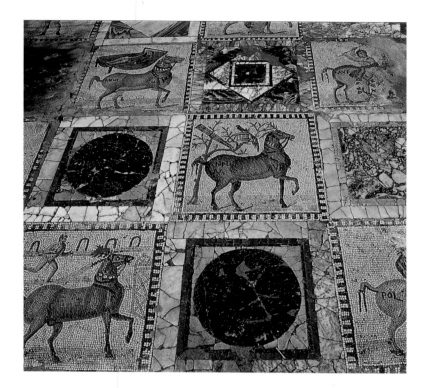

FIGURE 4.9
*Horse mosaic from the House of the Horses at Carthage
(no longer in existence). This pavement mosaic consists
of a checkerboard created of alternating opus tessella-
tum and opus sectile panels. While the opus sectile
squares contain common geometric designs, the opus
tessellatum squares are decorated with prancing horses.
Some squares contain inscriptions and images toward
the top, which together make up a word puzzle, or
rebus. The mosaic is no longer in its original location,
since it covers the floor of the oecus in the House of
the Aviary at Carthage. Fourth century.*
Photo: INP.

FIGURE 4.8
*The restored peristyle and a copy of a floor mosaic
from the House of the Aviary, in the Roman Villas
quarter at Carthage.*
Photo: Guillermo Aldana, 1993.

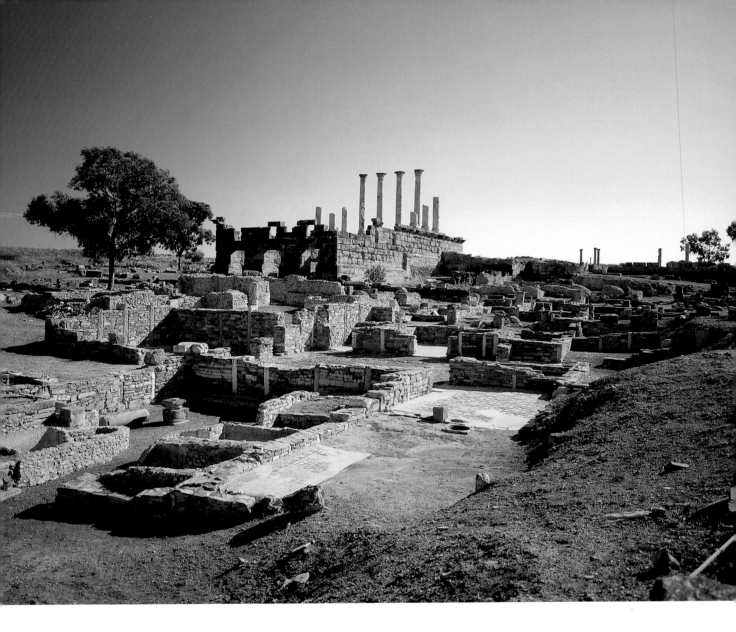

Thuburbo Majus

FIGURE 4.10

The Forum quarter at Thuburbo Majus. In the foreground are mosaics in situ, among the ruins of houses. In the distance, the remains of the capitol, whose columns were righted in the 1920s, overlook the forum, which dates to the last half of the second century.

Photo: Bruce White, 2005.

Thuburbo Majus was one of the many sites in Proconsular Africa that accounted for the prosperity of the *pertica*—the cities and the surrounding land—of Carthage throughout the Roman period. Of Berber origin, as the name Thuburbo indicates, the city underwent a period of Punic occupation, dated to between the third and second centuries BCE, as revealed by many archaeological traces found in the core samples and the persistence of some Punic institutional and architectural traditions.

The Romanization process that began in the first century CE continued into the second century. Under the emperor Hadrian, Thuburbo Majus gained the status of a *municipus*—the legal status of a city before it became a *colonia*—and under Commodus, it became a full-fledged Roman colony. This official sanctioning was accompanied by an urban boom, marked by the construction of a forum and a capitol, symbol of the power of Rome (FIGURE 4.10). In the late second and the early third century, the city was practi-

cally blanketed with temples and public monuments, such as the large winter and summer baths. The local bourgeoisie built dwellings in the prestigious quarters near the monumental center, close to the seat of power. These elegant houses were paved with polychrome mosaics that reflected the tastes of the period (FIGURE 4.11). In the mid-third century, the major crisis that shook the Roman Empire put an end to the city's development, but important construction projects were to resume during the fourth century with the building of luxury residences in the eastern and western quarters. Construction of civic structures was limited to projects of lesser importance, which were nevertheless extolled by their greatly exaggerated inscriptions. Several ruins in Thuburbo Majus testify to the presence of Christianity, such as a temple converted into a church in the fifth century. The city experienced a decline in the late fifth and early sixth century. The last vestiges of the city's glory that can be accurately dated are ceramic shards from the last half of the sixth century.

The city appears to have been gradually abandoned during the seventh century. Over time Thuburbo Majus disappeared under its own rubble, only to reappear in the late nineteenth century through the efforts of modern archaeologists. The site is located some thirty-five kilometers (twenty-two miles) to the west of Carthage, in a region whose gentle, rolling land is particularly fertile and contains several polychrome limestone and marble quarries. Although occupation of the site goes back to the Punic period and even earlier, as evidenced by the many ruins found in the area, most of the urbanization that is still visible today dates to the imperial period and late antiquity—that is, between the second and seventh centuries. Excavations, undertaken especially in the first half of the twentieth century, have uncovered traffic arteries whose irregular courses reflect the

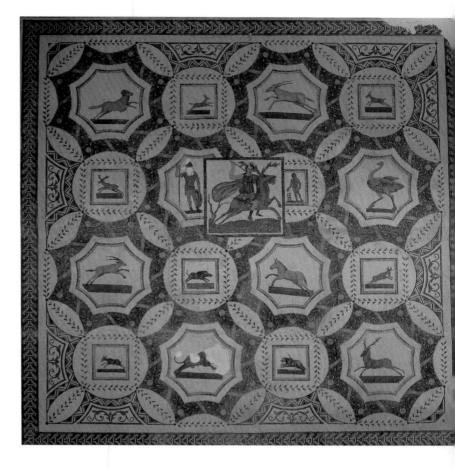

uneven topography of the site. The heart of the city is occupied by the Roman monumental center and by residential quarters. Many of the houses were paved with polychrome mosaics, both figurative and geometric. The city's oldest houses were built in the area surrounding the monumental complex, close to the forum and to major public monuments.

Among those dwellings, one is particularly characteristic of Thuburban domestic architecture in the late second century and the first half of the third century. It is located at the end of a residential quarter where houses were built after the construction of the forum and its annexes. The House of Neptune comprises two apartments situated

FIGURE 4.11
A mosaic with a tableau depicting the huntress Diana, from Thuburbo Majus. In the off-center tableau, the goddess is portrayed astride a buck. She is surrounded by two figures and various bounding animals. Third century.
Bardo Museum.
© Cérès Éditions, Tunis.

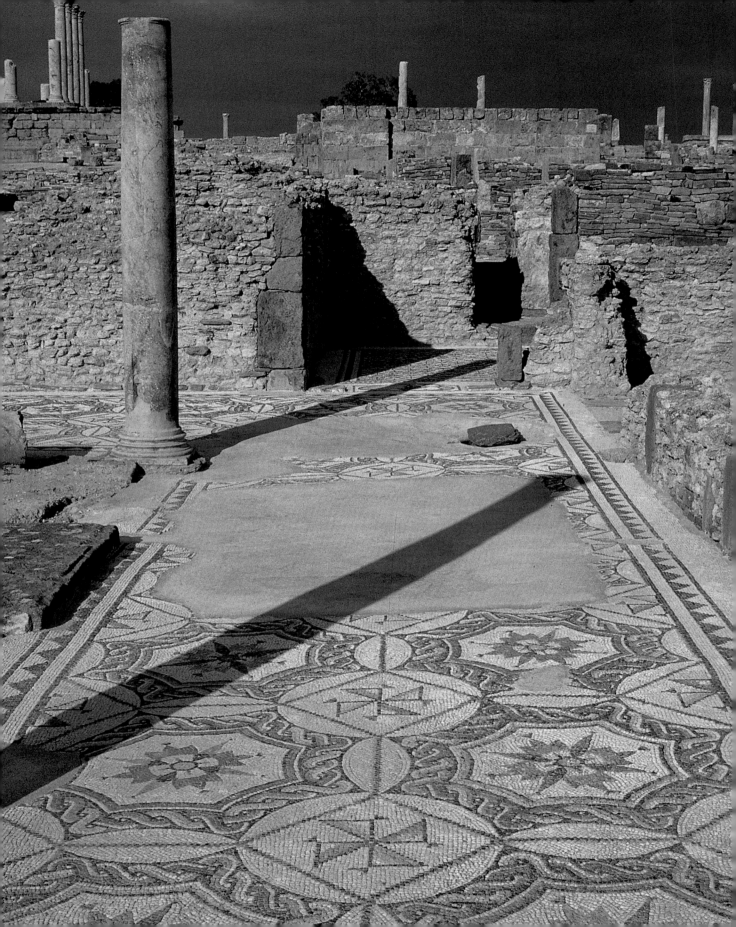

in a quarter around the forum. On coming into the House of Neptune from the street, the visitor enters a room that is somewhat separate from the main body of the house, which was undoubtedly used by the owner to receive customers and acquaintances without bringing them into the private areas of the home. The room, paved with a polychrome geometric mosaic, leads to a passage that ends in a lovely limestone stairway, then to a hallway, also paved with mosaic, which leads indirectly into the peristyle (FIGURE 4.12). The peristyle is composed of four arcades, decorated with a polychrome geometric composition over a background of white limestone. A colonnade separates the arcades from the central garden, whose excavation revealed imprints of the roots of an olive tree. On the west side, facing the main reception room, is a fountain basin, which was originally decorated with a scene showing Neptune in a sea teeming with fish. The large reception room, the oecus, had a magnificent polychrome marble opus sectile threshold depicting a krater, leading to a floor composed of slabs of local marble, which was later (probably in the late fifth century) completely transformed into an artisans' workshop (FIGURE 4.13). Two other rooms, which open onto the

west and east arcades, are decorated with figurative bird mosaics. These two pavements were removed in the 1920s and transported to the Bardo Museum. Since the removal was poorly documented, it has been difficult to determine the original setting and placement of these mosaics.

The bedrooms must have been on the northeast side, as indicated by a plan of one of the rooms. Several years after the original house was built, the owner apparently added an independent apartment near the main body of the house. The spaces in this annex open onto a courtyard. The apartment is remarkable in that it had a kitchen space, recognizable from the structure of a table and the proximity of a cistern. The rooms in this annex were paved with polychrome geometric mosaics. Soon after this apartment was added, the owners subdivided the space and created two independent units. If the House of Neptune was built by a prosperous Thuburban in the early third century, perhaps the annex was then built and subdivided in the first half of the third century. Differences between the mosaics in the main house and those in the annex reflect the stylistic changes of the two or three decades that separate the two stages.

FIGURE 4.12 (OPPOSITE)
A polychrome geometric and floral peristyle pavement mosaic from the House of Neptune in Thuburbo Majus. The composition of straight and curvilinear octagons and the use of rich color are characteristic of third-century African mosaics. The mosaic remains in its original location. Third century.

Photo: Elsa Bourguignon, 2002.

FIGURE 4.13 (ABOVE)
Splendid opus sectile mosaic from the House of Neptune in Thuburbo Majus. It depicts a vase. Third century.

Bardo Museum.
Photo: Bruce White, 2005.

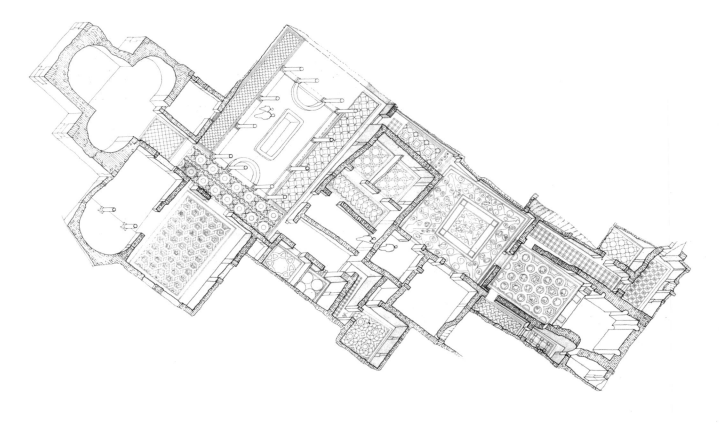

FIGURE 4.14

The design of the House of the Trifolium, located in the western quarter at Thuburbo Majus. This house is composed of two related sections, built around a peristyle. The northwest section comprises a three-lobed chamber, or trifolium, which served as a ceremonial room. The two sections each have multiple reception rooms. The design of the House of the Trifolium is typical of fourth-century African houses.

Photo: CMT.

The dwellings of the first half of the third century in Thuburbo Majus possess a classical simplicity. However, that is not the case for residences built in the quarters toward the outskirts of the monumental center, to the east and west of the site. One such dwelling is the House of the Trifolium, which is composed of two main sections, the trifolium section—so designated because of its three-lobed room—and the protomes section, which are connected by a sloped passage (FIGURE 4.14). The two sections, which constitute separate residences, were probably built during the first half of the fourth century. The reception rooms were particularly spacious and luxuriously decorated with figurative mosaics that are now considered some of the treasures of the Bardo Museum.

The trifolium section of the house, located at the northwest of the complex, is built around a rectangular peristyle, whose center was occupied by a long pool with two semicircular basins at either end. The

interiors of the basins are covered with bird mosaics. A colonnade separated the center from the four arcades, whose floors were covered with four different polychrome geometric mosaics. Three large reception rooms opened onto the arcades of the peristyle, either directly or indirectly, as did the trifolium room. The architectural decor, as well as the mosaic work in these rooms, is remarkable for its richness and variety. The three apses of the triconch were paved with figurative mosaics, of which only a fragment, which depicts a torch-bearing cupid, remains. The floor of the second large reception room is covered with a *xenia* pavement, where birds, marine fauna, and fruits and vegetables are enclosed in a composition of intersecting hexagons composed of a laurel garland. The pavement of the third reception room, which comprises an apse, has been totally destroyed. Opening onto the south arcade, in the southwest corner, are the apartments and bedrooms, which are paved

with exuberant polychrome geometric and floral mosaics (FIGURE 4.15). These mosaics are splendid examples of fourth-century Thuburban style.

The protomes section is located at the south of the dwelling. The architecture is remarkable, as is the quality of the figurative pavements that adorn the floors. This section is built around an entirely mosaic-covered tetrastyle courtyard, whose three arcades lead into large reception rooms. The first of these is particularly sophisticated, since the floor was covered with a mosaic depicting the forequarters (or protomes) of animals used in amphitheater combat spectacles. The mosaic is now on display at the Bardo Museum (FIGURE 4.16). This room opens onto another room that was originally heated, as evidenced by the vestiges of columns of terra-cotta tiles beneath the floors and draft stacks whose imprints remain on the walls. The pavement of this room has completely disappeared, as is usually the case with heated spaces, whose floors are fragile. Heated rooms were relatively rare in Africa, given the generally clement weather. The mosaic pavement of the second reception room is entirely gone.

The four arcades of the tetrastyle courtyard are decorated with a mosaic with a lavish composition of acanthus branches that shelter a multitude of birds (FIGURE 4.17). The combination of greens and browns gives this tableau an autumnal feeling. Between the columns are battle scenes with amphitheater animals, unfolding in rough landscapes.

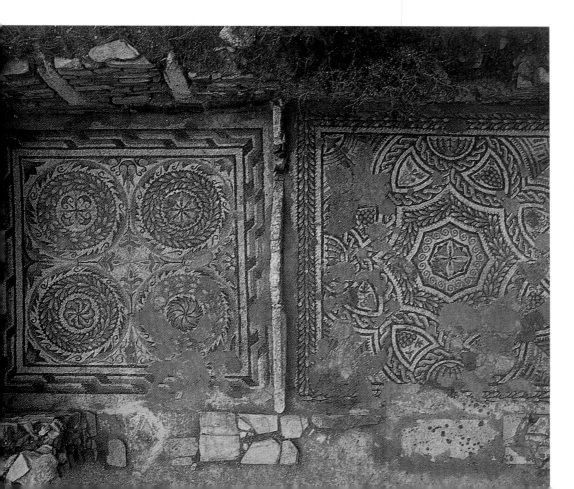

FIGURE 4.15
Mosaics from the trifolium section of the House of the Trifolium in Thuburbo Majus. These polychrome geometric and floral pavement mosaics are from two adjacent rooms and are still in their original locations. The heavy and intricate, densely polychromatic compositions and style of tessellation make these excellent examples of fourth-century African mosaics.
Photo: CMT.

FIGURE 4.16

*Mosaic from the pro-
tomes section of the
House of the Trifolium
at Thuburbo Majus.
The forequarters (or
protomes) of animals
used in amphitheater
combat spectacles are
portrayed in a geometric
composition of laurel
wreaths. The animals
include bears, zebus,
boars, a lion, a wild ass,
a doe, and an antelope.
Fourth century.*

Bardo Museum.
© Cérès Éditions, Tunis.

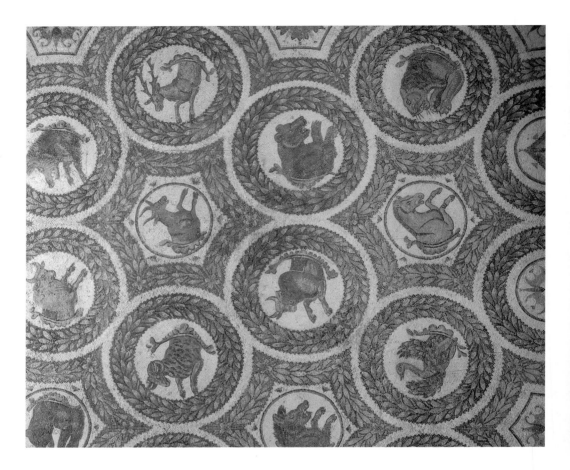

The center of the courtyard is enhanced with
a very dense mosaic pavement representing
grape-picking cupids moving through a space
filled with branches, tendrils, and grape
leaves that branch out from four kraters
placed in the corners. All of these figurative
tableaux were taken to the Bardo Museum,
where they are now on display. The bedroom
corridors are paved with polychrome geo-
metric mosaics of a fairly common type. Of

the themes treated in the figurative mosaics,
the subject of amphitheater animals seems to
have held a special attraction for the owner.
Other than at El Jem, where this subject is
found as early as the second century, the
theme of *venatio,* or professional hunting
to supply animals for amphitheater games,
was not to gain popularity until the fourth
century.

FIGURE 4.17

*Detail of a mosaic that paved a gallery in the protomes
section of the House of the Trifolium in Thuburbo
Majus. The lush foliage spreading out from acanthus
bases placed at the corners shelters a population of
birds. Fourth century.*

Bardo Museum.
© Cérès Éditions, Tunis.

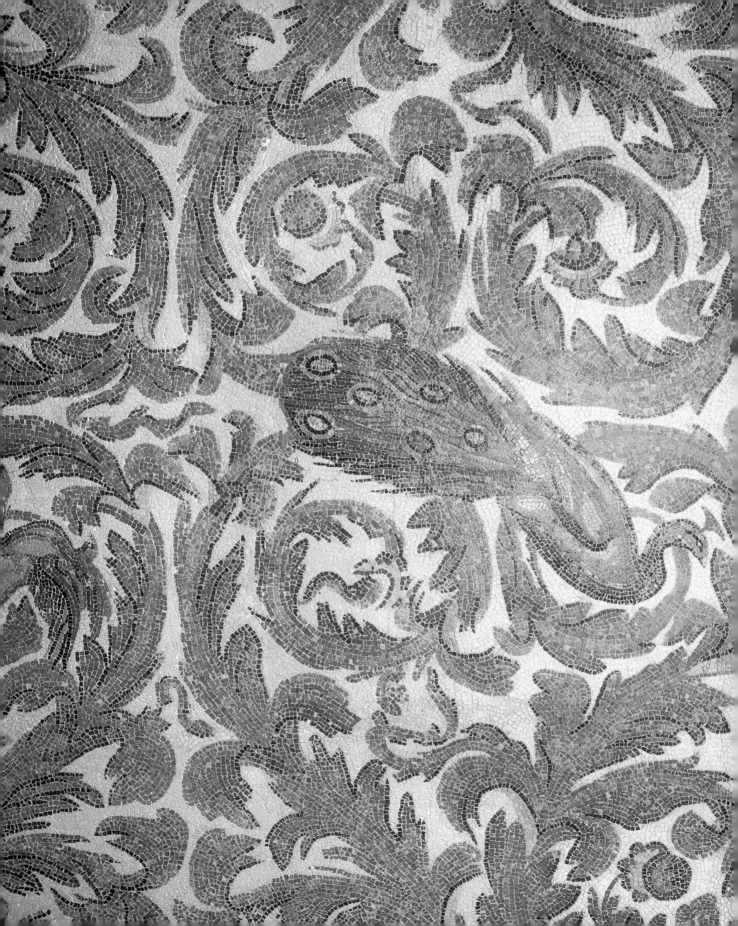

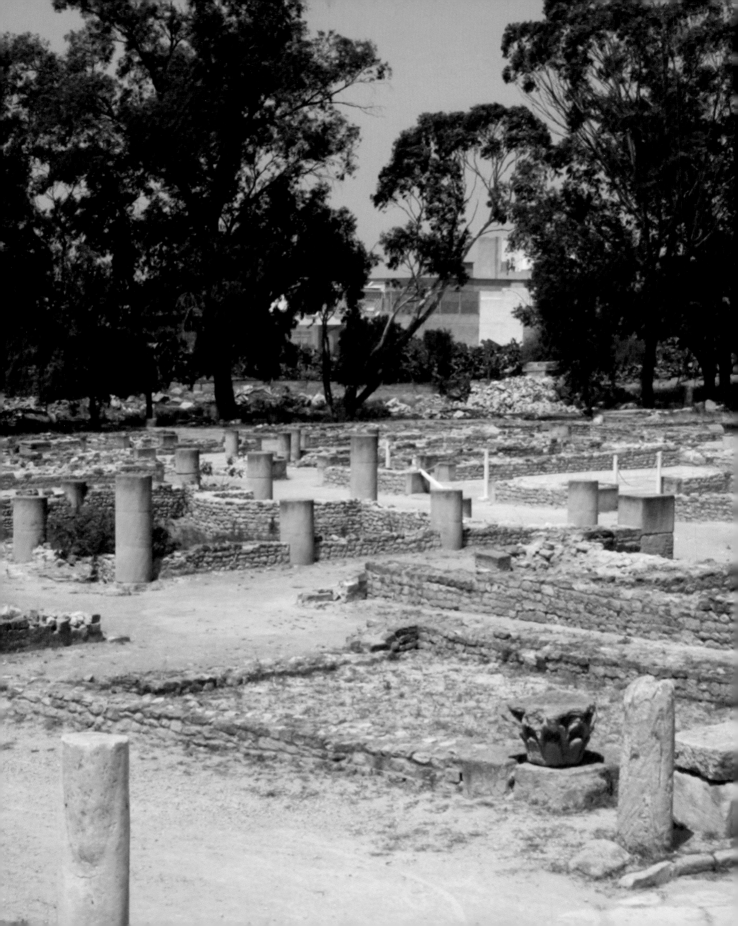

El Jem

Situated in inland Byzacium, approximately forty kilometers (twenty-five miles) from the coast, ancient Thysdrus, today known as El Jem, is one of the most renowned sites in Tunisia (FIGURE 4.18). A small town in the time of Julius Caesar, the city experienced a meteoric rise due to its essential role in the olive oil trade. In the second to third centuries, El Jem's urban expansion reached its zenith. In the second or third century, the magnificent amphitheater was built. It could hold some 45,000 spectators and was ranked as the third amphitheater after those at Rome and Capua. El Jem also had a circus, or arena, used for sports, as large as the Circus Maximus in Rome. Luxurious residences entirely paved with rich mosaics were built, including some larger than 2,000 square meters (about 21,500 square feet). This grand domestic architecture shows that a wealthy merchant class existed. The city's rise allowed it to play a leading role during the uprising of 238, which resulted in the triumph of Gordian, who was proclaimed head of the Roman Empire.

Excavations in the 1960s revealed a sizable residential quarter in the southwest of the city. This quarter provides an idea of what a complex of luxury homes in El Jem might have been like during the second century and the first half of the third century. As was common until about twenty years ago, most of the figurative mosaics were removed from these houses and shipped to the Bardo Museum, then to the Sousse Museum, and, finally, to the El Jem Museum.

FIGURE 4.18
View of the ruins at El Jem.
Photo: INP.

One of these houses, called the *Sollertiana Domus*— Sollertiana House— has a surface area of approximately 1,120 square meters (12,000 square feet). Its mosaic decor is remarkable for its richness and diversity (FIGURE 4.19). The center of the house is built around a first large peristyle, which, on the north side, has a fountain basin tiled with a mosaic representing a sea teeming with fish and boats. The basin faces the triclinium, which is decorated with a simple U-shaped mosaic with a geometric composition of overlapping circles that form quatrefoils and a T-shaped mosaic composed of several tableaux (FIGURE 4.20). The stem of the T comprises three juxtaposed panels, delimited by three borders. The wide border surrounding the panels has an original composition of circles and ovoid figures decorated alternately with animals and fish.

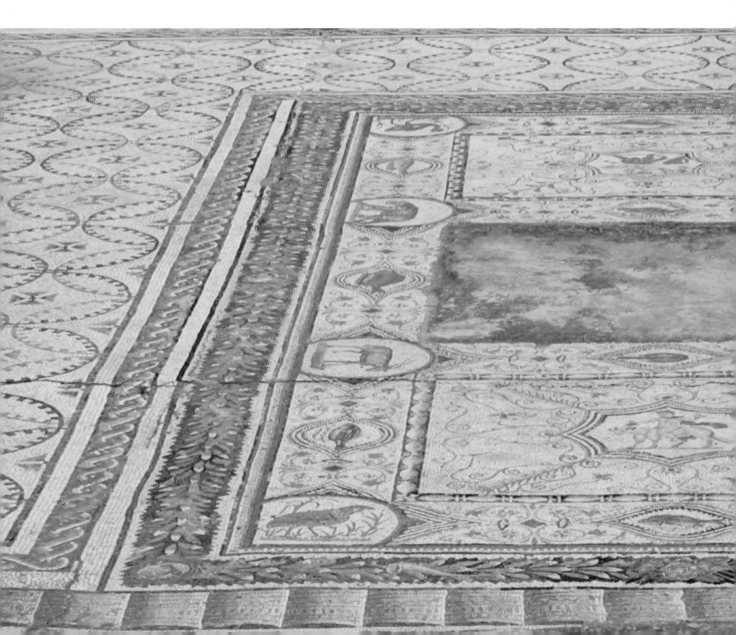

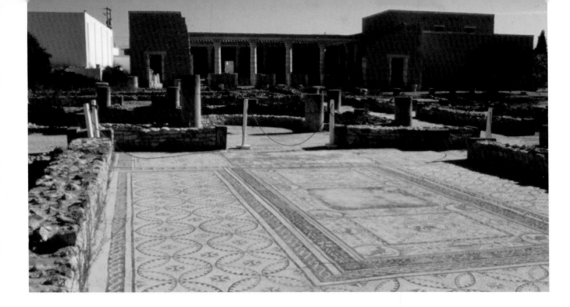

FIGURE 4.19
*Mosaic in its original
location at the* Sollertiana
Domus *in El Jem. Late
second or early third
century.*
Photo: Elsa Bourguignon, 2004.

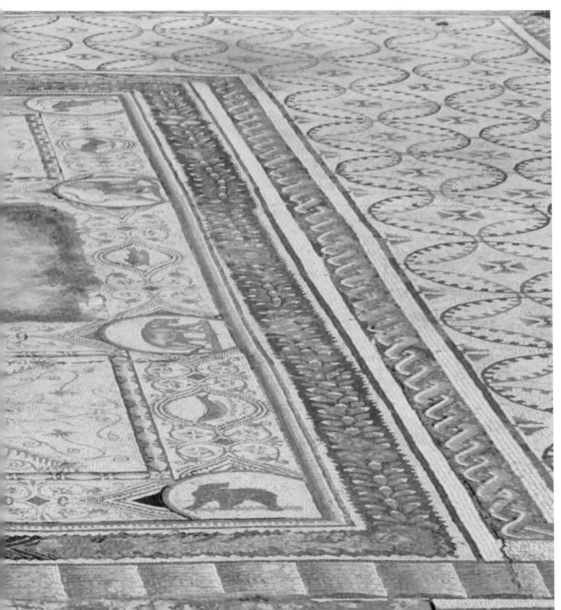

FIGURE 4.20
*Triclinium mosaic in its
original location at the*
Sollertiana Domus *in
El Jem. Late second or
early third century.*
Photo: INP.

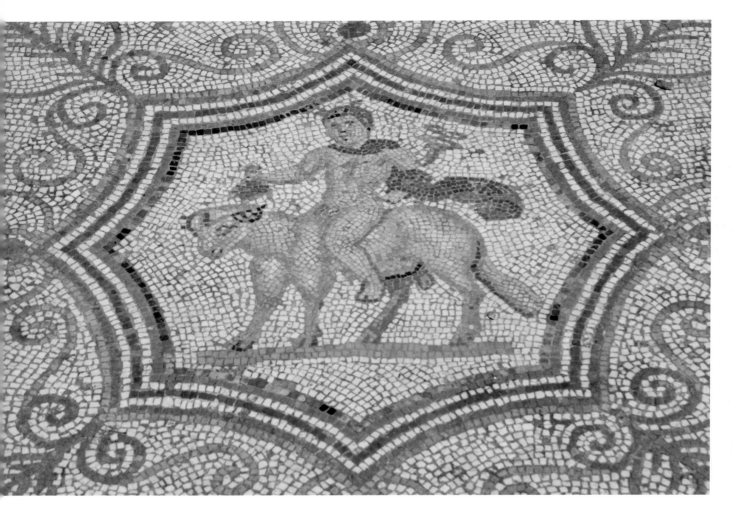

FIGURE 4.21
Detail of a panel from a triclinium mosaic, depicting the child Bacchus astride a panther, from the Sollertiana Domus *in El Jem. The mosaic remains in its original location. Late second or early third century.*
Photo: INP.

Two of the panels have figures inscribed within elegant vegetal compositions; the center panel, now missing, seems to have once been paved with marble. The two existing panels depict Mercury on a ram and the child Bacchus astride a panther (FIGURE 4.21). The crossbar of the T is also divided into three panels. The center panel represents a very lively scene centering on a small monument sheltering a statue of the goddess Diana the Huntress. The structure is depicted in a wooded landscape, and all around it free-roaming animals appear to flee an imminent danger. This panel, remarkable in its theme, style of execution, and vitality, is now on

display at the UNESCO headquarters in Paris, a gift of Tunisia. On either side of the tableau of Diana are two geometric and floral panels.

The west arcade of the peristyle opens onto a series of rooms, which were *cubicula*, or bedrooms. One of these rooms has a mosaic that is remarkable for the theme of its decor and its appropriateness to the function of the room. Another bears the inscription that lends its name to the house. The first room has a built-in banquette and, beneath it, a floor mosaic.

This original composition depicts the cast shadows of various elements of an arch that compose a large curvilinear cross at

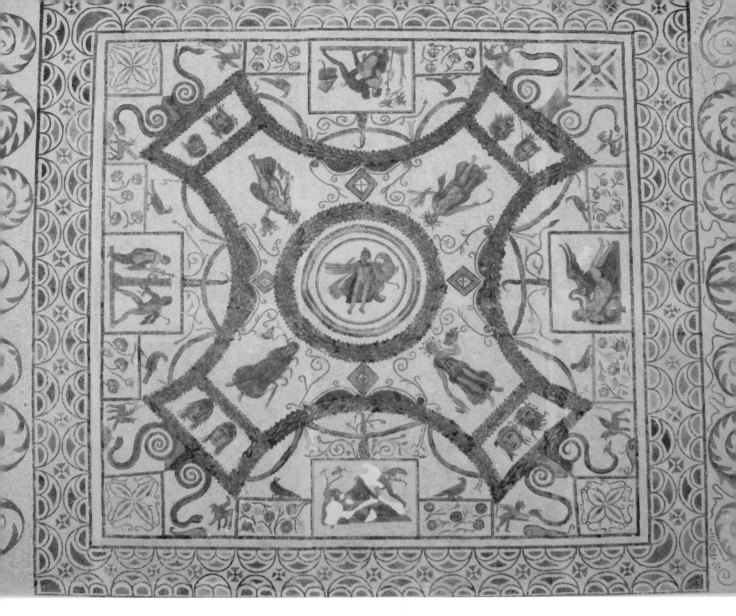

whose center is the figure of Ganymede,
inscribed in a circle (FIGURE 4.22). The arms
of the cross are inhabited by figures of the
seasons, endowed with their individual
attributes. The ends of the arms of the cross
are decorated with pairs of masks. The outer
areas between the arms of the cross have
vignettes depicting elegant scenes, including
Leda and the Swan (FIGURE 4.23), a satyr
fondling a maenad, a satyr frightening a
maenad with a snake, and a satyr disrobing a
maenad. These tableaux, executed with great
delicacy and refinement, are surrounded by
curvilinear vegetal designs and birds. It is
easy to identify this room as a bedroom,

FIGURE 4.22 (ABOVE)
*Mosaic depicting
Ganymede, in a cubicu-
lum of the* Sollertiana
Domus *in El Jem. The
mosaic remains in its orig-
inal location. Late second
or early third century.*
Photo: INP.

FIGURE 4.23
*Detail depicting Leda and
the Swan, from a cubicu-
lum mosaic from the*
Sollertiana Domus *in
El Jem. Late second or
early third century.*
Photo: INP.

both because of its architecture and because of the erotic subject matter.

The second room contains a black-and-white mosaic with a simple composition of overlapping scales and an inscription placed in front of the threshold:

SOLLERTIANA
DOMUS SEMPER
FELIX CUM SUIS

(The Sollertiana House is eternally happy with its occupants) (FIGURE 4.24). To the northwest of the inscription room is another bedroom, identifiable by the banquette that occupies the entire back wall. The seat of the banquette and the floor are covered with geometric and polychrome mosaics. Finally, at the end of the wing is a small apse, probably used for worshiping the household gods.

At the northwest corner of the *Sollertiana Domus,* along the same axis as the triclinium, is a complex composed of a small peristyle whose arcades are tiled with an elegant geometric composition. The west wing opens onto several rooms, one of which is remarkable for its mosaic work. Although its west end is heavily damaged, the tableau seems to be composed of a large boxlike structure decorated with trophies in the corners. The box is surrounded by animals used in amphitheater combats, running excitedly in all directions. The two surviving corners are occupied by scenes in which a prisoner is delivered up to a wild beast. The realism and liveliness of this tableau mark this work as the product of a master mosaicist (FIGURE 4.25).

The mosaics from the *Sollertiana Domus* and most of its architecture are dated to the late second or early third century, as indi-

FIGURE 4.24
Detail of a mosaic from the Sollertiana Domus *in El Jem. The inscription means, "The Sollertiana House is eternally happy with its occupants." The mosaic remains in its original location. Late second or early third century.*
Photo: INP.

cated by the archaeological materials found in core samplings. This dwelling is an excellent example of the lavish domestic architecture at the El Jem site. It also illustrates the fondness of the residents for the amphitheater and for hunting scenes. Its pavements demonstrate the existence of mosaic workshops with an exceptional knowledge and mastery of their art.

Another house at El Jem—the House of the Peacock—illustrates equally well the opulence of the ancient residences and their distinctive mosaic style. This grand house shares its north wall with the *Sollertiana Domus* and occupies over 1,800 square meters (19,000 square feet). As with the neighboring residence, the design of the House of the Peacock is composed of two

FIGURE 4.25
Mosaic depicting amphitheater animals, from the Sollertiana Domus *in El Jem. The mosaic remains in its original location. Late second or early third century.*
Photo: INP.

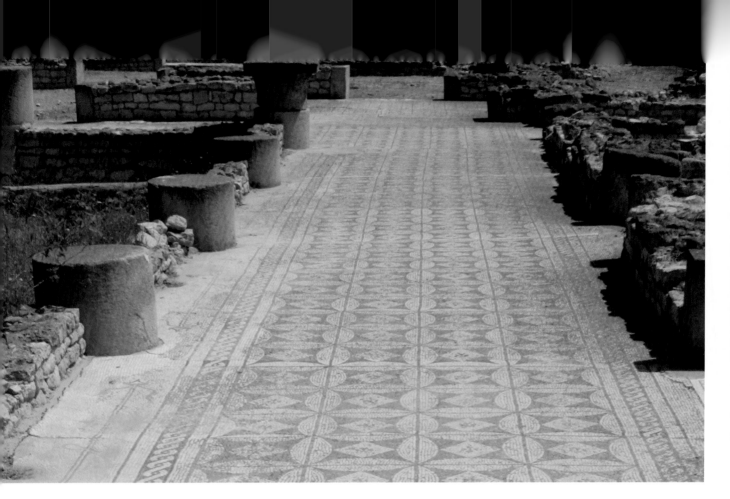

FIGURE 4.26 (ABOVE)
Mosaic in its original location at the House of the Peacock in El Jem. First half of the third century.
Photo: INP.

FIGURE 4.27
Mosaic depicting a peacock, from the House of the Peacock in El Jem. First half of the third century.
Photo: INP.

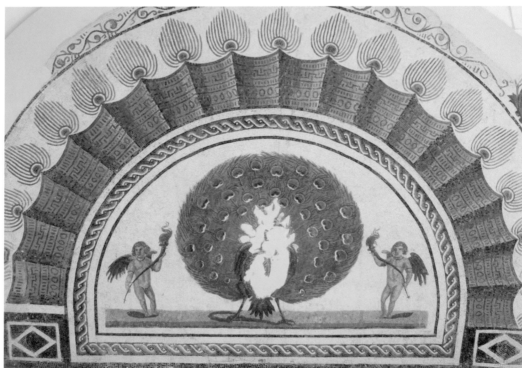

sections, one large and one small, built around a peristyle. The first section comprises the major portion of the residence. Three of the four arcades of the immense peristyle are paved with a simple geometric mosaic of overlapping circles that form white quatrefoils and black curvilinear squares, dated to the first half of the third century (FIGURE 4.26). The fourth arcade, located on the north, is tiled with the same motif, but the axes, module, and overall pattern are totally different. In fact, the materials collected from one archaeological core sampling from below this mosaic date it to a later period—around the last half of the fourth century. The center of this wing is adorned with a mosaic fountain basin facing the oecus. This reception room is paved with a curiously all-white mosaic with a composition of overlapping scales whose ceramics date it to the last half of the third century or even the early fourth century. On either side of this room are two corridors, one of which retains its mosaic pavement.

A series of rooms open onto the west arcade of the peristyle. One, with a threshold depicting a still life, is a triclinium, as revealed by the mosaic layout. The U-shaped floor mosaic has a simple geometric composition encircling a panel with a complex lattice motif, some of whose compositional units contain various figures (the four seasons and Dionysian figures). The other spaces that open onto the west arcade form a small apartment, set back from the circulation in the peristyle, one of whose rooms contains a geometric tableau with still-life figures. The south arcade also opens onto an apartment with three connected rooms, whose geometric mosaic pavements are extremely complex. Finally, adjacent to this apartment—opening directly onto the peristyle via a threshold depicting a dog catching a hare—is a small room whose architecture and mosaic decor are truly exceptional: at the back of the

room is a curved dais tiled with marble slabs. Below it, occupying the other part of the room, is a peacock spreading its tail between two winged cherubs bearing lamps (FIGURE 4.27). The stage is surrounded by a drapery that enhances the theatrical effect of the peacock. Because of its decor, this room would appear to have played a cultural role—perhaps, as suggested by the peacock, relating to Bacchus.

The second complex of the House of the Peacock occupies the northwest corner. Although it is connected to the rest of the house, this section is distinctive in its individuality. A colonnaded courtyard surrounds a small central garden. The short sides of the courtyard are adorned with fountain basins, and the west basin faces a triclinium whose main threshold is decorated with a mosaic panel with a special motif, formed of a crescent on a staff surrounded by two bars. This motif is a symbol of one of the city's sodalities—societies sponsoring amphitheater games—named Telgenii, which was very popular in El Jem. The pavement of the triclinium consists of U-shaped and T-shaped panels. The U-shaped mosaic is white and undecorated, while the T-shaped panel is composed of a strip with an ivy scroll and a black-and-white geometric composition composed of tangent hexagons that form rhombuses. The east wing of the house, which has very few mosaic-tiled rooms, was probably devoted to servants and domestic work. Archaeological evidence dates the triclinium's mosaics to the first half of the third century.

Utica

Unearthed in the late nineteenth century, the site of Utica has fascinated historians and archaeologists, in particular because it dates from the earliest antiquity. According to legend, it was founded in the twelfth century BCE—although archaeological excavations have not revealed any ruins dating earlier than the eighth century BCE. These ruins consist of traces of a necropolis. After having supported Carthage, Utica switched its allegiance to Rome, and the empire spared the city when the Punic metropolis was defeated in 146 BCE. Utica even became the capital of the new Roman province of Africa. Later, having participated in the civil war between the supporters of Caesar and those of Pompey, Utica was conquered by the armies of Caesar. Augustus promoted the expansion of Utica, which remained the seat of the African proconsul until 12 CE. Throughout the first century and early second century CE, the city experienced its greatest urban expansion. To the theater, circus, and forum that had already been built by the late first century BCE and the early first century CE, new public buildings were added; these included large baths, an amphitheater, and a wide colonnaded traffic artery. Houses were built and equipped with water basins and an ingenious water conveyance system, as was the case for the House of the Waterfall (FIGURE 4.28). This prosperity was to last until the end of the third century, after which time, beginning in the fourth century, urban development declined. Knowledge of Utica's early history has enabled archaeologists and historians to visualize the quality of African urbanization, and of domestic architecture in particular, in the late first and early second century.

The House of the Waterfall is one of the gems of Utican domestic architecture, and its multiple transformations span four centuries (FIGURES 4.29A AND 4.29B). The residence was, in all likelihood, built in the late first or early second century. Later, it was extensively renovated and decorated—in the late second and early third century, then again in the late fourth or early fifth century. Very few vestiges of the earliest phase remain, and it is only from the second phase onward that the greater portion of the residence's design has survived. The various spaces of the house were built around a garden. The peristyle is surrounded by four arcades alongside rooms, the largest of which are reception spaces. The west arcade leads to reception rooms, including the large oecus, which is magnificently paved with opus sectile. The geometric composition of the mosaic pavement and the use of a wide variety of imported marbles display the home owner's considerable wealth. This large room is flanked on either side by two wings, delimited by columns and pillars. In their center are basins, one of which retains its mosaic tile, which depicts a magnificent hunting scene. The wings open onto other rooms decorated with either opus sectile or polychrome geometric mosaics. The north wing of the peristyle also opens onto a large ceremonial room paved with a geometric mosaic, which is connected to an apartment to the east. The arcade runs alongside a series of smaller rooms, all decorated with polychrome geometric mosaics.

In the third phase, the house seems to have once again undergone major renovations of the spaces and floor coverings. The center of the peristyle was occupied by a basin delimited by a low wall, inset with

FIGURE 4.28 (OPPOSITE) *Water basin at the House of the Waterfall in Utica. Mosaics adorn the bottom of this basin, set at an incline to produce a waterfall. The mosaic adorning the upper basin is from the late fourth or early fifth century; the mosaic covering the lower basin dates to the early second century.* Photo: Bruce White, 2005.

FIGURES 4.29A AND 4.29B
*View of the House of
the Waterfall in Utica
(4.29A), with its opus sec-
tile pavements seen in
detail (4.29B).*

Photos: Bruce White, 2005.

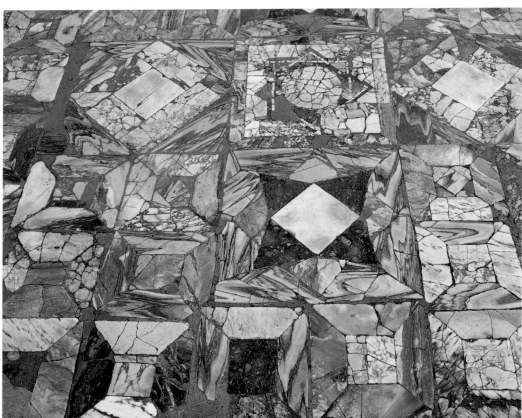

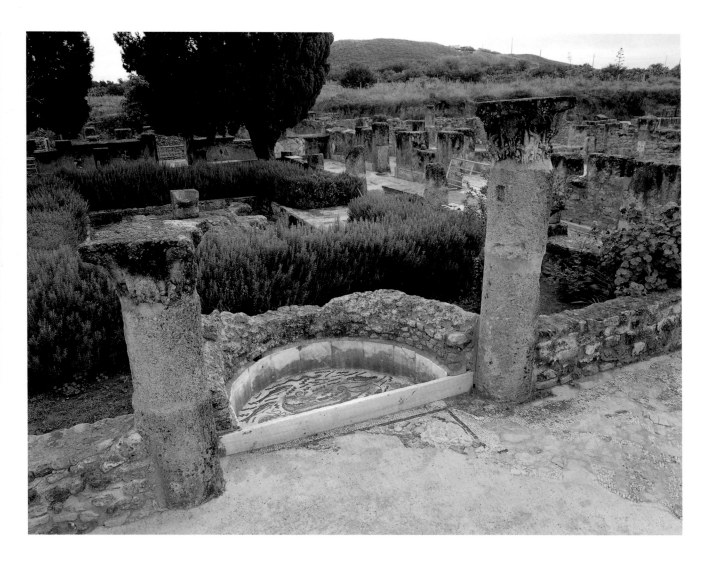

alternating rectangular and semicircular niches. A fountain basin tiled with a marine mosaic faced the room at the center of the north wing. That room was extensively renovated by the addition of a smaller room along the axis at its center, paved with opus sectile. Its north end comprises a dais, identified by archaeologists as a chapel. It is surrounded on three sides by a U-shaped passage, whose north end is tiled with a mosaic tableau representing marine fauna. The oecus, which is situated to the west of

the peristyle, is decorated with an opus sectile floor mosaic, which leads from the room to the edge of the basin in the garden. In addition, one of the basins that adorn the apartment to the south of the oecus has an inclined plane for a waterfall (SEE FIGURE 4.28). An interest in commissioning architectural features with such spectacular effects reflects the luxurious tastes of the fourth-century African bourgeoisie (FIGURE 4.30).

FIGURE 4.30
Fountain basin tiled with a marine mosaic, at the House of the Waterfall in Utica. Fourth century.
Photo: Bruce White, 2005.

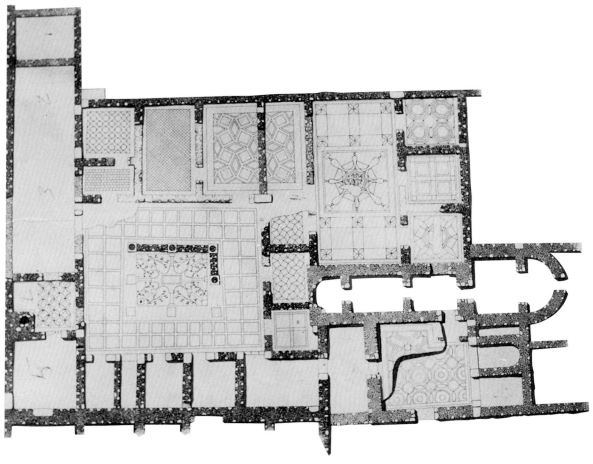

Pupput

FIGURE 4.31
Plan of the House of the Figured Peristyle in Pupput. Last half of the fifth century.
Photo: INP.

This is the site of ancient Hammamet, situated on the coast, about seventy kilometers from Carthage. Located in a tourist area, the site of Pupput was identified thanks to an inscription found in the early twentieth century, providing the full title of the city, which became "Colonia Aurelia Commoda Pia Felix Augusta Pupput" under the reign of the emperor Commodus. Rediscovered in the late nineteenth century and partially unearthed by French army battalions in the early twentieth century, the site of Pupput was then neglected for several decades. It was rediscovered in the late 1960s when promoters of tourism built hotel complexes on the Tunisian coast. The Tunisian archaeological authorities were able to save only a residential quarter and baths northeast of the site. The remnants of the central complex of

monuments and the public buildings now lie below hotel foundations. Only the large necropolis, which has been excavated in recent years, could be identified.

The ruins that now constitute the archaeological park of Pupput provide an idea of the evolution of domestic architecture between the second and sixth centuries. The mosaic pavements, which remain in situ, speak volumes about the styles and tastes of that period.

One of the monuments most representative of domestic architecture in Pupput is the House of the Figured Peristyle, built during the last half of the fifth century—that is, in the midst of the Vandal period (FIGURE 4.31). This large residence with its own bath complex is entered from the street. The surface area of the house is approximately

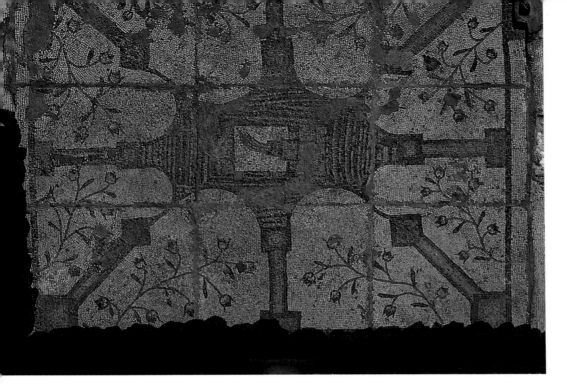

FIGURE 4.32
Detail of a courtyard mosaic, depicting a beacon, from the House of the Figured Peristyle in Pupput. The beacon is a symbol of good fortune and health. The mosaic remains in its original location. Last half of the fifth century.
Photo: INP.

900 square meters (9,700 square feet). The peristyle of the house is entered indirectly. The peristyle's four arcades were paved with a lively mosaic formed by squares adorned with different geometric, floral, and figurative motifs. An observer can follow the process of the creation of the mosaic, from north to west to south and then east. The most sophisticated parts of the mosaic are found on the walkway that borders the grandest rooms of the house, such as the oecus and the triclinium. The execution of the mosaics of the south arcades, which border the service areas and the servants' quarters, is rougher and more awkward. The courtyard of the peristyle, usually reserved for a garden, is paved with an exceptional mosaic consisting of images of shadows cast from the various architectural elements of the peristyle onto the floor. The center of this unique mosaic is decorated with a beacon, a symbol of good fortune and health (FIGURE 4.32). The large reception rooms are also paved with luxurious mosaics, excellent specimens of African mosaic production in the fifth century. The small bath complex situated at the northeast corner of the residence already existed prior to the last phase

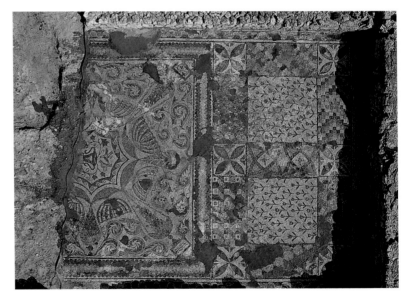

of the house's construction, as evidenced by the superimposed mosaic pavements (FIGURE 4.33).

The existence of the House of the Figured Peristyle points to the vitality of a well-to-do class in Pupput in the midst of the Vandal period, as well as to the impressive repertoire of the African mosaic artisans.

FIGURE 4.33
Mosaics in the bath complex of the House of the Figured Peristyle in Pupput. Last half of the fifth century.
Photo: INP.

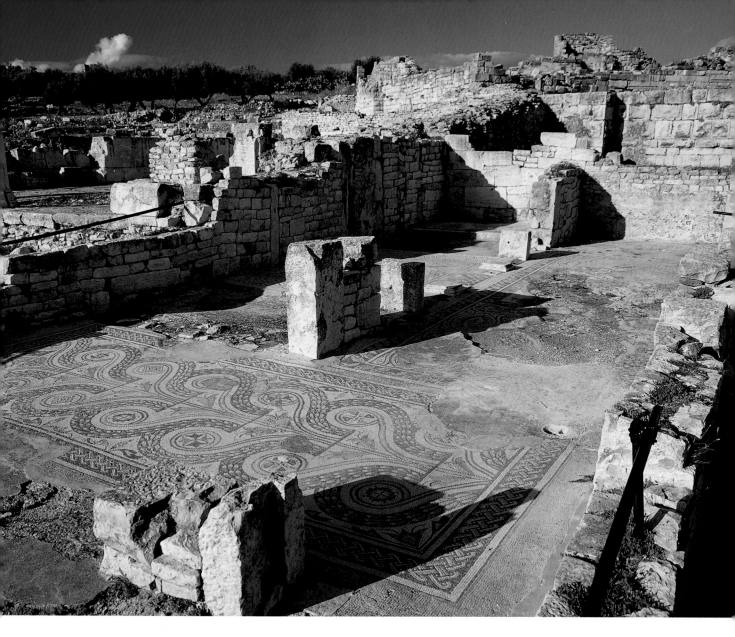

Dougga

FIGURE 4.34
Mosaic from a residence in Dougga, among the ruins of the site. Second or third century.
Photo: Bruce White, 2005.

Located in northwestern Tunisia, in an extremely fertile region, the site of Dougga (ancient Thugga) was settled in ancient times. The Greek historian Diodorus Siculus spoke of it as a large metropolis. The town of Dougga remained under Punic domination until it was appropriated by the Numidian king Massinissa in the second century BCE. After the destruction of Carthage by Rome in 146 BCE, the territory of Dougga was not occupied by Rome—in fact, it was not until the middle of the first century BCE that the

site of Dougga was eventually annexed by Rome. Dougga was rapidly Romanized for several reasons, including the presence of a colony of Roman citizens.

In the first century CE, the metropolis expanded, as indicated by the inscriptions that attribute the construction of the forum to the reign of Tiberius and the construction of the marketplace to the reign of Claudius. But the metropolis did not experience its true urban boom until the second and third centuries, under the Antonines and Severans,

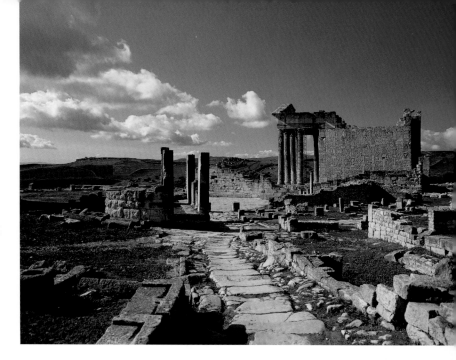

with the construction of temples, baths, and residential neighborhoods, and of dwellings adorned with sumptuous mosaic pavements (FIGURE 4.34). Great families vied with one another in sponsoring building programs to give the city its monumental appearance. The Gabinia family distinguished itself by building a remarkable complex of temples dedicated to Concordia, Liber Pater, and Frugifer. Another family, the Maedii, built a temple to Fortuna. Augustus, Venus, Concordia, and Mercury. Finally, under the reign of Marcus Aurelius, a third family, the Marcii, gave the city two of its most famous monuments, the Capitol and the theater (FIGURES 4.35 AND 4.36). This urban expansion would continue under the Severan dynasty. In 261 the Municipium Thuggense became the Colonia Licinia Septimia Aurelia Alexandriana Thuggensis. Eventually, in the last half of the fourth century, the city's development tapered off.

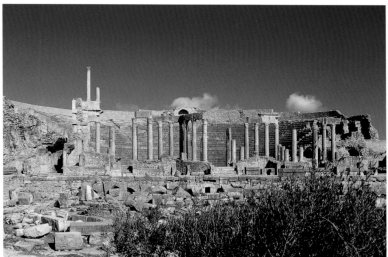

NOTES

1 *Corpus des mosaïques de la Tunisie*, vol. 1, fascs. 1–3 (Utica and El Alia), ed. M. Alexander et al.; vol. 2, fascs. 1–4 (Thuburbo Majus), ed. M. Alexander and A. Ben Abed; vol. 3, fasc. 1 (El Jem), ed. M Alexander et al.; vol. 4, fasc. 1 (Carthage), ed. A. Ben Abed et al.
2 The choice of sites was also governed by studies that have been published systematically on certain monuments in the *Corpus des mosaïques de la Tunisie* (see n. 1).

FIGURE 4.35 (TOP)
The Capitol at Dougga.
Second century.
Photo: Bruce White, 2005.

FIGURE 4.36
The theater in Dougga.
Second century.
Photo: Bruce White, 2005.

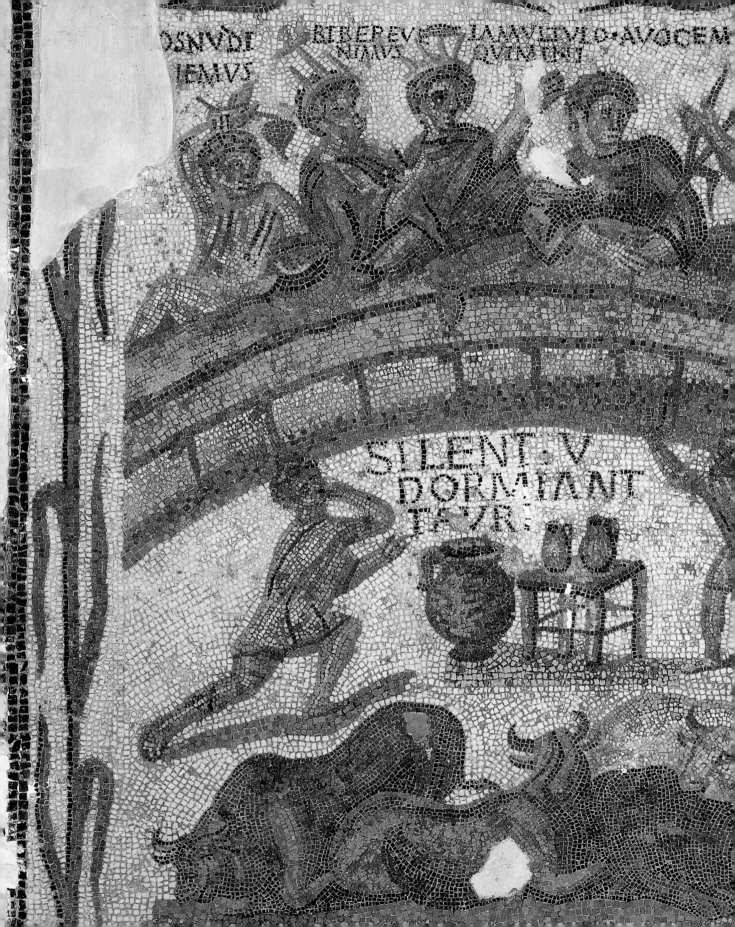

OS NVDI
EMVS BIBERE VE IAM XEVLO AVOCEM
 NIAMS QVIN ARM

SILENT V
DORMIANT
 TVR

NOSTRESTE
NEMVS

SPLENDORS OF THE BARDO

Founded in 1888 by decree of the bey, the indigenous ruler of Tunisia, the Bardo Museum is now more than a century old. The excellent collections housed by the museum are exhibited in a magnificent palace built by the beys of the Husseinite dynasty, who ruled Tunisia from the early eighteenth century (FIGURE 5.1).

FIGURE 5.1

Detail of a mosaic from El Jem showing five banqueters in an amphitheater setting. They are holding or wearing objects — a crescent-tipped baton, a five-pointed crown, and so on — that identify them as members of the fraternities that sponsored hunting games in ancient Thysdrus. Their words are inscribed above their heads. The individual at the far right addresses the other guests, saying, "The three of us stick by one another." The second banqueter says, "Let us enjoy ourselves." The third responds, "Enough talk." The fourth exclaims, "We have come to drink." The last guest exhorts his comrades to disrobe. Five humped-back bulls, probably destined for future hunting games in the amphitheater, sleep in the foreground, while one of the servants admonishes the revelers, "Silence! Let the bulls sleep." Third century.

Bardo Museum.
Photo: Bruce White, 2005.

The palace, built as a residence in the mid-nineteenth century, is Hispano-Moorish in style and features; halls, corridors, and arcades are decorated with ornamental sculpted plaster and ceramic tile. Soon abandoned by the family of the bey, the palace was converted into a museum to house archaeological collections belonging to Prime Minister Kheireddine, as well as gifts from archaeological societies, such as the one in Le Kef. These collections consist of artifacts discovered primarily in archaeological excavations conducted over nearly a century throughout the Tunisian territory. The museum also contains historical and ethnographic collections illustrating the history of Tunisia through the early twentieth century.

Despite these and varied artifacts, however, the Bardo Museum clearly owes its renown to the size and quality of the mosaics collection, which is the world's largest. Not only does this collection illustrate the evolution of a craft into an art form, but it also recounts the history of mosaic restoration and conservation techniques over more than a century. In addition, it sheds light on the attitudes of the archaeologists and historians of the period, who placed value only on spectacular works — whether they were inscriptions, monumental sculptures, or figurative mosaics. The only nonfigurative mosaics accepted were those that served as palace floors, and they were so little cherished that visitors were allowed to walk on them without restriction. Particularly because of its magnificent mosaics, a visit to the Bardo Museum is essential for anyone who wishes to know more about this ancient art form (FIGURE 5.2).

When mosaics were found during the initial large-scale excavations — especially those that presented some historical or aesthetic interest — they were removed and shipped to museums, where they were exhibited on walls or on floors. When panels did

FIGURE 5.2
Outer entrance to the Bardo Museum, which was founded in the late nineteenth century. This entrance opens onto a square leading to a mosque and the Bardo Palace, which now houses the National Assembly.
Photo: Bruce White, 2005.

not conform to the taste of the times, they were relegated to storerooms, perhaps without complete documentation. In several cases, their provenances were ultimately forgotten. Even for mosaics considered to be of major importance, it is often impossible to determine original locations. When archaeologists and others documented the excavations, they sometimes failed to pass this critical information on to museums, believing that the research was their personal, proprietary work. For example, when the team compiling the scholarly work known as the *Corpus des mosaïques de la Tunisie* was working in Thuburbo Majus, studying the mosaic pavements in their original settings, it was unable to place a beautiful mosaic from the Bardo that depicts a poet; the museum's records give no specific information beyond its general origin, the Thuburbo Majus site.

Today the Bardo Museum has about a thousand mosaic pavements or pavement fragments, about half of which are on display (FIGURE 5.3). They are organized and presented according to the general historical development of mosaic art. Because most of the Bardo's mosaics date from the second to the seventh century, Punic works are not represented, nor are those rare mosaics attributed to the first century CE. The oldest mosaics in the Bardo Museum include those from the Acholla site, approximately thirty kilometers (nineteen miles) north of the city of Sfax. Excavations conducted in the 1950s revealed several buildings, such as the Baths of Trajan, as well as the house of a man originally from Acholla, M. Asinius Rufinus Sabinianus, who was a Roman senator appointed consul under Commodus from 180 to 185 CE. His residence is known as the House of Asinius Rufinus. Both of these structures are dated to the second century.

These Acholla buildings were remarkable for their mosaic decor. The figurative tableaux were removed and are now dis-

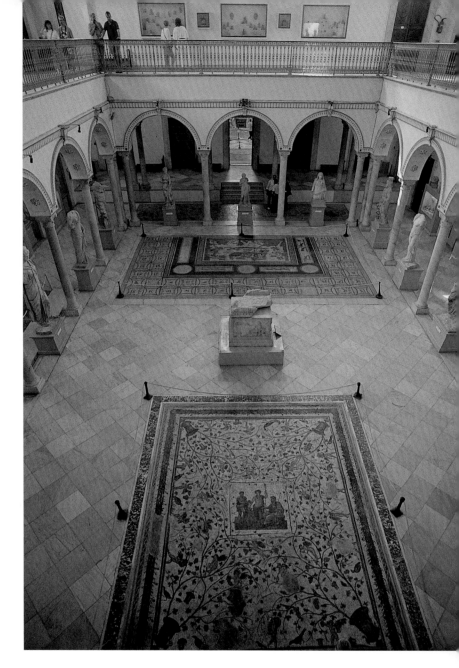

FIGURE 5.3
The Carthage Gallery of the Bardo Museum, in the heart of the former palace. This corridor is primarily reserved for Roman statuary found at Carthage. On the floor are two mosaics from the House of the Laberii at Oudhna, separated by the altar to the Gens Augusta from Carthage.
Photo: Guillermo Aldana, 1993.

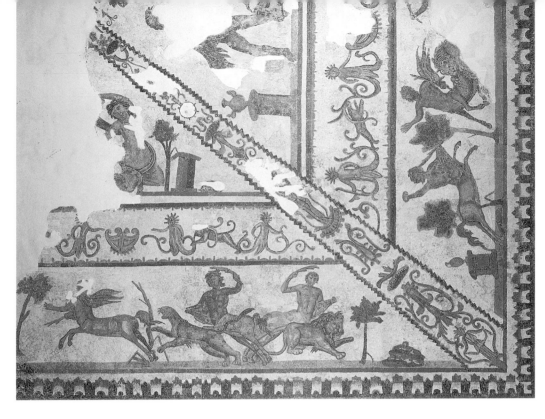

FIGURE 5.4

Mosaic from the frigidarium of the Baths of Trajan at Acholla. It represents a projection onto the floor of shadows cast by a groined arch, whose framework and ornamentation are visible. The first group depicts the Battle of the Lapiths and the Centaurs; the second group is decorated with small grotesques. The center, which is damaged, is filled with scenes of satyrs and maenads. Last half of the second century.

Bardo Museum.
Photo: Mohamed El Ayeb.

played in the great hall on the third floor of the museum. Stripped of their mosaic treasures, to the benefit of museum collections, these structures are now neglected and attract few visitors. The mosaics from the Baths of Trajan include the floor mosaics from the frigidarium, formed of a square tableau alongside two oblong rectangles. The composition of the square, of which only a very damaged portion remains, represents the cast shadow of a groined vault; the network of groins is decorated with vegetal motifs incorporated into scrolls and volutes. The border is organized in horizontal bands — sorts of friezes — the first of which depicts the Battle of the Lapiths and the Centaurs and the second of which depicts grotesque little characters incorporated into a scroll (FIGURE 5.4). The trapezoidal spaces between the center and the border friezes contain scenes of a struggle between a maenad and a satyr, in a landscape hinted at by a pillar and a shrub. The rectangular panels, which represent the cast shadow of a barrel vault, are organized into three horizontal strips, ornamented in the center with a square medallion. The border consists of a

frieze with vegetal grotesques and the suggestion of a wall. Two side areas along the central strip are peopled with beautiful Nereids astride mythological creatures that combine the forms of horses and fish. The central strip contains two circular medallions representing winter and spring, depicted as two beautiful young women with the attributes of the seasons, and the square central medallion contains the god Bacchus, depicted as a youth standing astride his chariot, led by two satyrs, one young and one old. Other fragments from the same building are in the Hellenistic style, with frieze decorations and grotesques, sphinxes, and peopled scrolls.

The mosaics from the Baths of Trajan that adorn the Acholla Room in the Bardo Museum are exceptional examples of the African mosaic school since they illustrate — both thematically and technically — the influence of the Hellenistic art that was still dominant in the second century. Another mosaic from the House of Asinius Rufinus shows the evolution of Achollan mosaics over more than half a century. This pavement forms the T of a triclinium, or dining room, and has a composition of knots of

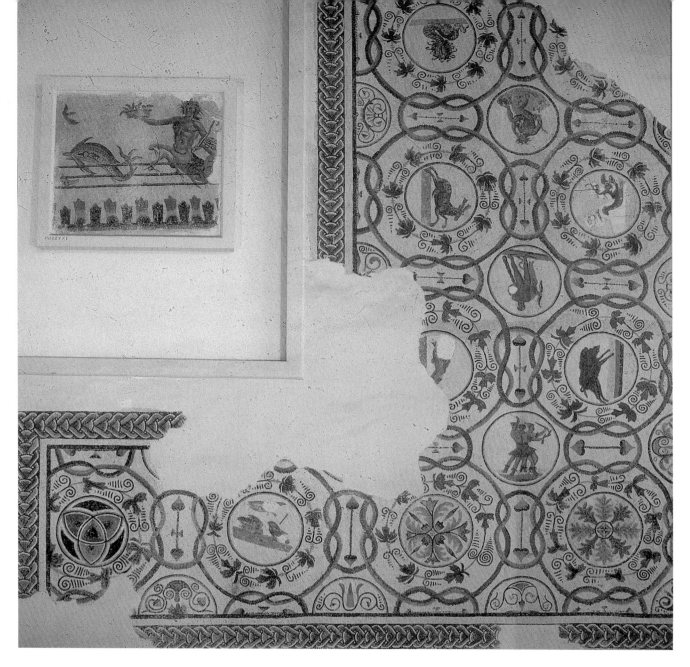

Hercules, arranged in a lattice of cables, with the large units of the design encircled by a crown of grape leaves (FIGURE 5.5). The main axis contains circles encompassing various scenes from the Labors of Hercules. The hero himself is depicted nude, holding his club. The other units are peopled either with human or animal figures related to the hero's labors or with complex decorative rosettes and florets. The figures are positioned so as to be viewed by guests reclining on the couches that covered the U-shaped mosaic

FIGURE 5.5

Mosaic representing the Labors of Hercules, from the triclinium of the Achollan House of Asinius Rufinus, a major figure of the Roman Empire under the reign of Commodus. An interwoven composition contains figures of humans, animals, and monsters related to the Labors of Hercules. Hercules is depicted partially nude at the center of the tableau, wearing the skin of the lion of Nemea and carrying a club and a bow. The floral elements of the composition create a rich effect. Second century.

Bardo Museum.
© Cérès Éditions, Tunis.

pavement surrounding the crossbar of the T.
Crafted several years after the mosaics from
the Baths of Trajan, those from the House
of Asinius Rufinus reveal the characteristics
of the Byzacene workshops, both in their
fuller compositions and in their use of com-
plex floral and vegetal elements, which are
handled with assurance and grace.

Another favorite subject of African
mosaicists is *xenia*—depictions of traditional
still life subjects, as well as animals. A *xenia*
theme is found at Acholla, in a mosaic from
the partially excavated House of the Lobster.
The theme of the still life combines fowl,
fruits, vegetables, marine fauna, and animals
to populate the composition and celebrate
the richness and fecundity of nature. In this
mosaic—a pavement of a triclinium—the
still life theme is worked into a fine and com-
plex pattern of interconnected swastikas,
which form oblong octagons containing fig-
ures of a lobster, gazelles, deer, a peacock, a
guinea hen, a goat, a bunch of artichokes, and
fruit-filled baskets (FIGURE 5.6). The mosaic
from the House of the Lobster is dated to the
last half of the second century.

Among the Bardo Museum mosaics that
represent the spirit of early African mosaics
are pavements from the House of the Laberii
at the site of Oudhna (ancient Uthina). This
pre-Roman site (approximately thirty-five
kilometers, or twenty-two miles, southwest of
Carthage) was elevated to the status of a
colony by Emperor Augustus. The city first
developed and prospered during the second
and third centuries and then prospered again
during the last half of the fourth century,
after the uprisings and repressions of the late
third century. Excavated by Paul Gauckler in
the late nineteenth century, the House of the
Laberii yielded numerous mosaics, some of
which, because figurative, were removed and
taken to the Bardo Museum. Neglected for
over a century, the site is now being excavated
and restored. The House of the Laberii, which

FIGURE 5.6

*Triclinium mosaic from a house at Acholla. In a composition of
curved, interwoven forms are xenia—still life motifs — of animals,
birds, fish, and crustaceans, as well as fruits and vegetables for the
table. Second century.*
Bardo Museum.
© Cérès Éditions, Tunis.

was rediscovered more than ten years ago, has been supplied with copies of the original floor mosaics. The house is designed around a very large peristyle surrounding a garden. The rooms that open onto the arcades include a large reception room decorated with a tableau of Icarus and another inner space — a sort of atrium — with a mosaic of pastoral scenes. Of the many figured tableaux in the house, some are remarkable for their themes as well as for their quality of workmanship. Three small vignettes, or emblemata, veritable master-pieces that were unquestionably created by a great artist, were inserted into geometric floor mosaics. These works are probably older than the mosaics into which they were inserted. The artist produced them in a workshop on a tile backing, which allowed them to be transported. Executed in the Hellenistic technique, the mosaics consisted of tiny tesserae (sometimes smaller than one millimeter), generally of polychrome mar-bles. One of the vignettes from the House of the Laberii contains a still life of table scraps: fragments of eggshells, fish heads and bones, melon slices, and lemon peels, scattered on the floor. The prototype for this theme, called "unswept floor" mosaic, was created by the Greek artist Sosos of Pergamon in the second century BCE. Such an image would serve, of course, to symbolize the owner's bounty and wealth. Another tableau of the

same size appears to represent two rounded loaves of bread, a mound of butter pierced with a knife, and a glass filled with wine (FIGURE 5.7). A third tableau, as damaged as the others, portrays a magnificent bird perched on a stick (FIGURE 5.8). The fourth emblema repeats the subject of the leftover scraps from a meal. These masterful emblemata appear to date to the early second century—that is, prior to the installation of most of the pavements, which apparently date either to the last half of the second century or, more likely, to the early third century.

Another exceptional mosaic pavement from the House of the Laberii represents a mythological scene inserted into a composi-tion featuring a lavish grapevine motif

FIGURE 5.9
Mosaic of Icarus from the House of the Laberii at Oudhna. This mosaic, which paved the floor of a reception room, has an elegant diagonal composition of grapevines, which branch out from the four kraters in the corners, spreading and intermingling to cover the entire field. Four cupids are harvesting the grapes, lifting baskets laden with fruit. The center of the tableau contains a scene depicting the young Bacchus, his head crowned with grapevines, his body partially wrapped in a blue mantle of glass tesserae. The god, who is supported by a thyrsus, holds a krater depicting the peasant Icarus, symbol of the gift of grapes to mankind. The scene unfolds in the presence of a seated king. First half of the third century.
Bardo Museum.
Photo: Mohamed El Ayeb.

FIGURE 5.7 (TOP LEFT)
Emblema from the House of the Laberii at Oudhna. This is a beauti-fully executed tableau of the type mounted on a support, usually a tile, separate from the rest of the mosaic and inserted into the pavement as a finishing touch. This vignette represents a mound of butter with a knife protruding from it, a glass of wine, and a loaf of bread (not shown). Conservators have discovered that the oblique angle of the wineglass is a modern error, made when the mosaic was dismantled in the nineteenth cen-tury. Third century.
Bardo Museum.
© Cérès Éditions, Tunis.

FIGURE 5.8 (TOP RIGHT)
Emblema from the House of the Laberii at Oudhna. This tile-mounted tableau depicts a bird perched on a branch. Second century.
Bardo Museum.
© Cérès Éditions, Tunis.

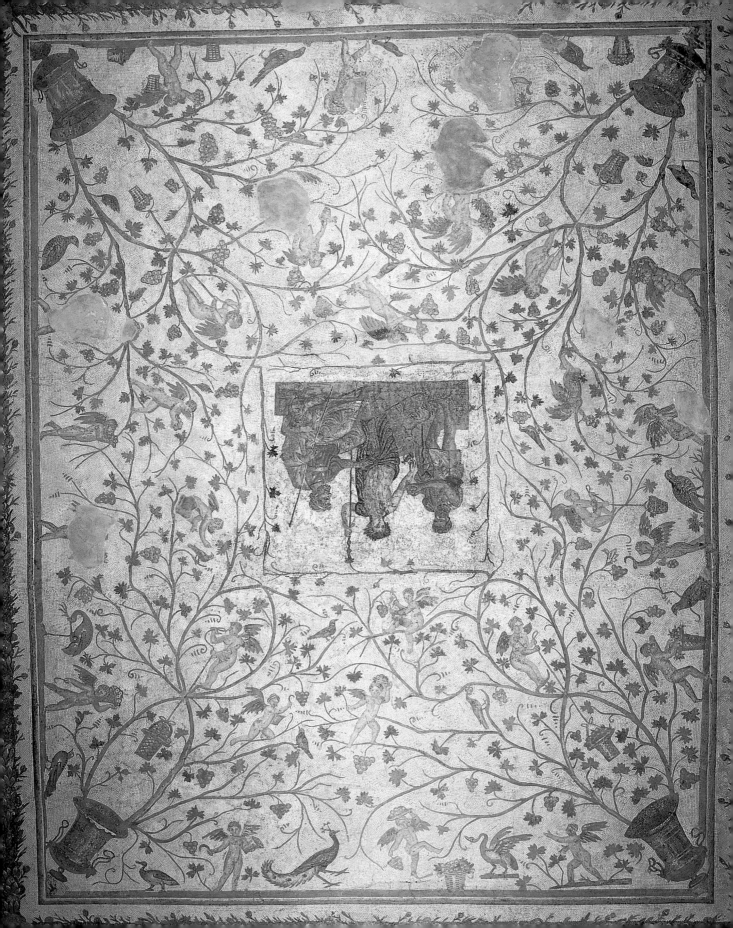

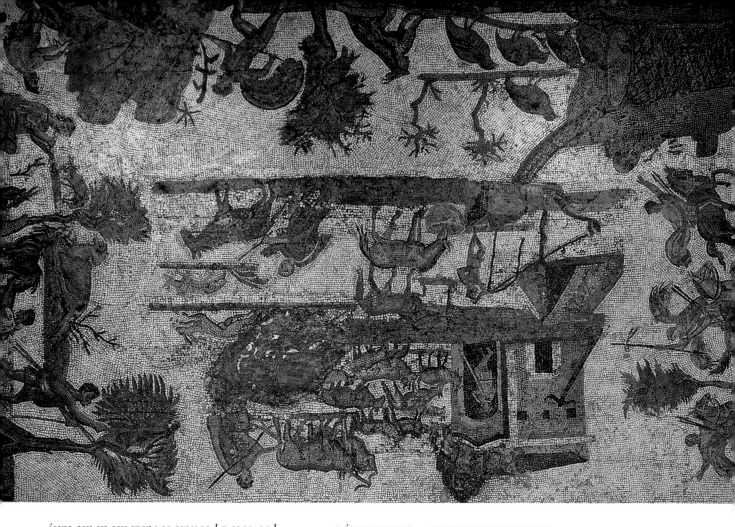

(FIGURE 5.9). This composition is peopled with small birds and cupids, playfully gathering clusters of grapes. In the center of the tableau, a panel depicts the young god of wine, Bacchus, who holds his characteristic staff, or thyrsus, in one hand and in the other a krater, whose contents he pours onto a panther. He faces two figures, the peasant Icarus, standing to receive the gift of wine from the god, and the legendary king of Attica, seated on a throne, his head encircled by a diadem. The superb execution of this scene reveals the hand of a great mosaic master. The threshold of the room with the mosaic of Icarus is decorated with a figurative panel in a style completely different from the floor mosaic — undoubtedly a

fourth-century addition (SEE FIGURE 2.11). In this hunting scene, two horsemen, followed by their servants and preceded by hounds, whip up their mounts to pursue two hares. This mosaic is one of a rich series of hunting scenes — a subject beloved by the African elite.

The second large floor mosaic from the House of the Laberii, which is now displayed in the Carthage Gallery at the Bardo Museum, depicts scenes of pastoral life, invaluable witness to the character of daily life on a farm in Roman Africa during the late second or early third century. Also displayed in the Carthage Gallery is another pavement from the same residence which provides a portrait of rural life in the early

FIGURE 5.10
Mosaic from the House of the Laberii at Oudhna depicting scenes of rural life. At the lower left is a curious scene in which a peasant, dressed in an animal skin, is pushing birds toward a trap. In the center, a peasant drives a donkey. The upper register shows livestock walking toward a building. On the sides of the tableau are scenes of hunting and other rural activities. First half of the third century.
Bardo Museum.
Photo: Jerry Kobylecki/GCI.

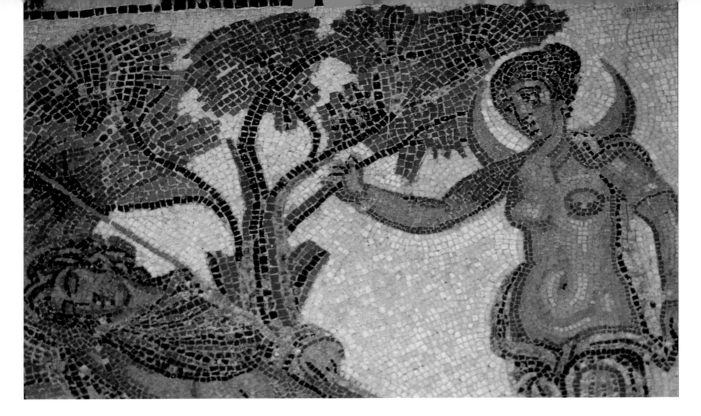

third century (FIGURE 5.10). At the top, two shepherds return their livestock to the barn, one corralling the animals, the other shepherding them into the building. In the center is a well with two horses accompanied by a peasant. In the near distance is a plowing scene. In the bottom register, a curious figure dressed in an animal skin attempts to drive some fowl into a basket trap. Behind this event, there is a heroic hunting scene, in which an almost nude hunter thrusts his spear into a boar. Other lively scenes were placed on the sides for the entertainment of the guests. A shepherd soothes his animals with his flute; another milks a goat. In the distance, a shepherd gives chase to some birds. Additional hunting scenes unfold on the third side. The artists have created an interesting amalgam of daily farm life, which is the lot of the humble folk, and of hunting scenes, a privileged activity of the lords and masters. In its rich depiction of various personages and events, this mosaic provides an essential record of daily life on the great estates of Roman Africa during the first half of the third century.

There are many other tableaux from the House of the Laberii, such as a tableau representing the handsome shepherd Endymion, discovered sleeping by Selene, the goddess of the moon (FIGURE 5.11). Another panel represents the abduction of Europa by Jupiter in the guise of a bull, under the complicit gaze of a cupid. Orpheus charming the animals is the subject of another mosaic (FIGURE 5.12). This rich mythological imagery — desired by an owner aware of classical culture and executed by mosaicists who knew the prototypes and conventions — reveals a high degree of cultural sophistication among the Romanized African bourgeoisie.

Another masterpiece in the Bardo Museum was probably produced during the same period at another site, Chebba, about 200 kilometers (125 miles) south of Carthage. This mosaic pavement was apparently found in a private residence. The composition has diagonal elements consisting of the figures of the four seasons, each framed by its vegetal attributes. Seasonal activities are illustrated on the panel's sides. The composition converges on a central medallion, which encom-

FIGURE 5.11
Detail of the central tableau of a mosaic from the House of the Laberii at Oudhna. The handsome shepherd, Endymion, lies sleeping near a tree, under the amorous gaze of the goddess Selene. Third century.

Bardo Museum.
© Cérès Éditions, Tunis.

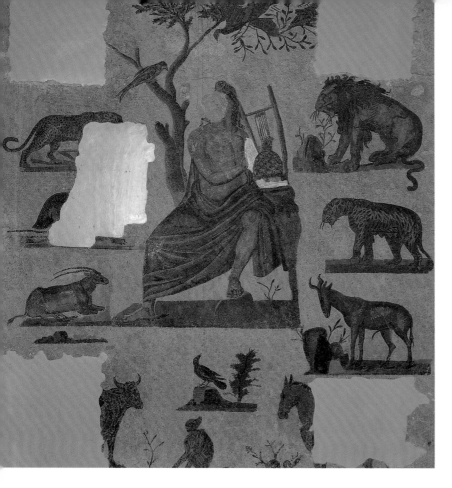

FIGURE 5.12

*Orpheus charming the
animals, a pavement
mosaic from baths near
the House of the Laberii
at Oudhna. The hero is
seated on a rock, playing
his lyre so beautifully
that he charms the wild
animals. The subject of
Orpheus was particu-
larly popular in Africa.
Fourth century.*

Bardo Museum.
Photo: Bruce White, 2005.

passes Neptune, triumphant on his chariot, pulled by two sea horses and led by Triton and a Nereid (FIGURE 5.13). With its elegant proportions, its lively composition, and the sensitivity and care with which it was executed, this mosaic is clearly the work of a masterful artist. The combination of themes is also unusual: Neptune, the supreme lord of the seas, is depicted along with the seasons, who represent the glorious abundance of the Earth. The style of this pavement dates it to the last half of the second century.

As already noted, the third century witnessed the maturation of the African style. This period constituted one of the greatest moments in Romano-African civilization, which reached its zenith with the advent of the Severan dynasty. One site in particular—Dougga, ancient Thugga—represents Africa's power to assimilate all of the civilizations that came to conquer it. Situated a little more than 100 kilometers (about 60 miles) west of Carthage, Dougga occupies a strate-

gic position on a plateau that dominates the surrounding plains as far as the eye can see. The many ruins indicate that the settlement of the site dates to pre-Roman times. These ruins include megalithic walls, dolmens, and the mausoleum of a Numidian prince dated to the second century BCE.

After Rome's defeat of Carthage, Dougga remained under the rule of Numidian princes allied with Rome. In 46 BCE, Caesar permanently annexed the territory of Dougga, which was Romanized relatively quickly, but throughout antiquity, Dougga retained its pre-Roman character. The process of Romanization continued, and in 216 the city attained the status of a colony. Dougga is now one of the sites that most interest historians and archaeologists of Roman Africa, for two reasons in particular: the superimposition of the various cultures that succeeded one another at the site and the phenomenon of successful assimilation.

Excavations at Dougga began in the late nineteenth century and continue to this day, as the site continues to enthrall scholars and yield new discoveries. The unearthed ruins, which cover dozens of hectares, are the subject of a vast restoration operation that forms part of an effort to develop the region economically, socially, and culturally. The excavations have led to the discovery of several buildings with mosaic floors, some of which are figurative and illustrate themes that are quite rare for African mosaics. These pavements were removed and shipped to the Bardo, where today they are considered some of the museum's greatest treasures.

These tableaux include the mosaics found in the House of Ulysses, which has a somewhat irregular design, since it conforms to the configuration of the street. The quadrangular peristyle is formed of four arcades surrounding a courtyard containing a pool with semicircular basins at either end. In front of each basin is a figurative mosaic.

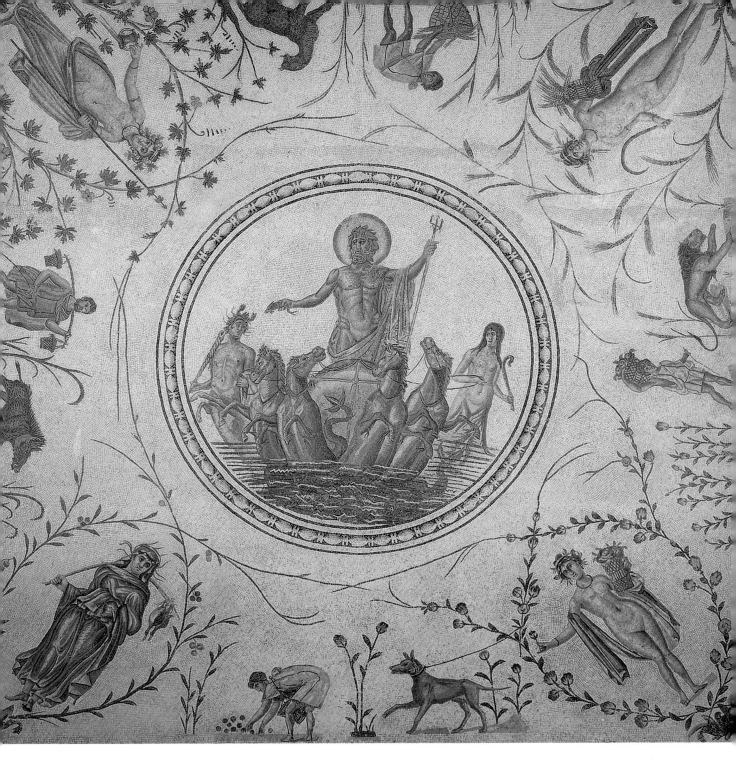

FIGURE 5.13

Triumphant Neptune mosaic from Chebba, dominated by a portrait of the victorious Neptune holding a trident, the symbol of his power, and a small dolphin. He is riding his chariot, pulled by four sea horses flanked by sea monsters. The four female figures in the corners represent the four seasons. Autumn, shown framed and crowned by vine branches, holds a thyrsus in one hand and a krater in the other. Summer is portrayed as a nude young woman, crowned with ears of wheat, holding a scythe, a basket of wheat, and a folded mantle. The nude young woman partially draped with her mantle represents spring. She is crowned with roses and carries a basket of roses along with a single rose. Warmly clad Winter, her head crowned with reeds, holds a staff from which a pair of game birds hangs. On the sides, four tasks associated with the seasons are shown: hunting for autumn, olive picking for winter, rose gathering for spring, and wheat harvesting for summer. Second century.

Bardo Museum.
Photo: Jerry Kobylecki/GCI.

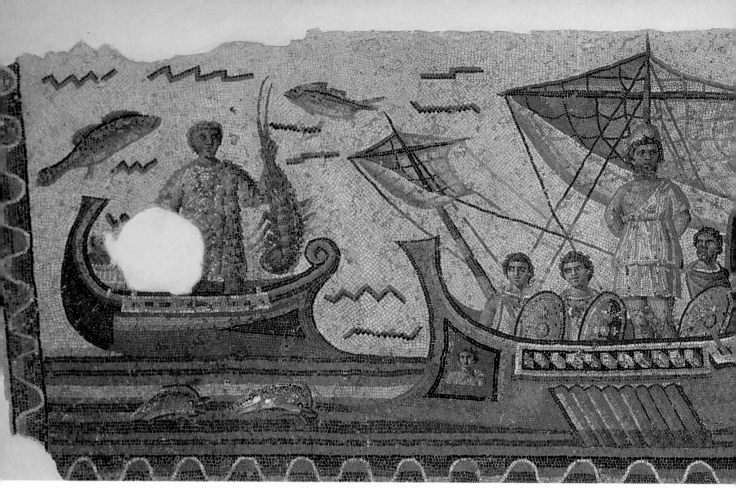

FIGURE 5.14

Mosaic representing Ulysses and the Sirens from the House of Ulysses at Dougga. This is one of the most famous mosaics in the Bardo Museum, since mosaic representations of this scene from the Odyssey are quite rare. Ulysses is standing, bound to the mast of his boat, charmed by the Sirens' song, while his companions look away. At the right are the Sirens, portrayed as winged young women with birds' feet. The first Siren holds a double flute, the better to bewitch her victims. At the left, a fisherman displays a large lobster. Third century.

Bardo Museum.
Photo: Bruce White, 2005.

Facing the oecus, or reception room, is the famous tableau representing an episode from the *Odyssey,* where we see Ulysses in his ship, bound to the mast, looking toward the Sirens, while his seated companions look in the opposite direction, avoiding the enchantment of the Sirens, who are depicted on an island at the right (FIGURE 5.14). They hold flutes and a zither, preparing to lure the sailors with their seductive song. The scene takes place in a sea teeming with fish and dolphins. Mosaics of this scene from the *Odyssey* are rare.

On the other side of the peristyle pool, a second tableau illustrates a scene inspired by the seventh Homeric Hymn, representing Bacchus punishing the pirates of the Tyrrhenian Sea, who had attempted to abduct the god, taking him for a mortal (FIGURE 5.15). The center is occupied by a superb boat in which Bacchus stands, dressed in a tunic (the head is damaged). He is surrounded by a

satyr and a maenad, while Silenus is sprawled in the stern. The god and his companions look toward the pirates, who have been driven mad and transformed into dolphins. As with the Ulysses scene, the story of Bacchus and the pirates is very rarely depicted in mosaics.

The oecus of the House of Ulysses is decorated with another Dionysian mosaic. The composition centers on a large laurel crown that encircles Bacchus, shown as a young boy astride a panther. The crown is surrounded by rectangular tableaux forming a sort of octagon around the circle. The vignettes are decorated with satyrs and maenads. The masterful mosaics from the House of Ulysses are superb examples of the lively spirit and high degree of animation found in African mosaics of the third century. Like most African bourgeois of the period, the owner had a predilection for Dionysian subjects, but the choice of the less usual themes

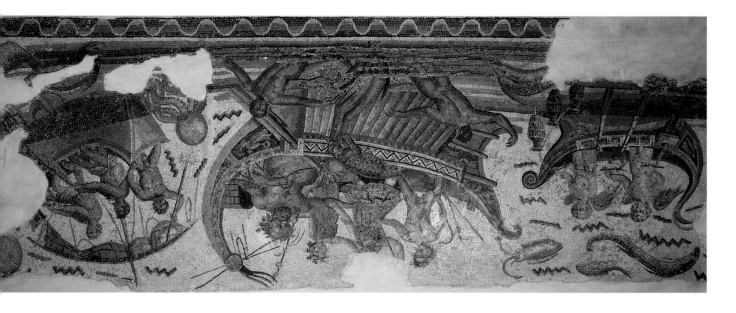

FIGURE 5.15
Mosaic from the House of Ulysses at Dougga. The tableau illustrates a Homeric scene depicting the god Bacchus dressed in a tunic, standing aboard the central boat, punishing the pirates of the Tyrrhenian Sea. On the same boat are a sprawling, bald, and paunchy Silenus, a satyr, and a bacchante, as well as a panther bounding from the boat to devour the pirates. As the pirates flee into the sea, they are turned into dolphins. On either side of the god's boat are two other vessels, one with winged cupids and the other containing sailors pulling in a net of struggling crustaceans. Fourth century.
Bardo Museum.
Photo: Gilles Mermet/Art Resource, NY.

103

of the voyage of Ulysses and the pirates of the Tyrrhenian Sea reveals a more sophisti-cated level of classical culture.

Before leaving the treasures of Dougga, it is fitting to point out a very deteriorated pavement mosaic from the frigidarium of the Baths of the Cyclopes, which is now on exhibition in the Dougga Room at the Bardo Museum. The theme is derived from the *Aeneid*, the epic poem by the great Latin poet Virgil. The mosaic depicts a cave in which the three Cyclopes are forging thunder for Jupiter (FIGURE 5.16). The mythological characters are represented with two eyes, contrary to legend, which describes them with a single eye (as seen in a mosaic from Piazza Armerina in Sicily). Although the mosaic is damaged, the composition of the tableau and, especially, the persuasive depic-tion of the muscles, bulging and straining with effort, are witness to the mastery of

the mosaic artists who created this splen-did tableau.

The Bardo is also known for one of the most famous mosaics produced in antiquity, dated to the first half of the third century and found in a private residence at Sousse. This is the tableau with a portrait of Virgil. The poet is seated with an open scroll upon his knees, which contains the eighth verse of the *Aeneid* (FIGURE 5.17). He is flanked by the two muses who inspired his work: Clio, muse of history, and Melpomene, muse of tragedy. In addition to its beauty, this tableau is exceptional because it is the only mosaic that has come down to us representing the great Latin poet, whose portrait was also exhib-ited publicly, according to reports of some ancient authors. This tableau is part of a series of mosaics illustrating the vitality of African cultural life in the third century and beyond. Such images were highly desired by

FIGURE 5.16 (OPPOSITE)
Mosaic pavement from the Baths of the Cyclopes at Dougga. This damaged tableau depicts a scene in a cave, where the Cyclopes are at work forging thun-der for Jupiter. The ren-dering of the figures and the composition of the scene make this tableau one of the masterpieces of the Bardo Museum.
Fourth century.
Bardo Museum.
Photo: Bruce White, 2005.

FIGURE 5.17
Mosaic representing the great Latin poet Virgil, found in a house at Sousse. The poet, dressed in a toga, is seated in a solemn pose. He seems pensive, undoubtedly inspired by the muses who flank him: Clio, muse of history, is at his right, and Melpomene, muse of tragedy, is at his left. Virgil holds a scroll on his lap, on which he has written a verse of his masterpiece, the Aeneid. Third century.
Bardo Museum.
Photo: Jerry Kobylecki/GCI.

the African bourgeois, who understood their meaning and valued their prestige and who commissioned them for their homes from mosaicists well versed in classical culture.

The Bardo Museum also has a rich collection of Christian mosaics, including several church floors, funerary pieces, and a superb baptismal font. The preserved floors include a fragmentary mosaic from Oued Rmel, in the Zaghouan region, consisting of an original scene of the faithful building their church (FIGURE 5.18). In the bottom register, a man transports a column on a horse-drawn cart led by another man. The middle register shows two masons mixing mortar. At the top the stonecutter is working on a column. The center was occupied by a cupid holding a wreath inscribed with the name of the church, only two letters of which survive. This mosaic, dating to the sixth century, is part of a series of mosaics from late antiquity that depict scenes of daily life in a simple, often naive manner.

The room devoted to paleo-Christian archaeology contains a rich collection of tomb mosaics, many of which come from the town of Tabarka, in the far north of Tunisia. Of these mosaics, which were inserted into the pavement of a fifth-century chapel floor, one of the most interesting is called the *Ecclesia Mater* (the Mother Church). This tomb mosaic shows an architectural cross section of a church—an original theme for a mosaic (FIGURE 5.19). The internal structure of the church is very clear, consisting of three naves, the choir, the rear of the apse, the colonnade, and the roof. The church floor itself is tiled with mosaic and has a bird motif. In addition to the inscription *Ecclesia Mater*, there is an invocation for the deceased to rest in peace: *Valentia in pace*.

Finally, the paleo-Christian department possesses a major work, an entirely mosaic-tiled baptistery from the Church of Father Felix in Kélibia, at the tip of the Cap Bon peninsula. The baptismal font was inserted into a pavement. The four corners are decorated with kraters, from which grapevines emerge, branching into scrolls ornamented with clusters of grapes and small birds (FIGURE 5.20). The inscription on the threshold reads *Pax, Fides, Caritas* (Peace, Faith, Charity). The baptismal font, quatrefoil in shape, is flush with the pavement and has a long inscription on the edge: *S[an]c[t]o beatissimo Cypriano episcopo anteste, cum s[an]c[t]o Adelfio presbitero huisce unitalis, Aquinius et Iuliana eius cum Villa et Deogratias prolibus, te[s]sellu[m] aequori*

FIGURE 5.18
Mosaic depicting the construction of a church from Oued Rmel, in the Zaghouan region. The mosaic shows the faithful building their church. In it, two men transport a column; a mason mixes mortar; and, at the very top, a stonecutter works. At the center of the tableau, a winged demigod flutters, holding a wreath that probably originally contained the name of the basilica. Sixth century.

Bardo Museum.
Photo: Mohamed El Ayeb.

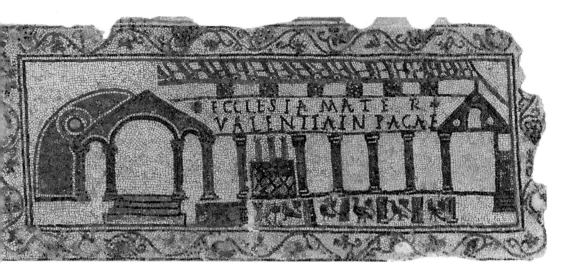

FIGURE 5.19
Mosaic from the Chapel of the Martyrs at Tabarka. This tomb mosaic depicts an architectural cross section of a Christian basilica. It contains an apse, three naves, and the roof of the church, as well as a mosaic floor and an altar with three candles. The inscription identifies the tomb as the resting place of Valentia, who rests in peace in the Mother Church. Sixth century.
Bardo Museum.
Photo: Bruce White, 2005.

perenni posuerunt (For the blessed bishop Saint Cyprian, head [of our church], with holy Adelphius, priest of this [church] of unity, Aquinius and Juliana, along with their children, Villa and Deogratias, laid this mosaic to hold the eternal water). This dedication by a family of the faithful, whose names are listed, honored Saint Cyprian, bishop of Carthage, who was martyred in 258. The interior of the font is entirely covered with rich and varied motifs related to Christian symbolism. It contains birds; fish; fig, olive, palm, and apple trees; candles; a box; bowls for consecrated oil, or chrism; and a cross beneath a canopy. The bottom of the baptistery is decorated with a chrism bowl with alpha and omega symbols. This structure, dating to the mid-sixth century, is part of an abundant group of mosaic baptisteries found in Tunisia, which date to after the Byzantine reconquest—a sign of the triumph of the Orthodox Church over the Vandal heretics.

NOTES

1 This house is still known as the House of the Laberii, even though recent research has called this longstanding appellation into question.

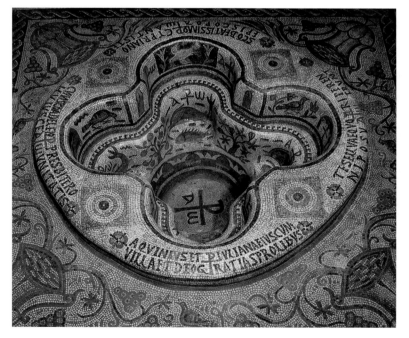

FIGURE 5.20
Mosaic from the baptistery of the Church of Father Felix at Kélibia. The mosaic quatrefoil baptismal font bears Christian iconography. The edge is inscribed with a dedication from a family of believers to Bishop Cyprian, head of the church, and to Adelphius, a priest of the church. The symbols of alpha and omega are repeated on either side of the chrism bowl, and there are Christian symbols of candles, a fish, and a dove. The mosaic surrounding the font is decorated with kraters from which vine scrolls grow. Sixth century.
Bardo Museum.
Photo: Bruce White, 2005.

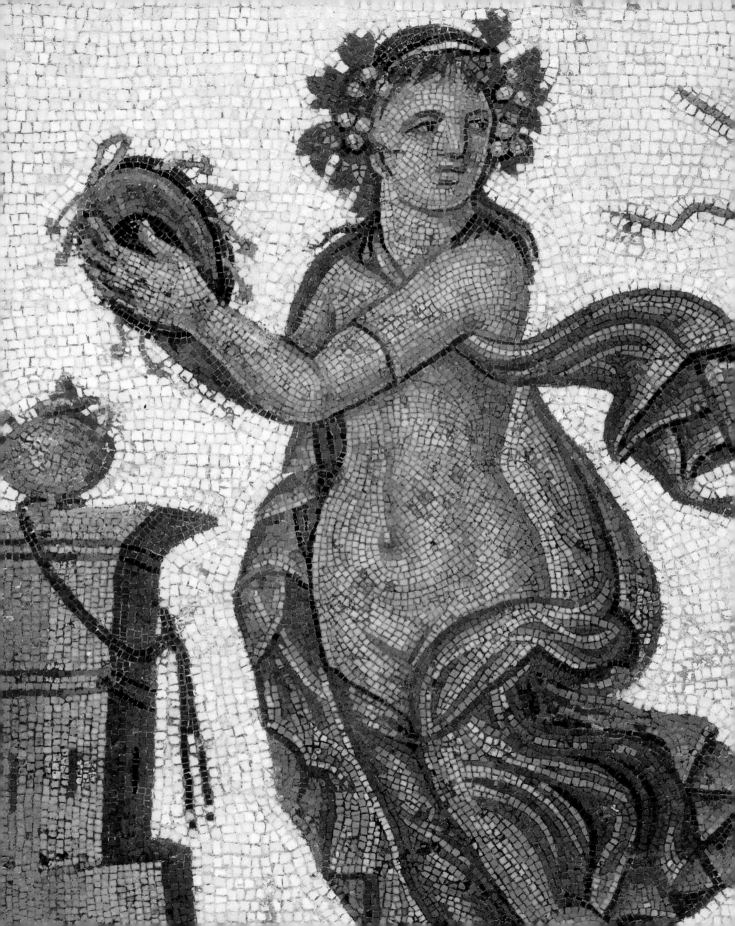

MOSAIC TREASURES THROUGHOUT TUNISIA

Since the late 1950s, when Tunisia gained its independence, the Bardo Museum has ceased to be the sole repository of archaeological finds. The Bardo's exhibition rooms and storerooms had over time become overloaded with thousands of objects accumulated from archaeological excavations conducted throughout the country.

FIGURE 6.1
Detail of a mosaic depicting a procession of the god Bacchus, from the House of the Dionysian Procession at El Jem. A bacchante — a female follower of Bacchus — plays a tambourine (see pp. 118-119). Third century.
El Jem Museum.
Photo: Mohamed El Ayeb.

Furthermore, as a part of its new cultural heritage policy, independent Tunisia sought to decentralize museum services and promote the creation of new regional and local museums near excavation sites, such as Nabeul, Maktar, and Bulla Regia. Thus, the authorities stepped in to showcase the collections and encourage the development of new museums and site depositories close to the original settings (FIGURE 6.1).

This policy is still in place, although the excavation programs have decreased considerably in recent decades because of a lack of qualified personnel and a scarcity of the preservation and exhibition resources that such operations require. In most cases, priority has been given to urgent excavations and new discoveries, which are increasing as a result of urban development in modern Tunisia. Tunisia must now meet the challenges of a developed country and become equipped to better manage the many magnificent discoveries that are continually coming to light in this land so rich in archaeological heritage.

Sousse Museum

Sousse (ancient Hadrumetum), one of the major sites for Punic and Roman antiquities, was the primary capital of Byzacium, owing to its geographic location on the coast and its proximity to the major olive oil production centers. Most of the finds from excavations during the late nineteenth and early twentieth century were sent to the Bardo Museum, as was routine practice at the time. In the 1950s, however, when archaeologists began excavating the residences rich in mosaics, the idea of an on-site museum was born, and an attractive museum with a large garden was rebuilt at the outskirts of the Islamic fortress. The Sousse Museum was designed to house the archaeological finds

from the town of Sousse and its immediate environs, including El Jem (which eventually built its own museum).

The mosaics in the Sousse Museum give a very good idea of the quality and quantity of the production of the Byzacene workshops, especially in the second and third centuries. The museum's mosaic glories include a head of Medusa from the tepidarium, or warm room, of a private bath belonging to a residence located in the environs of Sousse, dated to the third century. Medusa, with her locks of seething serpents, is portrayed in a circular medallion; her fixed gaze petrifies all who look into her eyes. A pattern of two-toned scales radiates around this medallion, suggesting armor.

Two mosaics from Sousse depict the theme of the abduction of Ganymede by Jupiter. One of these two pavements is particularly spectacular (FIGURE 6.2). It is the pavement from the dining room in a house in the Arsenal. The main scene, placed in a central circle, represents Jupiter, transformed into an eagle, preparing to abduct the young prince, with whom he is smitten, to carry him off to Mount Olympus. Around the central medallion are eight circles containing running animals of the sort used in amphitheater combat spectacles. The composition of the central medallion of Jupiter and Ganymede, the execution of the figures, and the sophistication of the palette reveal the hand of a master of mosaic art.

The many discoveries made at Sousse reveal that wealthy Byzacenes had a passion for anything relating to the cult of Bacchus, a god the Romans also called Liber Pater. His temples are often found at African sites. The giver of wine, of its pleasures and its mysteries, he was also associated with the seasons, the fertility of nature, and the cycle of life and death. He was, therefore, in a certain sense, the master of the world. The masterpieces of the museum include the Triumph of Bacchus

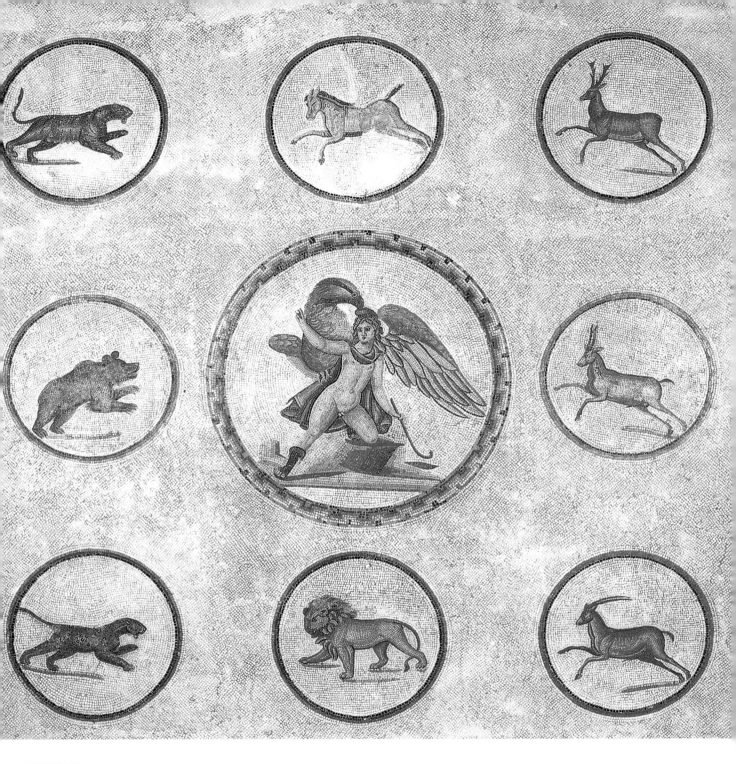

FIGURE 6.2

Mosaic from a house at Sousse depicting the abduction of Ganymede by Jupiter. The floor mosaic is formed of circular medallions inhabited by leaping wild animals, which surround a central medallion. The central scene is particularly dramatic: the young shepherd Ganymede is startled by an eagle, who is none other than Jupiter, preparing to abduct him. This central tableau stands out against the restrained white background—a contrast that accentuates the violence of the kidnapping scene. The theme of the abduction of Ganymede was particularly prized in Byzacium. Early third century.

Sousse Museum.
Photo: Mohamed El Ayeb.

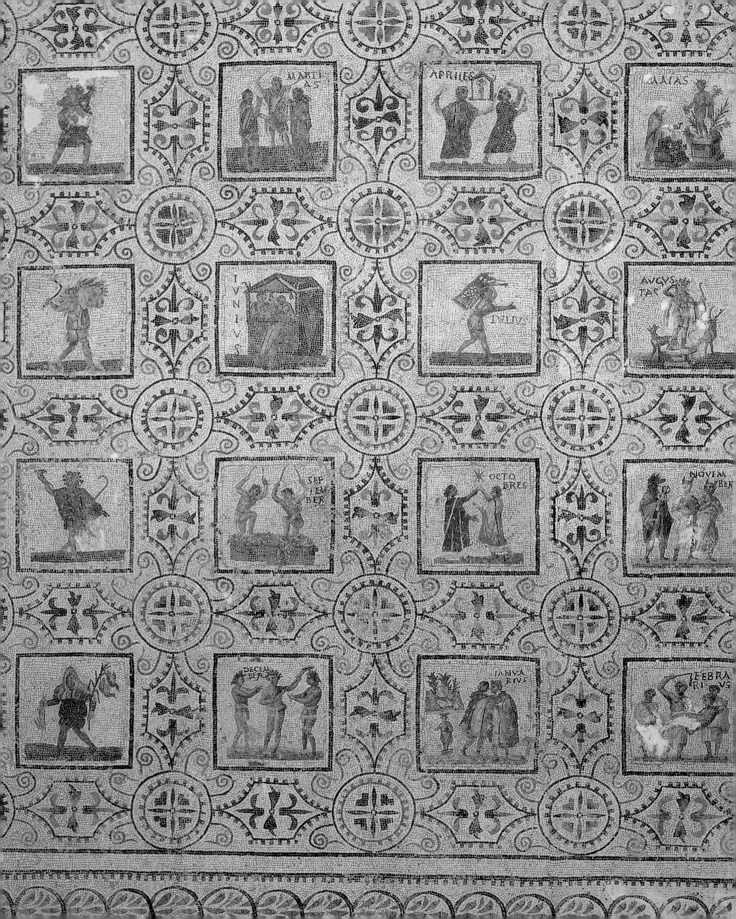

mosaic from a large reception room in the House of Virgil.

Another of the museum's famous mosaics, from the town of El Jem, constitutes one of the innovations of Byzacene mosaic production. It is a mosaic of the seasons and the months and can be seen as an illustrated calendar (FIGURES 6.3A AND 6.3B). The concept of time, which has always held great interest for humanity, took on a very particular meaning after the founding of the Roman Empire under Augustus. The empire was likened to the universe and the emperor likened to the master who regulated that universe. The passage of time and the succession of days, months, and seasons illustrate the eternal renewal of the universe and, thus, of the Roman Empire. Therefore, the theme of time took on particular importance in imperial propaganda. The African bourgeoisie also seized on this theme of eternal renewal to express its ties to the empire.

The mosaic of the months from El Jem is a significant example of this interest in the theme of time. It is composed of a design of sixteen boxes, aligned in four rows, set amid a field of vegetal patterns. Starting each row is the figure of a season, followed by the three corresponding months. They are identified by inscriptions, and each is represented by a religious or mundane scene. The year starts with spring, suggested by the figure of a young man crowned with roses and bearing a kid on his shoulders. The first of the three spring months is March, represented by three figures beating an animal skin, an image that refers to a feast called the Mamuralia, celebrated on March 15. April is represented by two figures playing percussion instruments in front of a small niche holding a statue of Venus (FIGURE 6.3B). This scene undoubtedly evokes the Veneralia, celebrated on April 1 in honor of the goddess. May is represented by a figure performing a sacrifice on an altar, before a statue of

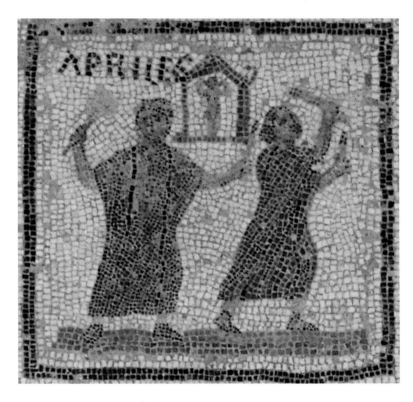

Mercury, the patron of El Jem. Summer is also represented by the portrait of a young man crowned with ears of wheat and holding a scythe. He is followed by June, which is represented not by a religious feast but by three figures drinking under a small, shrine-like shelter. July, also represented by a scene from daily life, shows a young man walking while carrying a bundle. August is represented by the portrait of the huntress Diana, accompanied by a deer and a dog. This scene symbolizes the birth of the goddess on August 13. The fall season is represented by a satyr wearing a crown of grape leaves. September is represented by two men crushing grapes, a theme particularly appropriate to this month. October is represented by two men standing face-to-face, perhaps dancing and gazing at a star. This image might be related to a political event of the period. November is represented by three figures; one wears a mask of Anubis, and the others

FIGURES 6.3A AND 6.3B
Celebrated mosaic from a house at El Jem. The tableau depicts a calendar with illustrations of the seasons and the months. Curiously, the seasons are represented by male figures, as in the detail of April (6.3B), depicting two figures playing percussion instruments. The months, which are also identified by inscriptions, are illustrated either by the holidays or by the agricultural activities that characterize them. The seasons and the three months that compose each of them are portrayed on individual lines. Third century.

Sousse Museum.
Photo: Bruce White, 2005.

FIGURE 6.4

*Mosaic of the Theater
Game from a house at
Sousse. It depicts a
bearded man dressed in
a white tunic, seated in
a pensive attitude and
staring fixedly at a sec-
ond, standing figure,
who is holding a comic
mask. A tragic mask is
placed near the first fig-
ure, and a container of
scrolls is at his side. It
appears that the scene
depicts a poet watching
an actor rehearsing.
Third century.*

Sousse Museum.
Photo: Bruce White, 2005.

wear the headdresses of priests of Isis. This
scene undoubtedly references the feast of
Isis. Winter is represented by an old man, his
head covered, holding a hare in one hand
and a stalk of millet in the other. December
is represented by the Saturnalia, with three
simply dressed figures crowned with leaves.
The figure in the middle holds a torch, while
the two others seem to be gesturing toward
him. January is represented by two amply
dressed men who greet one another near a
statuette. Finally, February is represented by
three standing figures, two of whom are
bearing a fourth person—a vignette that
probably relates to the February 15 festivities
dedicated to Lupercus, the Roman god of
fertility. This calendar observes the cycles of
nature and celebrates the characteristics of
the seasons by referencing the appropriate
agricultural work and protective divinities.
The pavement is dated to the third century.

Another mosaic representative of the
cultural life of the third-century bourgeoisie
of Sousse contains a scene depicting a seated
bearded figure, dressed in a toga and holding
a scroll (FIGURE 6.4). His pensive attitude sug-
gests that he is likely a poet. Next to him is a
mask of tragedy, and before him stands a
younger man, dressed in a mantle and hold-
ing a mask of comedy, suggesting that he is
an actor. At his feet is a receptacle holding
twelve scrolls.

While many other works in the museum
illustrate the specific character of Sousse and
its importance in defining Byzacene style,
there is one that must be mentioned here.
It is the head of the Titan Oceanus, from
Themetra (Chott Meriem, on the coast,
about twenty kilometers, or twelve miles,
north of Sousse), which came to the
museum in the 1990s (FIGURE 6.5). This
mosaic adorned the center of the frigidar-

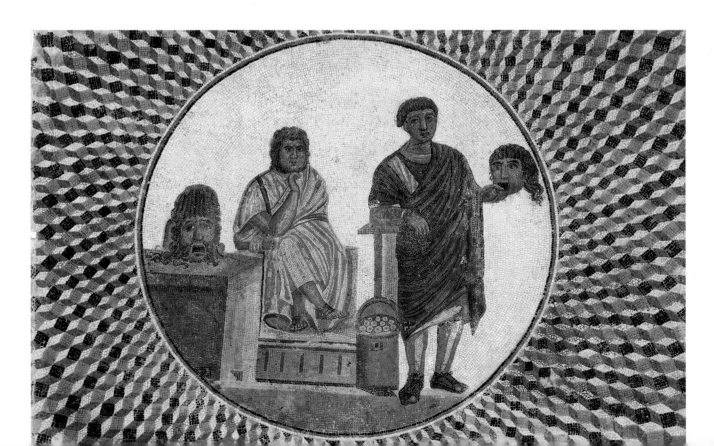

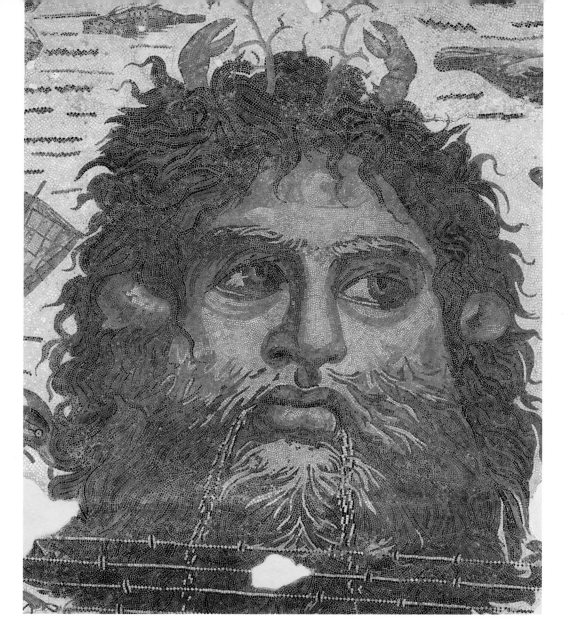

FIGURE 6.5
Mosaic from the frigidarium in the Baths of Themetra near Sousse. This head formed part of a complete pavement mosaic that also contained boats. The Titan Oceanus is depicted here as a bearded old man with vegetal hair, lobster claws emerging from his head, and rivulets of water streaming from his lips. Third century.
Sousse Museum.
Photo: Ellen Rosenbery,
J. Paul Getty Trust.

ium of the Baths of Themetra, a medium-sized bath complex. Its superb quality establishes it as the masterpiece among the entire series of heads of Oceanus found in Africa. Its archaeological setting and style date it to the mid-third century.

One of the most famous mosaics from Sousse is the mosaic of Magerius found at Smirat near Moknine in the Sahel. This pavement from a reception room in a private home commemorates venationes (animal combat spectacles in the amphitheater), sponsored by a certain Magerius for his fellow citizens. It is one of many mosaics celebrating the games that were such an important part of Roman life. The great Roman author Juvenal wrote of "panem et circences" (bread and circuses). The people were particularly fond of these violent action games, in which the strongest prevailed. In the Roman capital, the emperor spent lavish sums on these spectacles for the populace; in the provinces, wealthy men such as Magerius of Smirat staged and paid for such events. These practices allowed the bourgeoisie to assert their power and control the masses. We know that the games continued to be very popular well after the Christianization

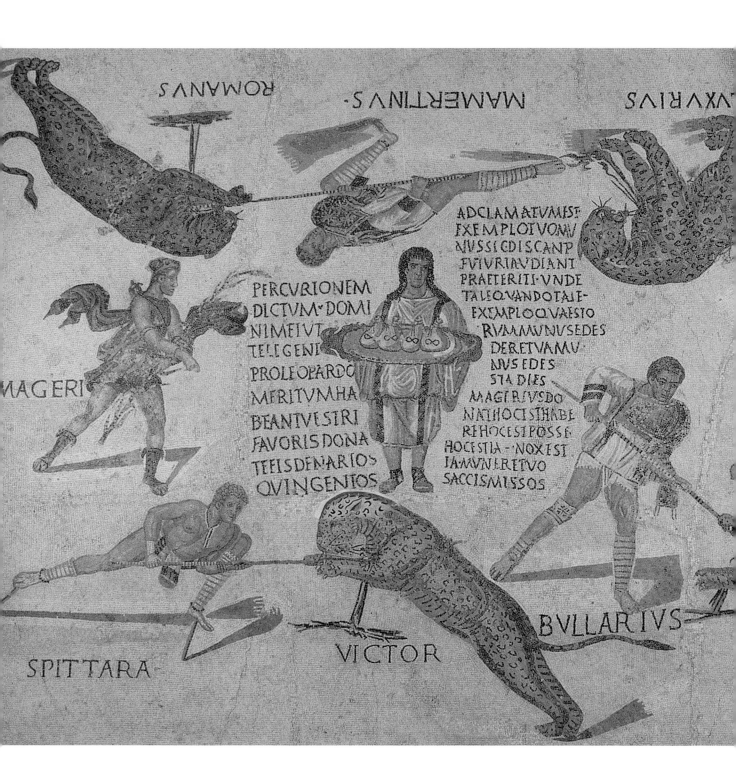

of Africa, since Saint Augustine found it necessary to censure such practices.

This mosaic has been described as a kind of "sportscast," since it records the spectators' comments and their cries of acclamation (FIGURE 6.6). The tableau is arranged in diagonals around battles between an individual *venator,* a kind of gladiator who hunted animals in amphitheater spectacles, and a leopard. The *venatores* (Spittara, Bullarius, Hilarinus, and Mamertinus) attack the four beasts (Victor, Crispinus, Luxurius, and Romanus), who are mortally wounded. The battle unfolds under the protective watch of the goddess Diana and the god Bacchus. In the center of the tableau, text reports the events in detail. At the end of the battle, after the victory of the *venatores,* a herald addresses the crowd to ask for payment for the entertainment—500 deniers per beast. One of the spectators then asks a dignitary named Magerius to cover the costs, invoking his generosity. When Magerius responds by paying twice the requested amount, the crowd exults and jubilation prevails. A servant is shown holding a large tray with four bags of money containing 1,000 deniers each. The realistic treatment of the figures, the accuracy of the details, the text recounting the events, and the staging of the entire scene indicate that the grand gesture of Magerius was an actual event of the mid-third century that was immortalized in this unusual mosaic.

FIGURE 6.6
Mosaic depicting the Smirat amphitheater games, showing four gladiators wrestling with leopards. Each contestant and animal is named. Two divinities—Diana on the left and Bacchus on the right—preside over the bouts. In the center is a figure holding a large tray with bags containing money destined for the winners. On either side of this figure, inscriptions report the crowd's cries of acclamation for the dignitary Magerius, who sponsored the games. The upper right corner of the mosaic is missing. Third century.

Sousse Museum.
© Cérès Éditions, Tunis.

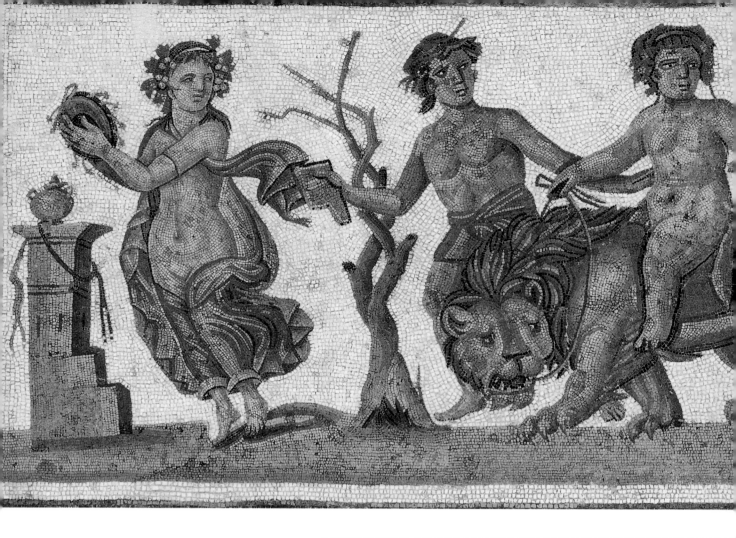

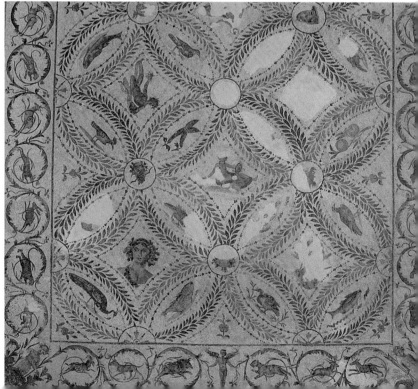

FIGURE 6.7

Pavement mosaic from the triclinium, or dining room, of the House of the Dionysian Procession at El Jem. The composition of overlapping circles, with small circles at the intersections, forms curvilinear squares. The motifs are vegetal elements. The main field as well as the scrolled borders are punctuated with various figures, including representations of the four seasons, Dionysian figures, and still life elements. Early third century.

El Jem Museum.
© Cérès Éditions, Tunis.

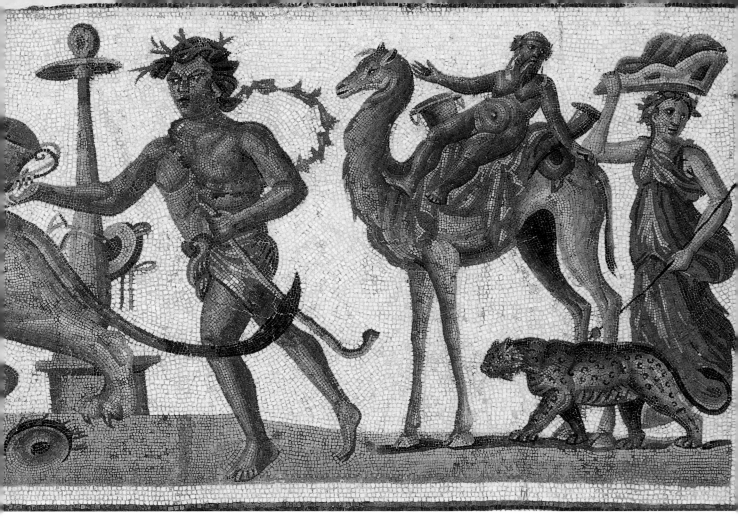

El Jem Museum

The El Jem Museum is newer than the
Sousse Museum. The bulk of its collections
derives from excavations at El Jem (ancient
Thysdrus) and its immediate environs over
some forty years. Most of the pavements
come from houses in the residential quarter
north of the museum (FIGURE 6.7). Because
the museum is so close to the site, it is possi-
ble to visualize the original settings. The
museum's mosaics have been largely restored
by teams of excellent conservators, and the
quality of their work sometimes makes it dif-
ficult to evaluate the original parts. Most of
these pavements are dated between the late
second century and the first half of the third
century, based on the history of the site.

FIGURE 6.8
Dionysian Procession mosaic from the House of the
Dionysian Procession at El Jem, depicting a procession
of the followers of Bacchus. In this mosaic, the nude
young god, his head crowned with grape leaves, rides a
lion. The god holds a krater. He is preceded by a satyr
and a bacchante playing a tambourine. Another satyr
follows, preceding a drunken Silenus mounted on a
camel. The procession ends with Mystis, Bacchus's
teacher, bearing on her head the veiled mystic basket
that holds the ceremonial phallus used in the Dionysian
rites. A panther strides into the scene from the right.
Third century.
El Jem Museum.
Photo: Bruce White, 2005.

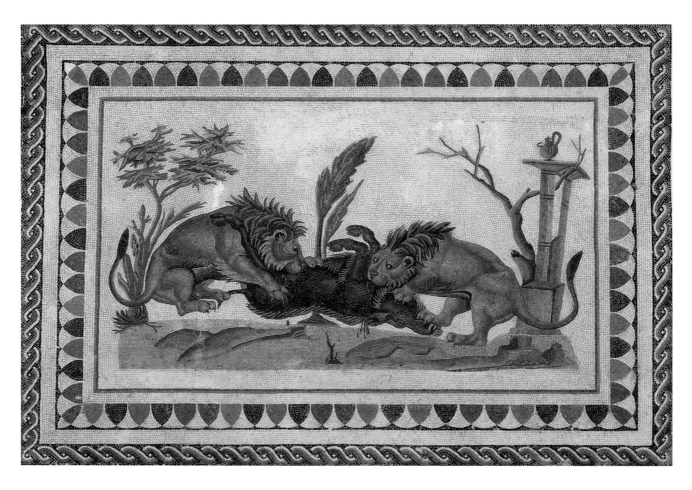

FIGURE 6.9
*Tableau from the House
of the Dionysian Proces-
sion at El Jem, depicting
an extraordinary scene
of two lions tearing apart
a boar as blood spurts
from their hapless prey.
The scene takes place in
a Hellenistic landscape.
Third century.*

El Jem Museum.
Photo: Bruce White, 2005.

Several tableaux exhibited in the museum almost appear to be paintings in stone. One of these masterpieces is a Dionysian procession discovered in 1959 in the triclinium, or dining room, of the house that is named after the theme of the mosaic—the House of the Dionysian Procession (FIGURE 6.8). The child Bacchus moves through a barren landscape (hinted at by a bare, knotty tree) astride a roaring lion, preceded and followed by satyrs. The first satyr holds a panpipe, while the second offers a krater to the god. Behind this first group is a camel bearing Silenus, the god's foster father who, as always, is depicted as bald, paunchy, and inebriated. At the head of the procession is a maenad playing a

tambourine or drum, and bringing up the rear is Mystis, Bacchus's teacher, who bears on her head the mystic basket said to contain a veil-covered phallus. One of the most important rites of the Dionysian mystery cult consisted of the revelation of the phallus—symbolizing the fertility of the earth and of men—to the initiate at the end of the initiation rites.

Two other perfectly executed tableaux come from the House of the Dionysian Procession. One portrays lions tearing apart a boar in a wooded area (FIGURE 6.9), and the other depicts a tiger assailing two wild asses in a rougher landscape (FIGURE 6.10). The spellbinding realism of the scenes in these two tableaux, the refinement of the composi-

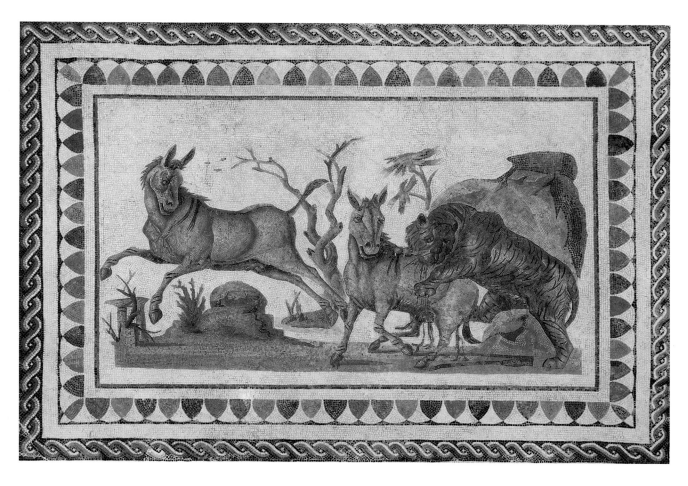

tions, the expert rendering of the animals, and the nuances of tone identify these mosaics as masterpieces of ancient art.

Another tableau from the same residence further illustrates the exceptional talent of the mosaicists who created it. This pavement represents the demigod of the year, who is surrounded by the four seasons. The central medallion is encircled by a rich laurel garland laden with fruits and flowers (FIGURE 6.11). It contains the bust of a handsome young man, crowned with fruits and plants of the four seasons. The delicacy and beauty of this mosaic are in keeping with the quality of the other tableaux from the house.

Another group of vignettes exhibited at the El Jem Museum is remarkable for the originality of its subject. This is a mosaic pavement from a triclinium in a house at El Jem, located on the land of Jilai Guirat. It is a pattern of squares surrounded by a rich laurel garland, abundantly laden with fruits, flowers, and birds. The squares are filled with chivalrous scenes, including depictions of couples—the Cyclops Polyphemus, with a single eye in the middle of his forehead, and the Nereid Galatea; Apollo and the nymph Cyrene; Apollo and Daphne; Selene discovering the beauty of the shepherd Endymion; Bacchus and Ariadne; Aurora seducing Cephalus, son of Hermes; and Poseidon and Amymone (FIGURE 6.12). These small emblemata are dated to the first half of the third century.

FIGURE 6.10

Tableau from the House of the Dionysian Procession at El Jem. In a conventional Hellenistic landscape, a scene of startling realism takes place, showing a tiger violently attacking a wild ass, while a second ass desperately attempts to flee. Third century.

El Jem Museum.
Photo: Bruce White, 2005.

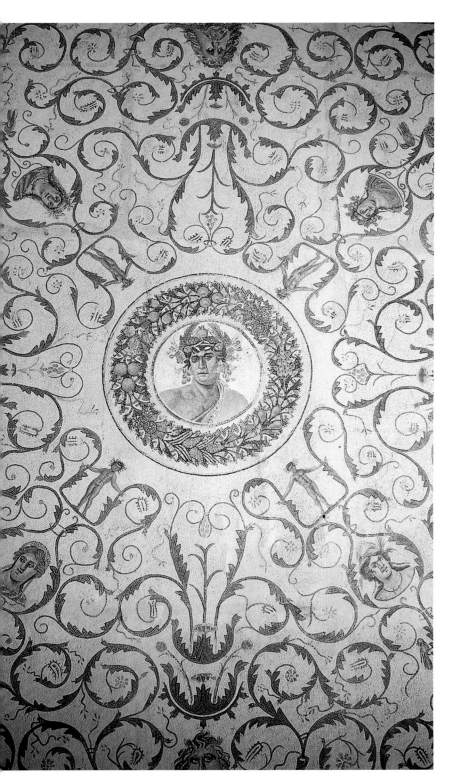

The El Jem Museum also houses a wide variety of geometric and floral mosaics, many of which have been inserted into the floors. Some are striking in their beauty and in the perfection of their composition and execution. That is the case for a mosaic pavement from the House of the Dionysian Procession. It is a composition of overlapping scales, composed alternately of a cable made of sections of rainbow and a fine garland of foliage. The connections between the scales are marked by small, tied ribbons, while each scale is decorated with a peacock feather—the eye of which the mosaicists took obvious pleasure in illustrating. This type of composition was very popular with African mosaicists, who progressively diversified and enriched it.

FIGURE 6.11

Mosaic from the House of the Dionysian Procession. This mosaic has a central medallion depicting the demigod of the year, surrounded by an intricate vegetal composition also comprising the four seasons. The bust of the demigod is encircled by a lavish laurel crown laden with fruits and flowers. The demigod, depicted as a young man, is crowned with flowers and fruits of the four seasons. Third century.

El Jem Museum.
Photo: INP.

FIGURES 6.12 (OPPOSITE)

Fragment of a mosaic from a house at El Jem. In a pattern of squares delimited by a rich laurel garland, chivalrous scenes unfold. The first scene shows a haloed, partially nude Selene admiring the delicate beauty of the sleeping shepherd Endymion, with whom she falls madly in love. The second, very damaged tableau shows a scene of the Cyclops Polyphemus, recognizable from the single eye in the middle of his forehead, playing the lyre to seduce the Nereid Galatea. The third tableau shows Ariadne unveiled by Bacchus, and the last scene of seduction shows Poseidon and Amymone. Third century.

El Jem Museum.
Photo: Bruce White, 2005.

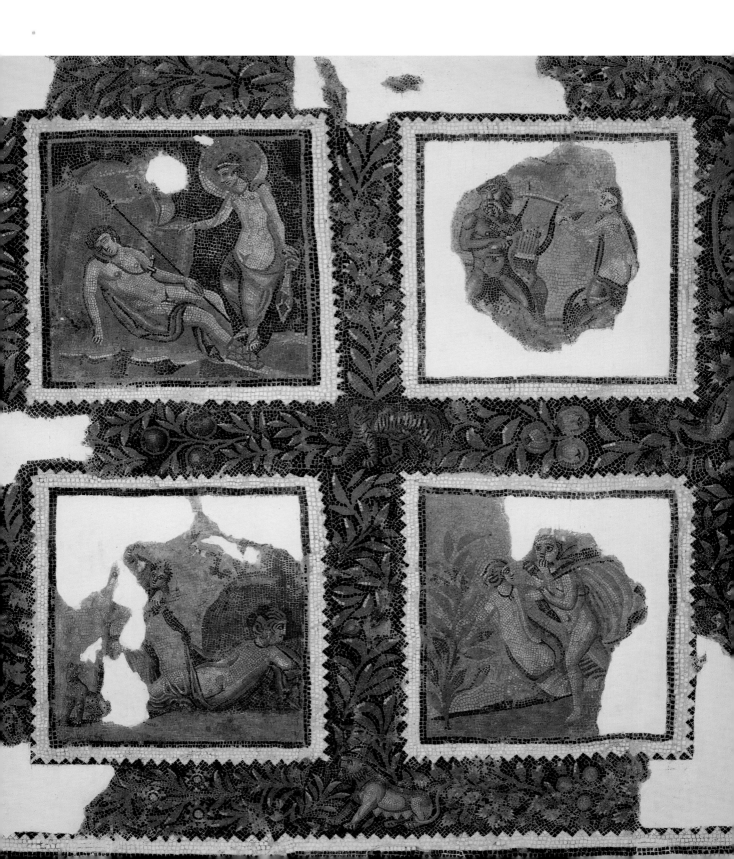

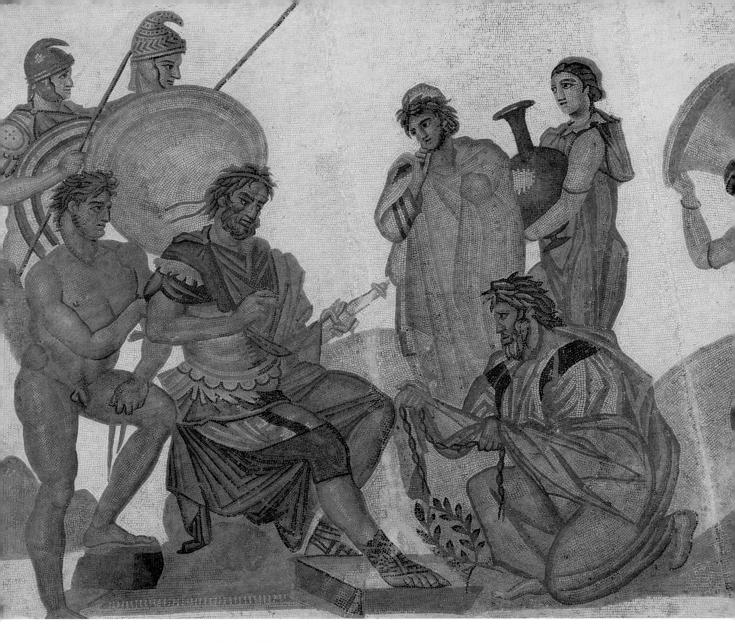

FIGURE 6.13

Tableau from the House of the Nymphs at Nabeul, depicting a priest of Apollo, Chryses, kneeling in supplication before King Agamemnon, who holds his daughter captive. The scene unfolds in the presence of Achilles, represented nude behind Agamemnon, and of servants bearing offerings. Fourth century.

Nabeul Museum.
Photo: Bruce White, 2005.

The Nabeul Museum

The Nabeul Museum is a regional museum of the type that Tunisia is promoting in order to decentralize the collection and display of antiquities throughout the country. Nabeul, one of the large towns on Tunisia's Cap Bon peninsula, was founded in early antiquity. The museum's collections primarily come from excavations of the site (ancient Neapolis) and its environs. The mosaics displayed there include an exceptional group found when the House of the Nymphs was cleared at the site. This resi-

dence, Romano-African in design, was built around a peristyle surrounding a garden. The various spaces that open onto the arcades of the peristyle mostly had polychrome geometric pavements, but some rooms contained figurative mosaics. These mosaics—now housed in the museum—came from rooms that open onto the east arcade of the peristyle. The panels depict mythological events from the Trojan War. The cycle begins with the arrival of Chryses, priest of Apollo, to beg King Agamemnon

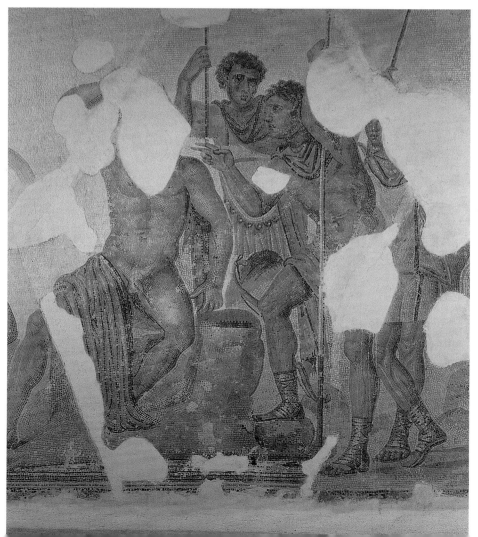

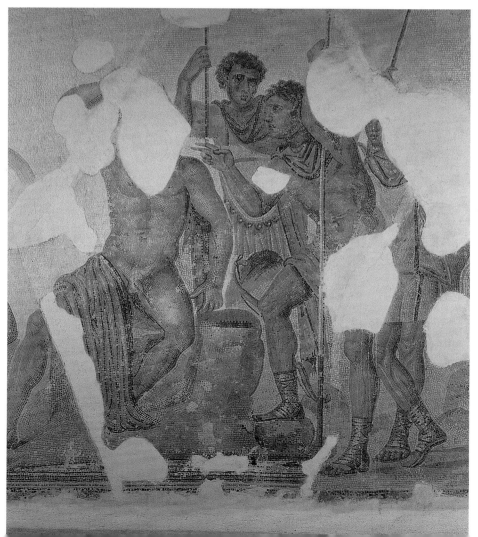

FIGURE 6.14

Tableau from the House of the Nymphs at Nabeul. The mythological hero Philoctetes is shown receiving a Greek delegation during the Trojan War. Philoctetes had suffered a snakebite on the foot, and the Greeks, on their way to lay siege to Troy, abandoned him on the island of Lemnos. They returned to plead with him to join them after the oracle predicted that his arrows would bring them victory. Fourth century.

Nabeul Museum.
© Cérès Éditions, Tunis.

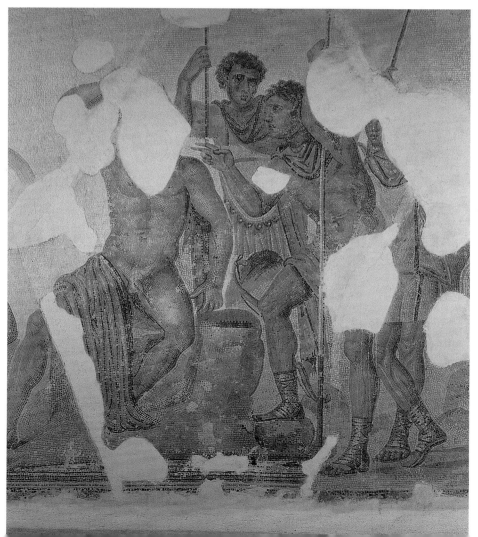

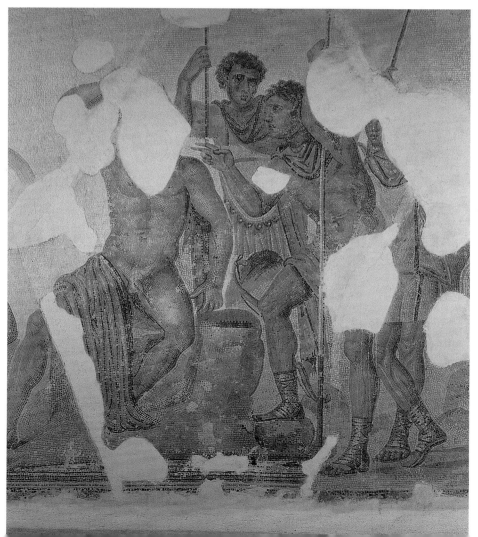

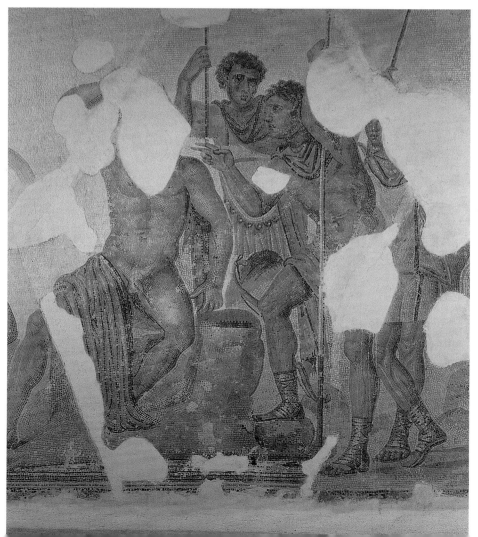

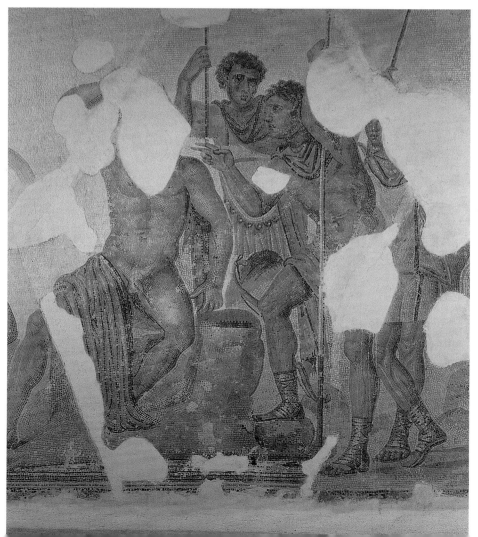

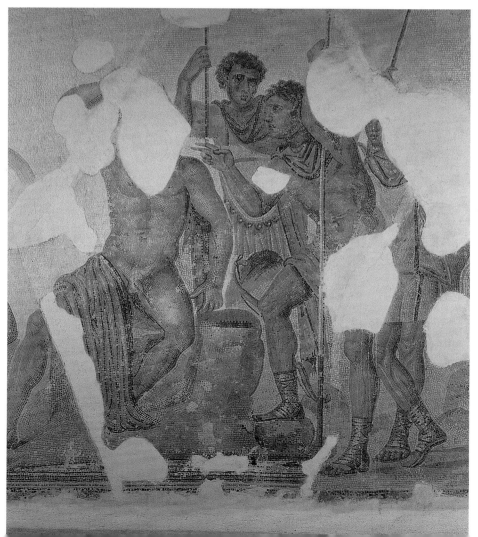

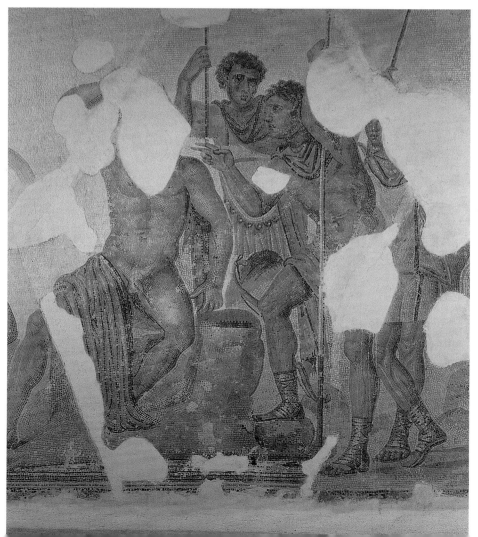

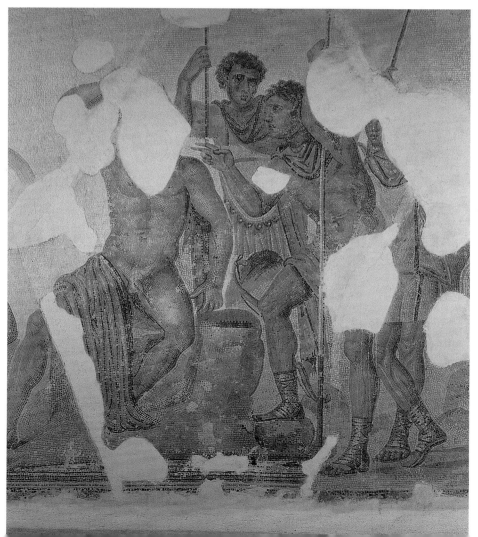

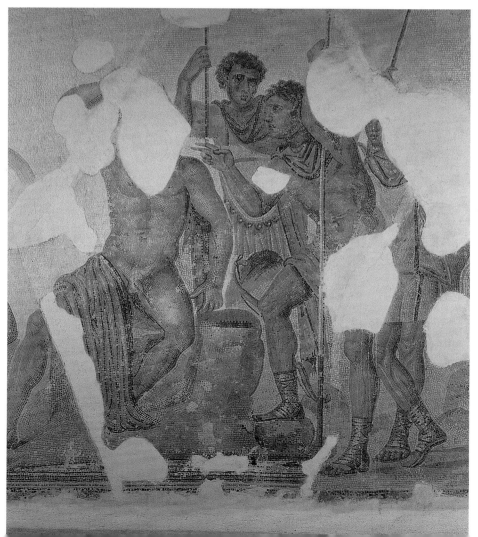

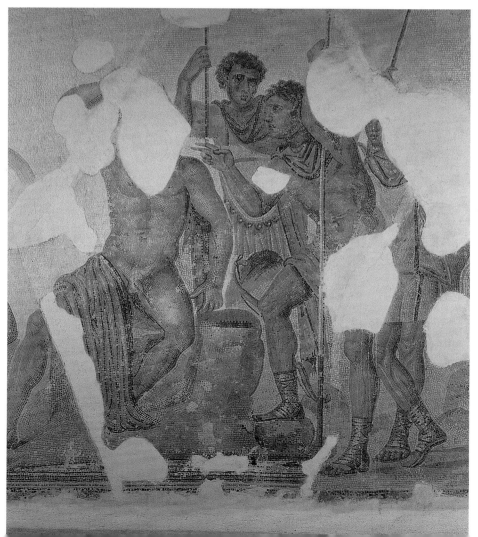

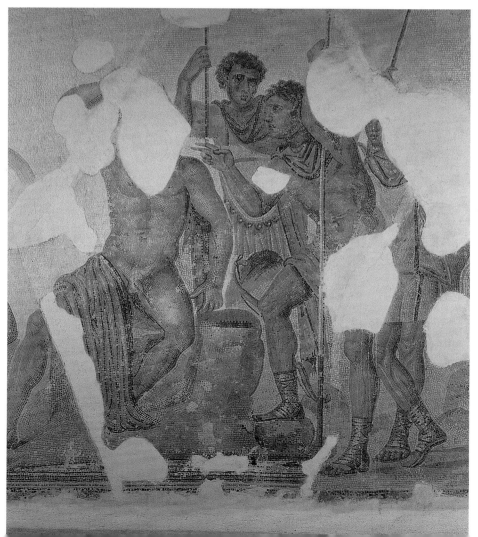

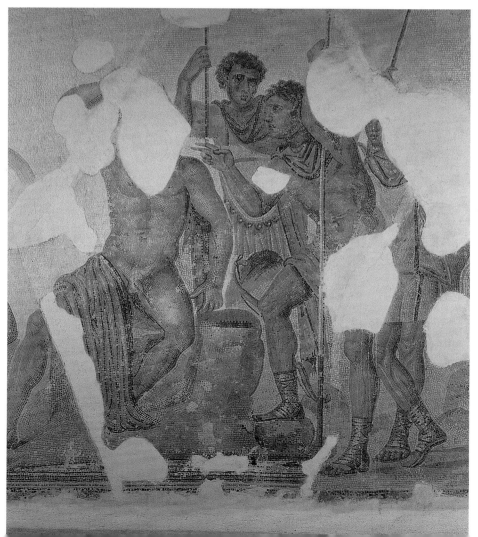

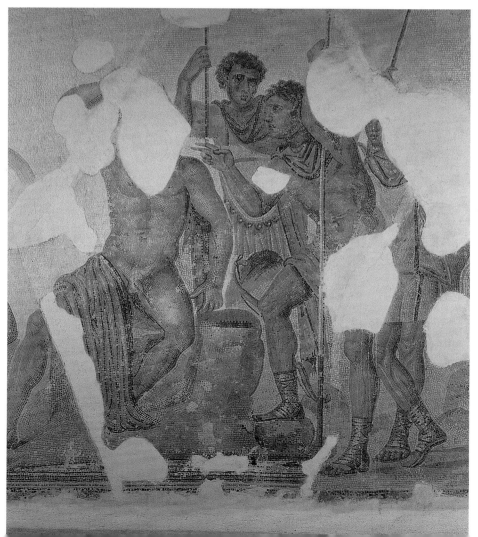

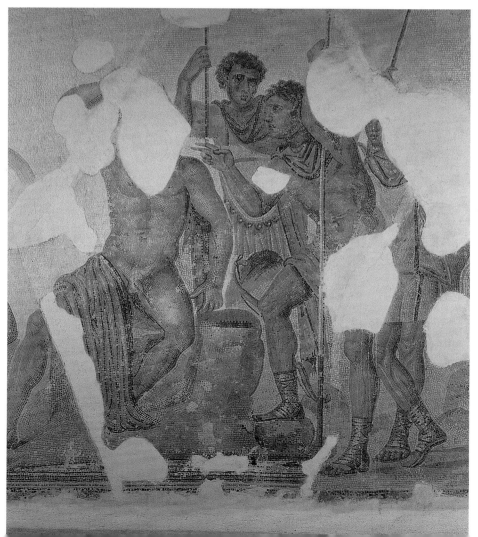

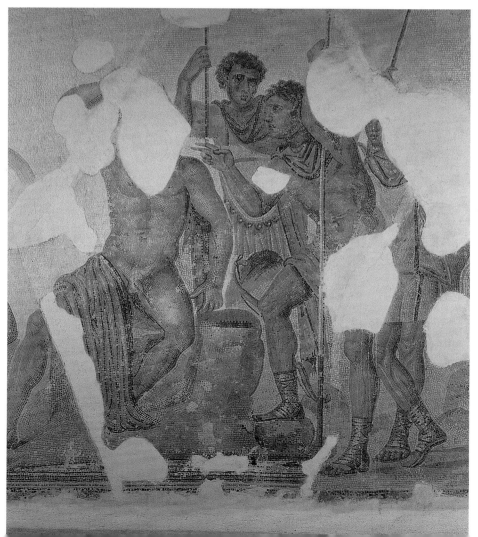

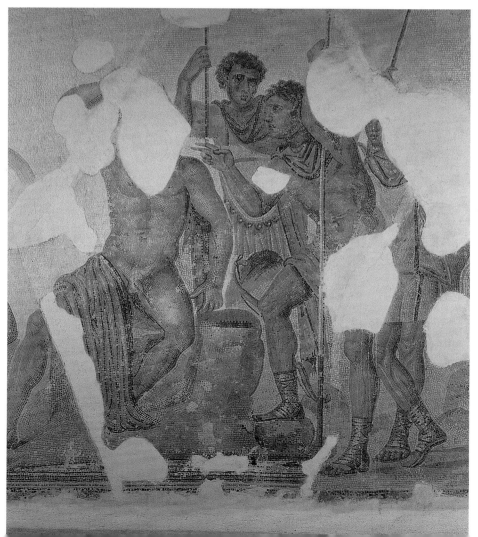

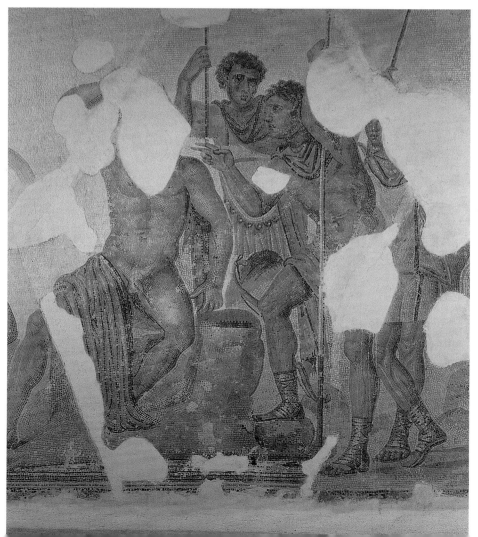

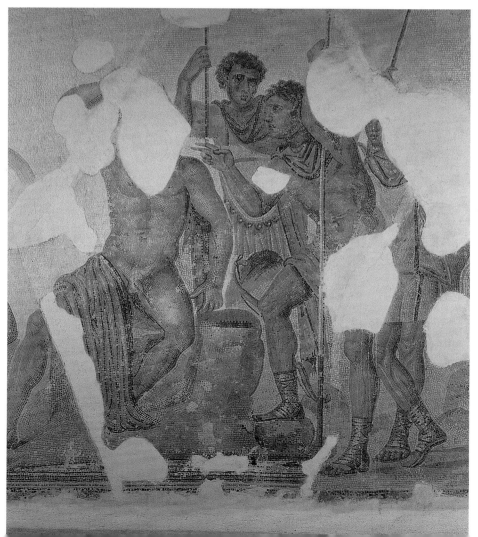

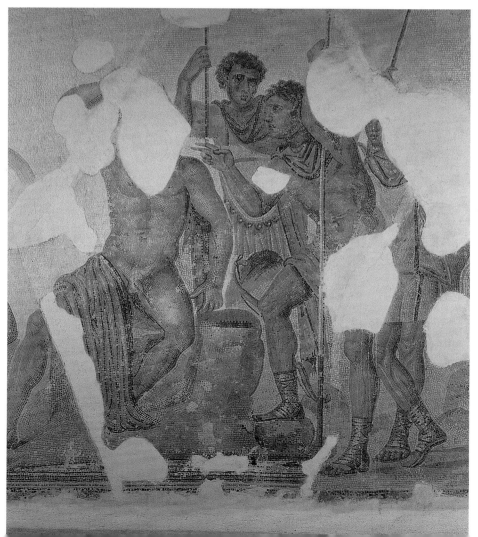

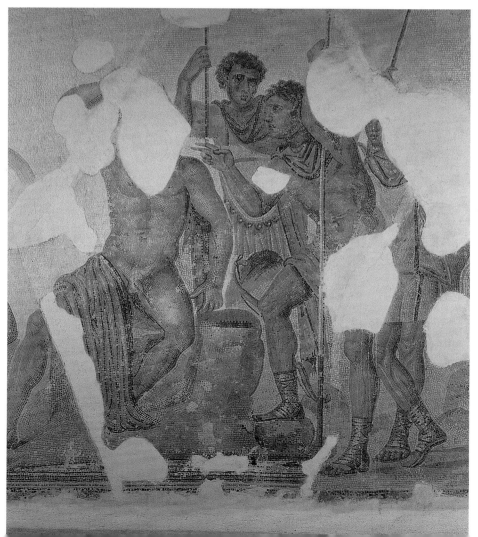

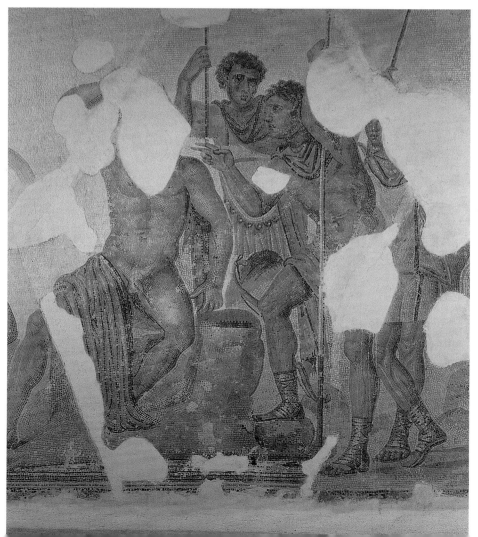

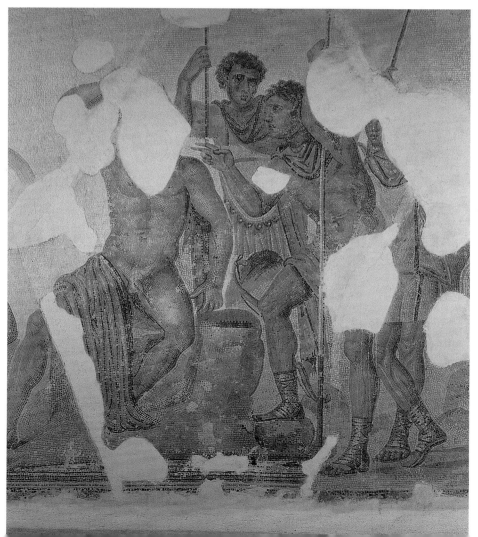

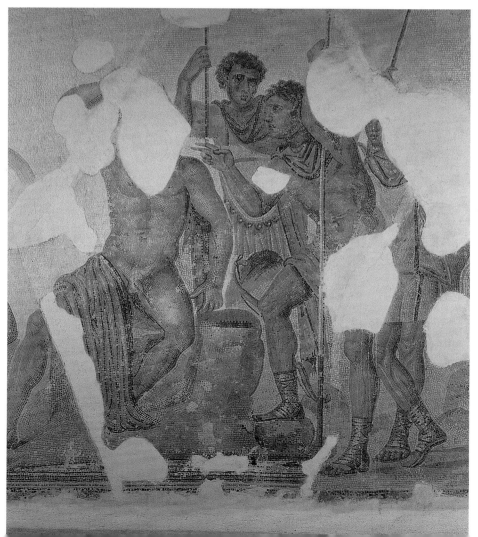

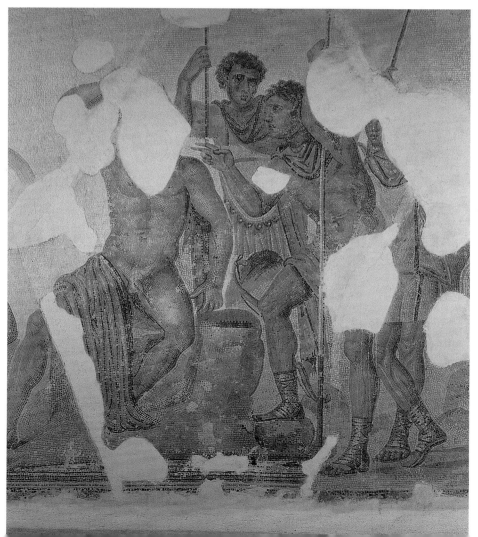

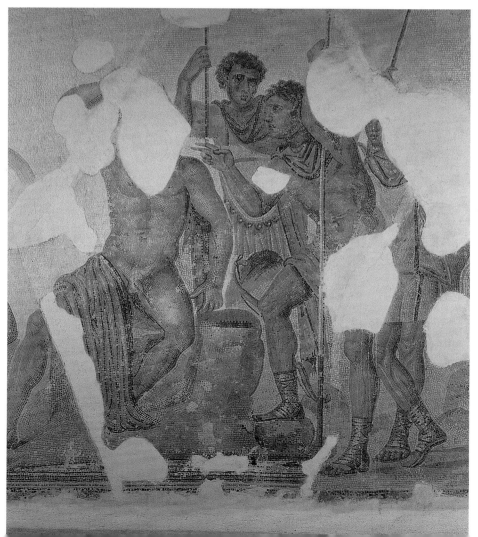

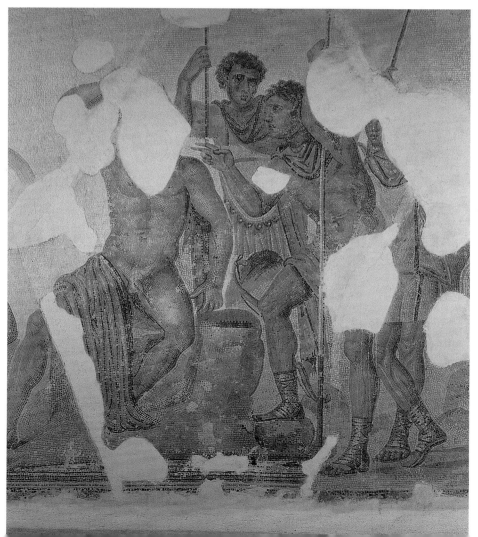

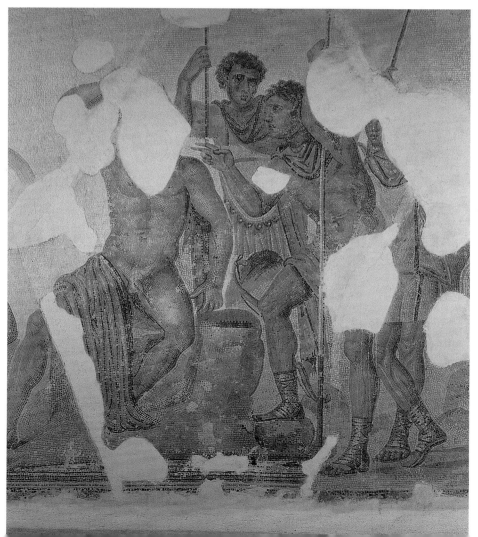

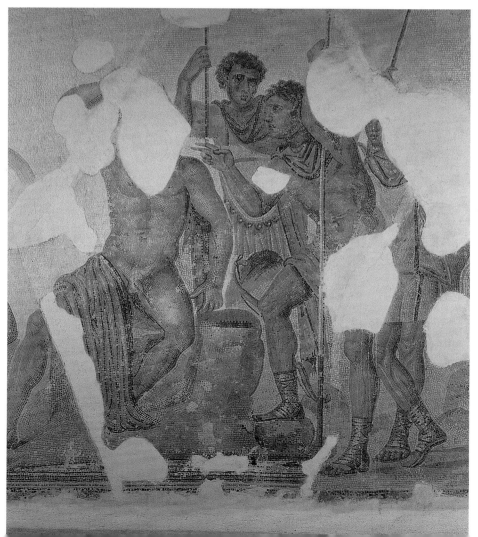

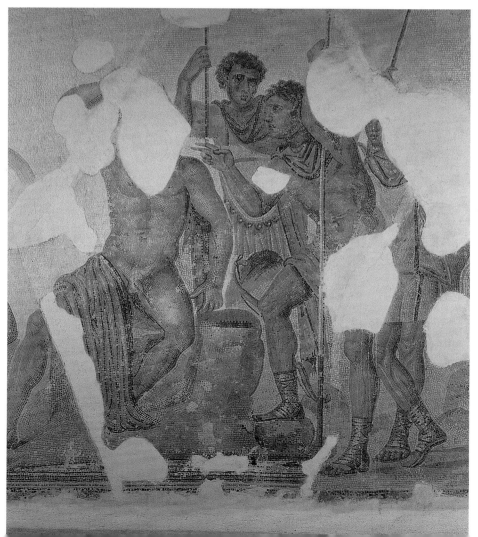

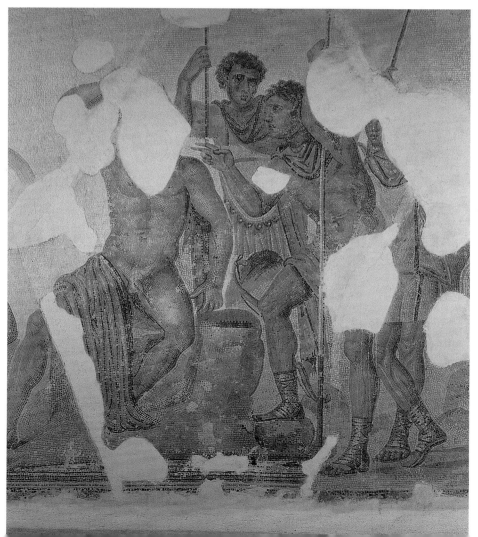

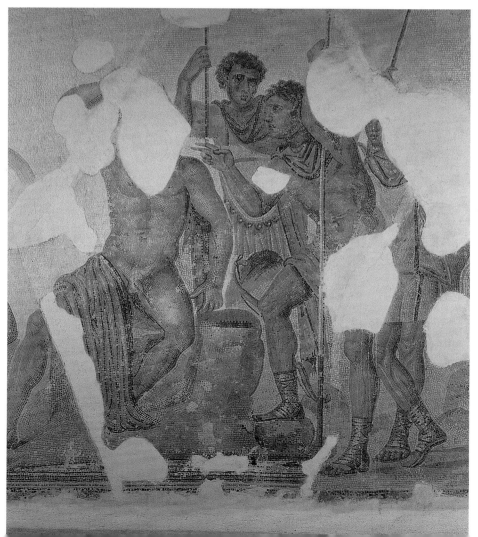

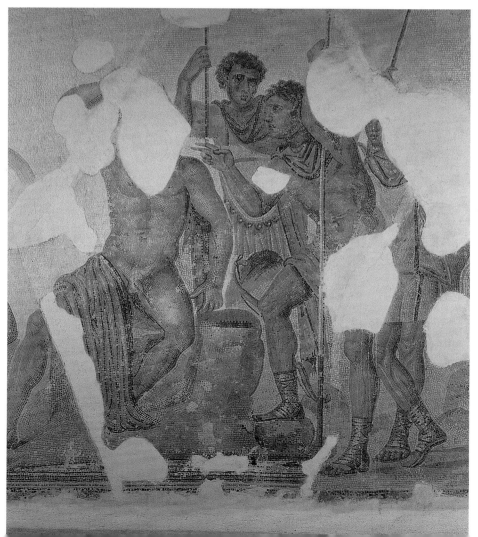

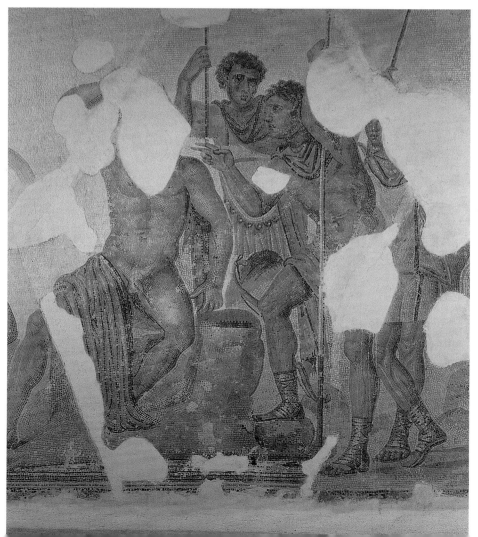

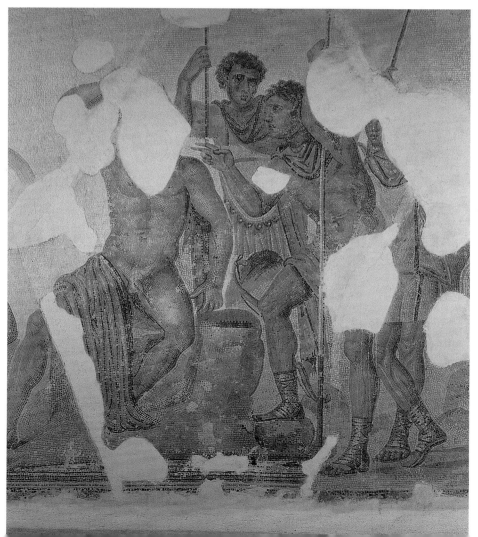

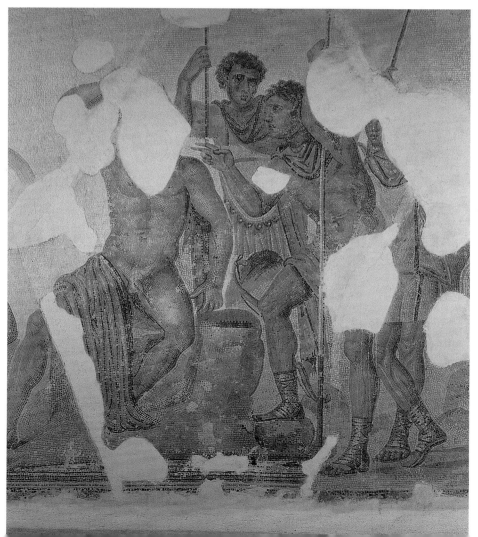

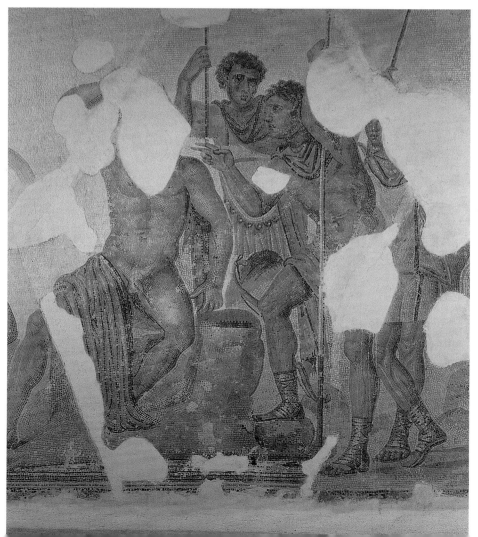

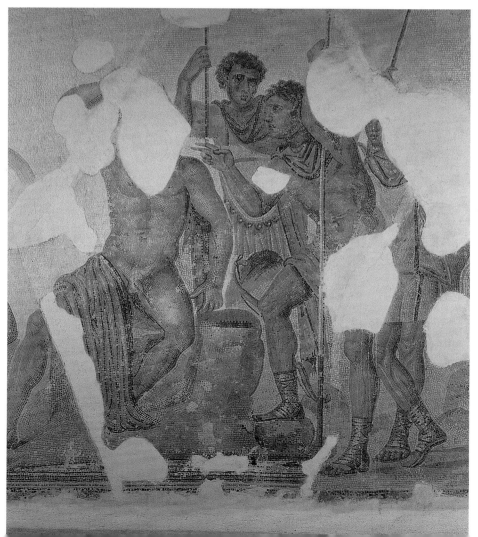

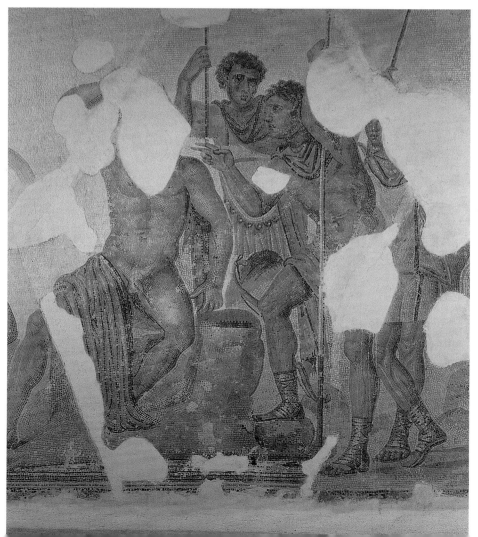

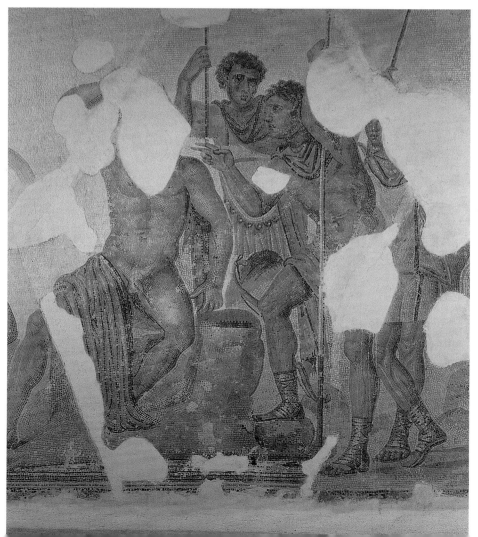

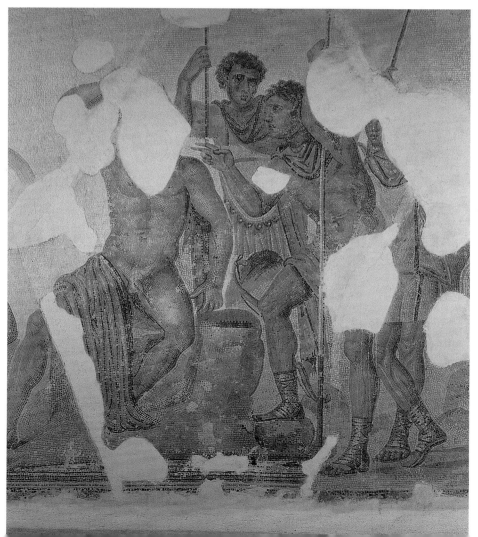

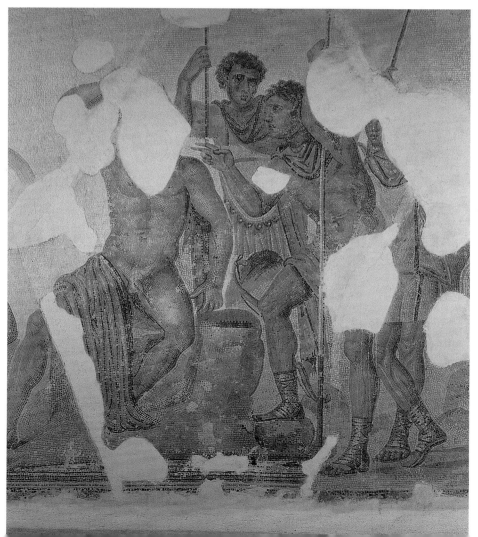

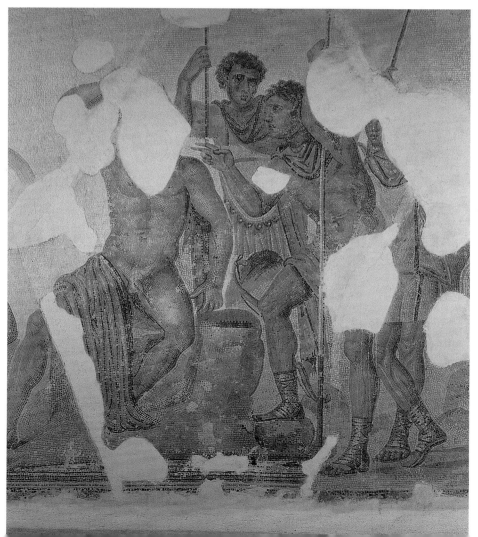

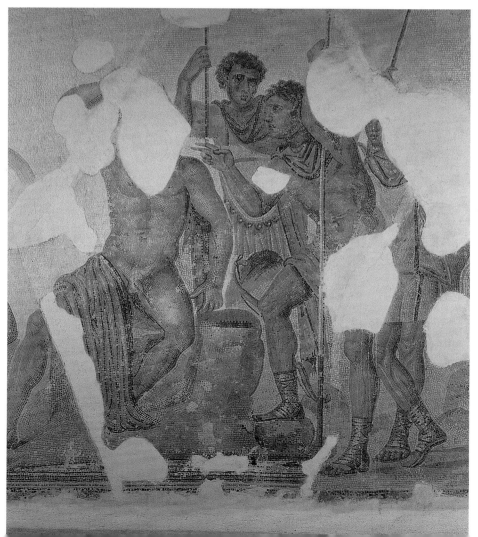

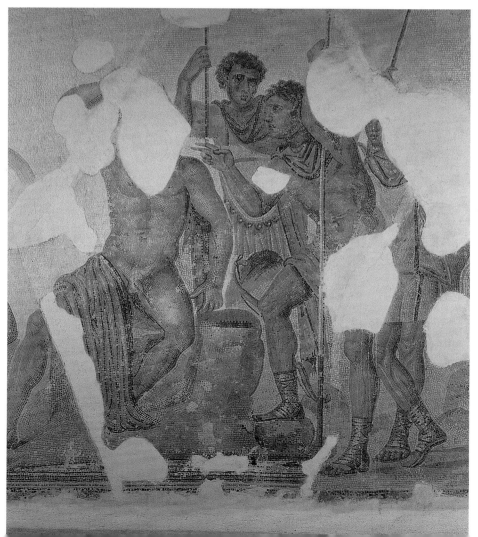

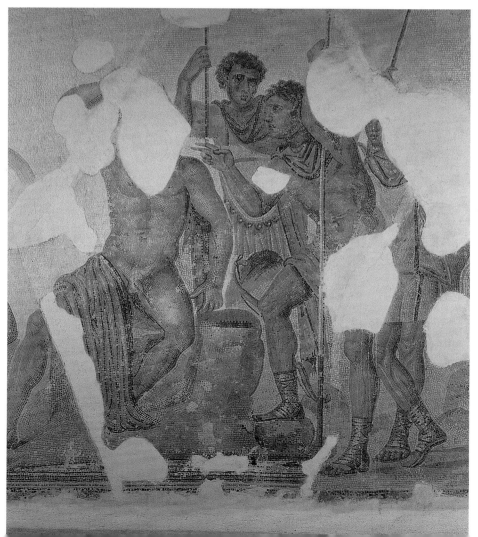

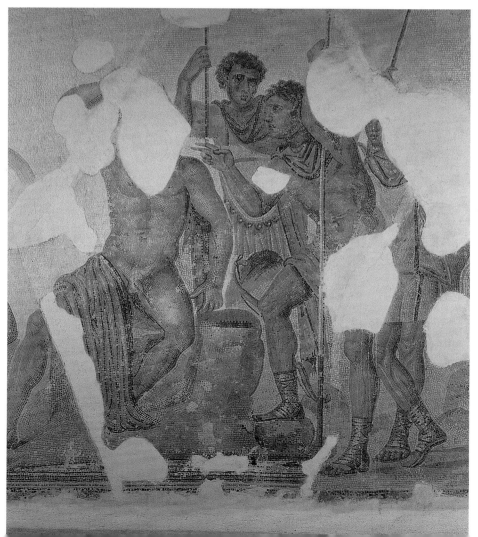

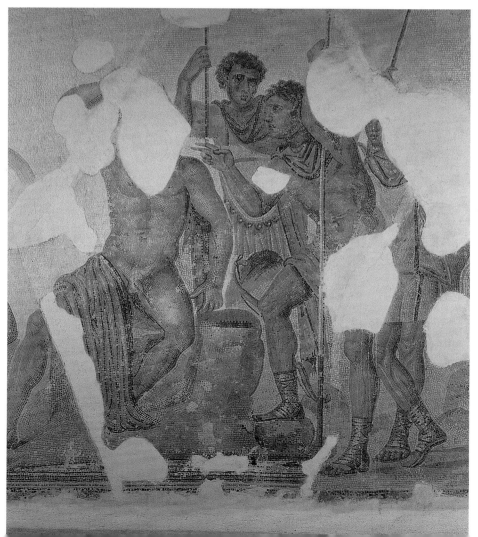

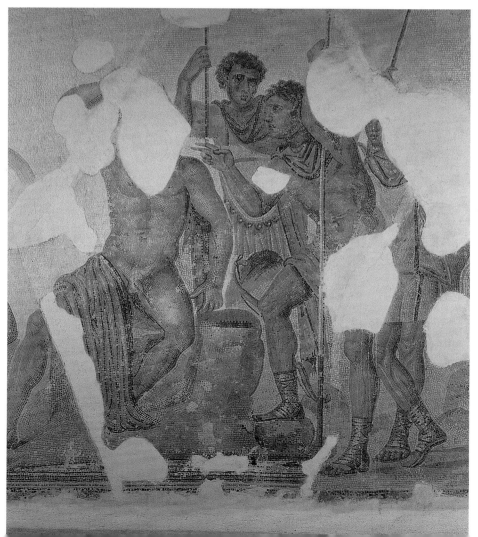

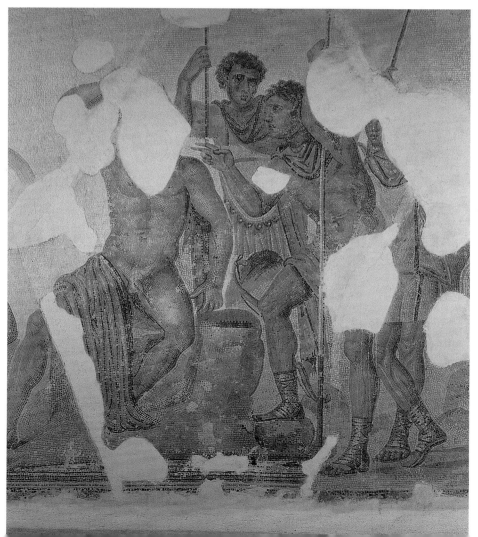

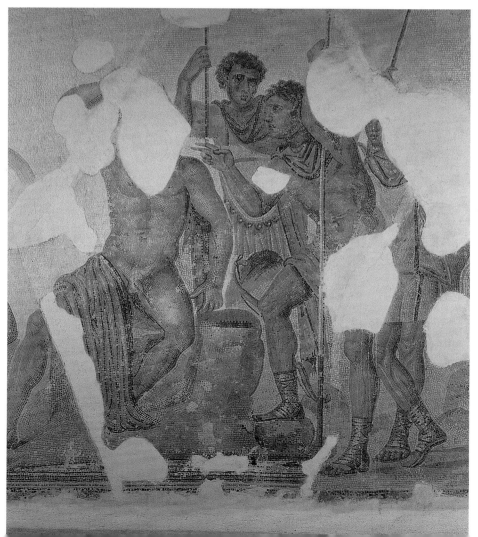

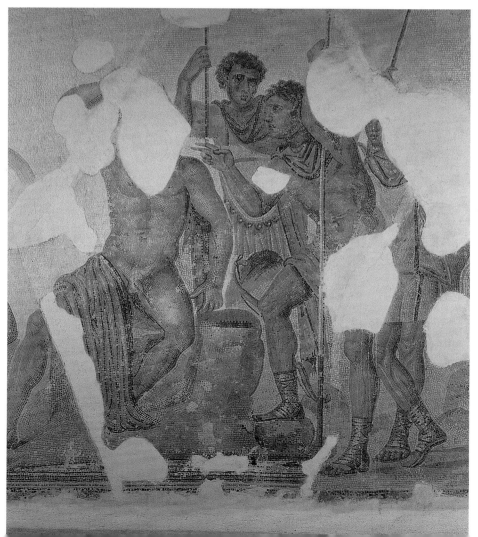

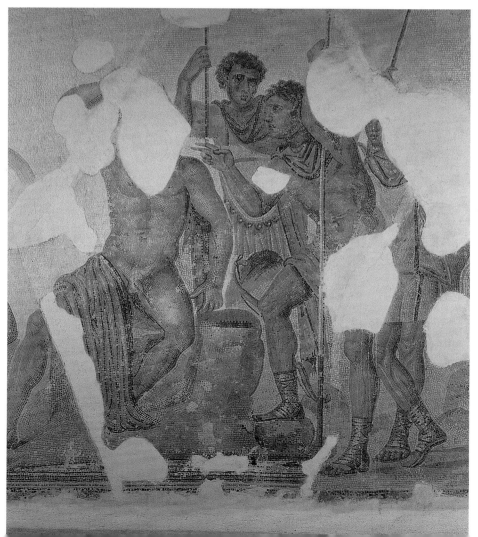

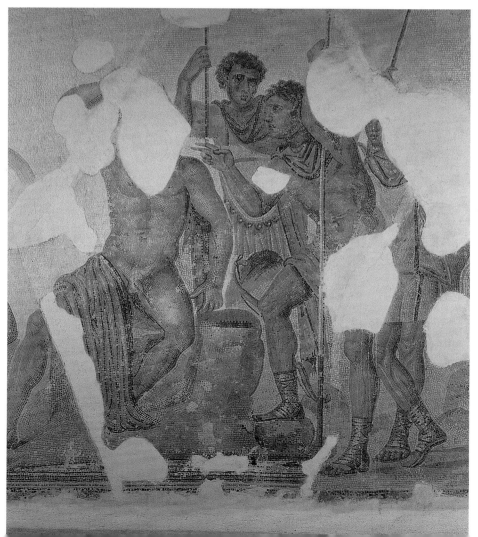

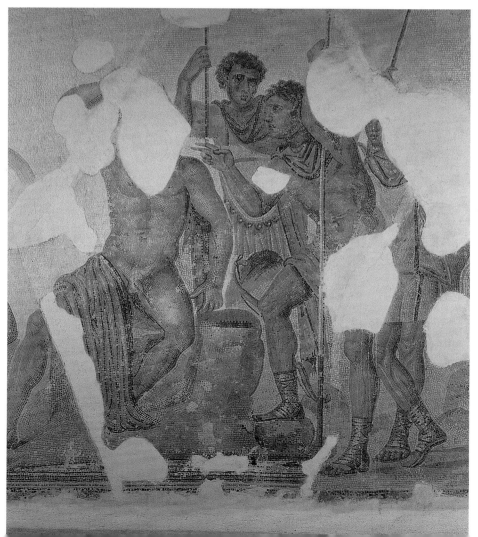

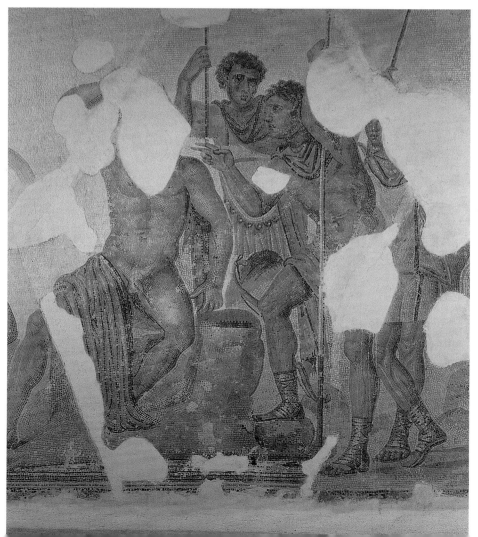

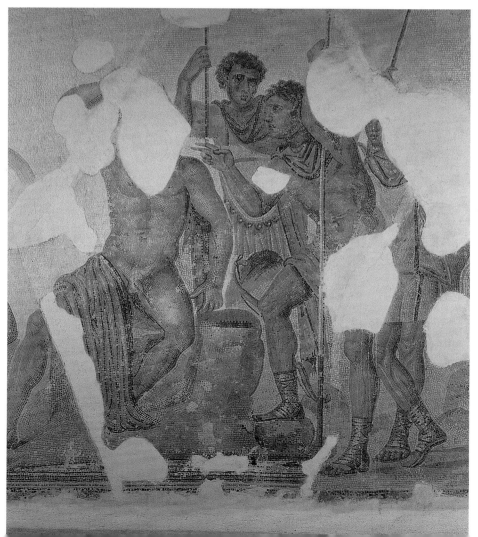

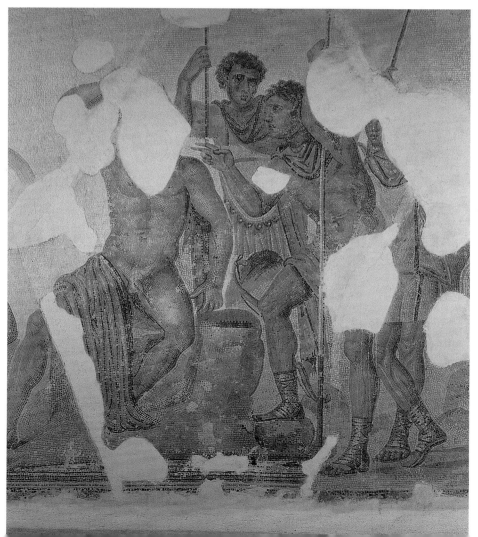

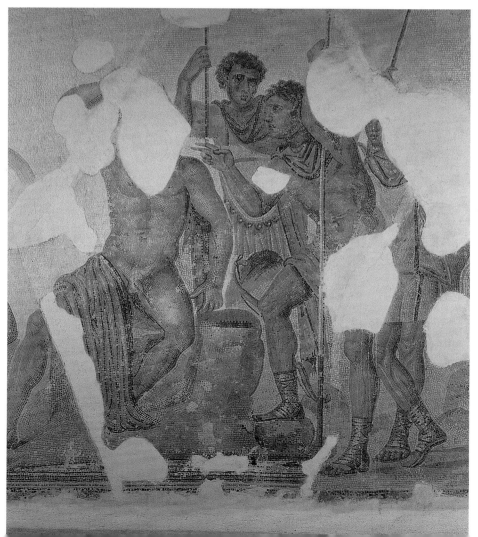

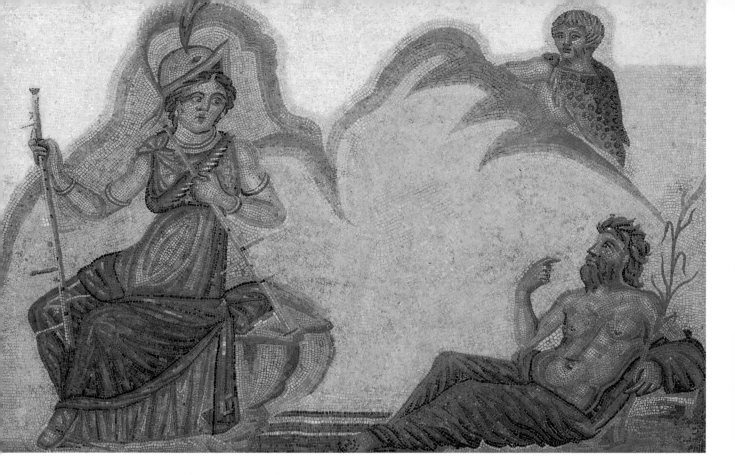

FIGURE 6.15

*Mosaic from a house
at Kélibia. The fourth-
century mosaic depicts
the first episode of the
myth of Marsyas, the
satyr who dared chal-
lenge the god Apollo and
was condemned to be
flayed alive. This tableau
depicts the goddess
Athena, gazing at herself
in the river, which is
represented by the old
man seated on the
ground. The satyr
Marsyas is shown
behind the hill, taking
the goddess by surprise
at an intimate moment
and thus incurring her
wrath. Fourth century.*

Nabeul Museum.
Photo: Bruce White, 2005.

for the release of his daughter Chryseis, a Greek captive (FIGURE 6.13). The tableau illustrating this episode depicts Agamemnon seated, dressed in military array, his brow encircled by the royal diadem. He looks attentively at Chryses, kneeling before him in a posture of supplication, after placing his laurel crown on the ground. Behind the Greek king is Achilles, in heroic nudity, watching the scene intently, as well as two helmeted soldiers equipped with shields and lances. Behind Chryses, Ulysses is recognizable by his cap. Servants, laden with gifts for the Greek king, arrive from the right.

The series of mosaics from the House of the Nymphs at Nabeul forms a significant part of the entire group of mosaics that illustrate the culture of the African elite in the third to fourth centuries. The mosaics of the games from Carthage, the Horse mosaic from the House of the Horses at Carthage (SEE FIGURE 4.9), the portraits of the poet and actor from Sousse (SEE FIGURE 6.4), and, especially, the portrait of Virgil (SEE FIGURE 5.17)

demonstrate that the African bourgeoisie possessed a classical culture that it enjoyed displaying, in the form of these impressive mosaics, for the enjoyment of guests.

A second tableau from the House of the Nymphs at Nabeul recounts events that took place much later, after the deaths of Achilles and Hector, when an oracle predicted a Greek victory over Troy, on condition that Philoctetes, left behind on the island of Lemnos after receiving a snakebite on the foot, return to fight with the bow and quiver bequeathed to him by Hercules. Ulysses, accompanied by companions, goes to persuade Philoctetes to return. This very damaged scene shows Philoctetes seated on a rock, his injured foot concealed under a fold of his mantle, listening to the young man who speaks animatedly and appears to be the spokesman for the delegation (FIGURE 6.14).

Two other panels come from the same residence. They were found in an apartment relatively removed from the center of the house. The first, which is somewhat damaged,

depicts a mythological scene showing the abduction of the nymph Amymone by Neptune. The god of the seas, identifiable by his trident, seizes the beautiful girl, who attempts to escape, under the complicit gaze of a river god (partially destroyed). The second panel represents the winged horse Pegasus, who, with one kick of his hoof, caused the spring of Hippocrene to flow. The tableau shows Pegasus raising his hoof to strike the ground, as a partially nude girl emerges from the fountain. These tableaux from a residence whose mosaics date to the fourth century are a striking illustration both of the breadth of the classical culture of those who commissioned figurative tableaux and of the mosaicists' sophistication and knowledge of the repertoire of conventional classical imagery. These panels also indicate the existence of a social stratum learned enough to easily interpret these complex images.

This supposition is corroborated by another figurative mosaic at the Nabeul Museum that comes from a house in Kélibia,

at the tip of the Cap Bon peninsula. This tableau depicts an episode from the adventure of the virgin goddess Athena with the Phrygian satyr Marsyas. The tableau portrays a helmeted Athena, seated on a rock, preparing to play a double flute while looking at herself in a river, which is represented by a reclining old man (FIGURE 6.15). Behind the hills that form the landscape, Marsyas appears, appropriately dressed in a leopard skin, incurring the wrath of the goddess for taking her by surprise. The style of this mosaic dates it to the fourth century. There are several African mosaic tableaux illustrating the myth of Marsyas, the musician satyr, who even challenged the god Apollo to a contest, judged by Athena. He lost the contest and was condemned to be hanged and flayed alive (a mosaic from Dougga shows the main episodes of this cycle). Another mosaic in the Nabeul Museum shows two roosters and a vase filled with gold, a theme often treated in mosaic scenes (FIGURE 6.16).

FIGURE 6.16
Pavement mosaic from the House of the Nymphs at Nabeul. The tableau depicts two roosters, face-to-face, pecking in an amphora filled with pieces of gold. This image represents a wish for luck and fortune. It was placed at the threshold to invite prosperity into the home. Fourth century.

Nabeul Museum.
Photo: Elsa Bourguignon, 2004.

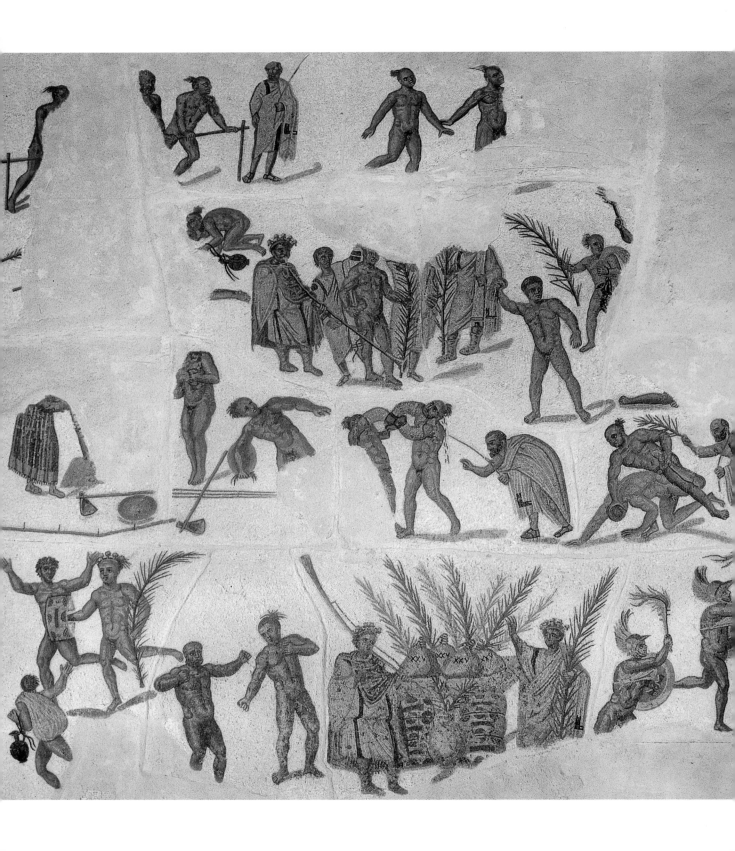

Gafsa Museum

Some of the museums that display mosaics were designed to house a few pavements, as is the case for the small Gafsa Museum. The discovery of Roman baths at Talh, in the vicinity of the city, revealed a frigidarium decorated with a highly original mosaic that depicts athletic games and boxing (FIGURES 6.17A AND 6.17B). Despite extensive damage, this mosaic, which can be seen almost as a "sportscast," is composed of four registers that depict different contests in the competitions. The tableau also comprises two ceremonial scenes. One, in the middle of the fourth register, shows the combat-sport crowns, palms, and money bags to be awarded to the winners. The second scene, in the middle of the second register, shows the crowning of the winning athletes. This extraordinary mosaic, which is dated to the late third or early fourth century, provides a wealth of information about games that was previously known only through written documents.

FIGURES 6.17A AND 6.17B
Mosaic of the Talh games in the region of Gafsa. These scenes of competition and of distribution of prizes are divided into four registers. At the top left are three athletes wearing hairpieces (which establishes them as professionals), waiting behind a bar, ready to run at the signal from the referee, who holds a baton. The scene at the top shows the race itself. The center of the second register shows a scene in which prizes are distributed to the winning athletes. At the left of the third register is a scene depicting the long jump, followed by an athlete about to throw a discus. In the middle, a boxing match is taking place under the watchful eye of the judge. On the right is a wrestling scene, with two athletes in a hold, under the supervision of a referee (6.17B). The lower register shows two other competitions: the pancratium, which combines elements of boxing and wrestling, and a torch race, as well as a parading winner bearing a wreath in one hand and a palm in the other. In the center of the register are many wreaths, money bags with amounts written on them, and palms, intended for the winners. Early fourth century.

Gafsa Museum.
Photo: INP.

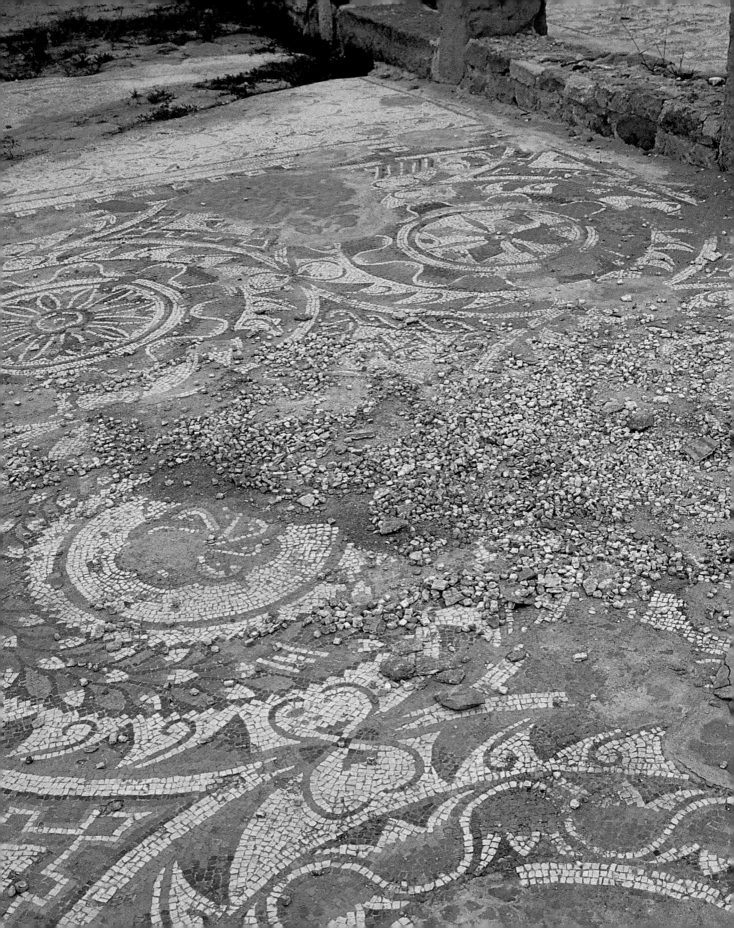

PRESERVING THE MOSAIC HERITAGE

Considered for centuries to be a minor art form, valuable solely for the adornment of museums with collections of ancient art — and then primarily only when the works depicted figurative scenes — mosaics are now considered to be of much greater consequence. In fact, the aesthetic aspect of a mosaic is just one of several areas of interest for scholars and other viewers.

FIGURE 7.1
Decaying tesserae.
Photo: Elsa Bourguignon, 2003.

Mosaic pavements are now seen to possess important archaeological as well as architectural and historical meanings.

The mosaic pavement takes on its full significance when viewed in its original setting. Each work illuminates the often-complex history of the space in which it was found and bears witness to the mastery of stonecutting and fitting techniques that are anything but simple. These works also reveal the characteristics, styles, and tastes of societies that lived many centuries ago. The geometric and floral pavements that form the bulk of this mosaic treasure—for decades considered secondary in importance to the figurative tableaux—are now valued as essential documents for the study of the evolution of the various mosaic styles and schools. They are especially useful for establishing chronology, for example, which enhances our understanding of mosaic art in general.

Cultural tourism is increasingly considered an important vehicle for emphasizing the value of our cultural heritage. For several years, cultural heritage professionals have used mosaic pavements to attract a variety of audiences who are interested to see the works themselves and to learn more about the past. The effects of cultural tourism and the impact of visitors have taught us about the fragility of mosaics and have encouraged us to expand scientific research in order to determine the best methods for conserving and preserving these assets. Professionals in the field then implement appropriate methods and train various participants in effective conservation practices. This approach is spreading rapidly throughout the countries of the Mediterranean—the cradle and favored site for the development of the technique and the art of the mosaic in antiquity and the Middle Ages.

Tunisia is fully involved in the process of discovery and enhancement of ancient mosaics. Beyond that, it is growing in its understanding of the many values inherent in the thousands of mosaic pavements that have already been discovered on its soil over the past century and longer. This understanding has led Tunisia to implement an entire process of scientific study, conservation, public awareness, and exhibition of the vast numbers of mosaic floors distributed throughout the country.

For more than a century, as we have seen, the mosaics that have been unearthed—especially the figurative ones—have served to enrich the collections of museums of ancient art. Geometric and floral mosaics have largely been left in situ, abandoned to the ravages of weather and time, with no form of protection (FIGURE 7.1). In the nineteenth and the first half of the twentieth century, figurative mosaics were removed through empirically developed and expedient methods. Once the decision to remove them was made by the archaeologists (or even by the foremen) in charge of the sites, the pavements were carefully cleaned to eliminate even the slightest trace of dirt, with hard, often metal brushes. The second operation consisted of covering the mosaic surfaces with heavy-duty cloth entirely covered with a strong vegetable-based adhesive. They were then arbitrarily cut into panels of a manageable size. The cloth that was bonded to the pavement surface dried in only a few hours. Once this operation was completed, the tesserae were detached from their original support. The tesserae were manually pried from the mortar with a flat metal bar inserted under them until the tesserae and bedding were fully separated. The panels were then removed and cleaned of the remnants of the foundations that still adhered to the backs of the tesserae. New supports were made from plaster and jute on a wooden armature. Finally, the mosaic panels

Training to Preserve Mosaics In Situ

by Thomas Roby

FIGURE 7.2
Loss of tesserae and growth of vegetation leading to further detachment of tesserae.
Photo: Elsa Bourguignon, 2004.

Over the course of the last century, archaeological excavations have revealed thousands of mosaic pavements from classical antiquity. Mosaics were an integral part of a wide variety of ancient architecture—from Roman bath buildings and villas to Byzantine churches—and their decorative surfaces of stone and glass tesserae are important artistic documents for experiencing and understanding the history, religion, and aesthetics of the ancient world. While excavation has brought the mosaics back to public awareness, it has also removed the soil and debris that had generally provided a protective covering for them over the centuries. Once reexposed, and without the protection of ancient walls and roofs, the mosaic pavements are subject to a range of destructive environmental forces and conditions, such as rain, sun, frost, groundwater, and the growth of vegetation, as well as human abuse and misuse. The results of years of exposure are rapid deterioration and eventual loss—first of the tesserae surface and then of the lime mortar foundation of the mosaic (FIGURE 7.2).

In recent decades, archaeologists and conservators have increasingly recognized the importance of conserving mosaics as whole pavements in their original architectural surroundings, in order to enhance the preservation of their cultural values and authenticity. Preservation of mosaics in situ, however, requires a new approach to archaeological sites. Such an approach will recognize sites not only as resources for current archaeological research (as well as potentially for museum collections) but also as finite cultural resources that derive their value from their locations in the landscape and that can benefit both the visiting public and the surrounding community.

Part of the new approach to conserving mosaics in situ, and sites in general, involves training and employing people to manage and maintain a site on a daily basis. The Getty Conservation Institute, together with the Institut National du Patrimoine of Tunisia, has taken on the challenge of providing training in both of these areas, starting in 1998 with the training of maintenance technicians for mosaics in situ. This training program was developed to include both practical and theoretical instruction, with an emphasis on the use of locally available materials and technologies. The trainees are given instruction on how to document mosaics and their condition, in graphic, photographic, and written form (FIGURE 7.3). Then they are instructed in how to program and carry out specific regular maintenance operations, as well as document their own treatment work as they do it. Work experience is provided at different sites and on different types of mosaic pavements, including those made of marble plaques (opus sectile) rather than small cubes (opus tessellatum). Each trainee is provided with

FIGURE 7.3
An important step in the mosaic maintenance process is to document the condition of mosaics before and after mainte-nance treatments. Trainees are taught to assess and document var-ious conditions, including the location of lacunae and detached tesserae, as well as the presence of vegetation. These condi-tion records are used to plan treatments and are then referenced during subsequent inspections to check the continued effec-tiveness of the treatments.
Photo: Elsa Bourguignon, 2004.

FIGURE 7.4
In addition to their prin-cipal activity—mainte-nance on some of the long-exposed, deterio-rated mosaics—mainte-nance technicians have carried out reburial oper-ations on selected mosaics to protect them until conservation treatment is possible.
Photo: Elsa Bourguignon, 2003.

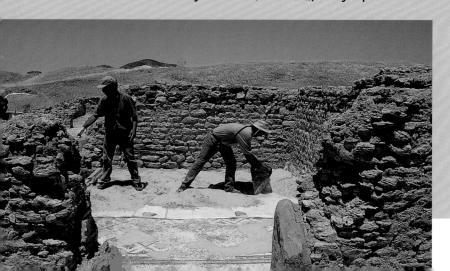

the documentation and treatment tools and equipment needed to carry out the maintenance work autonomously at any given site, under the direction of the site supervisor or director.

The goal of the program is to assure that the maintenance technicians' work becomes an integral part of an overall site management plan. Such a plan, among many other things, would iden-tify the mosaics that are to be protected by reburial (FIGURE 7.4), or by a permanent

shelter, as well as those that are to be covered seasonally and those that will be left unprotected. Regardless of the intervention chosen, subsequent main-tenance will be required; the amount needed will relate to the degree of pro-tection provided.

The work of the technicians has produced dramatic results at several important sites, such as Thuburbo Majus, Jebel Oust, and Nabeul (ancient Neapolis), by revealing again mosaics that had been covered by wind-blown soil, moss, algae, and lichen since their excavation decades earlier. The intricate and richly polychromatic geometric motifs of the peristyle mosaics of the House of Neptune at Thuburbo Majus and the House of the Nymphs at Nabeul are again visible (FIGURES 7.5 AND 7.6).

Once a mosaic has been cleaned, the technicians can carry out stabilization treatments with lime-based mortars, which are critical to the long-term sur-vival of the mosaics (FIGURE 7.7). Only after several cycles of maintenance have been completed—consisting of regular moni-toring of conditions as well as limited but regular cleaning and mortar repair operations—will the importance of the technicians' work for the conservation of in situ mosaics be fully understood by the technicians themselves and by future site managers.

A second category of training—site management training for archaeolo-gists and architects—is currently being prepared, and a site conservation and management workshop is scheduled in Tunisia for the near future.

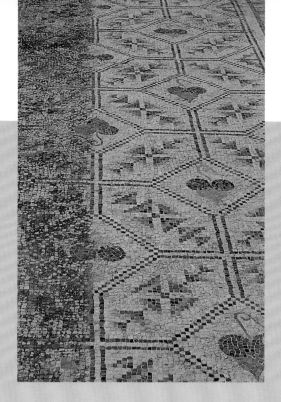

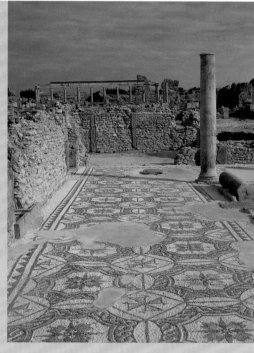

FIGURE 7.5 (ABOVE)
Trainees are taught to perform cleaning without chemicals; the dramatic results are evident here.

Photo: Elsa Bourguignon, 2003.

FIGURE 7.6 (RIGHT)
Peristyle of the House of Neptune at Thuburbo Majus, after maintenance treatment.

Photo: Elsa Bourguignon, 2002.

FIGURE 7.7
At Thuburbo Majus, the red, yellow, and black limestone tesserae with a beige limestone tesserae background were found to be preserved to different degrees because of the variable physical properties of each type of stone. The lime bedding mortar that surrounds each tessera on five sides is critical to the stability of the tesserae, and the removal of soil and biological organisms from the surface often revealed the loss of much of the lime between the tesserae, which were no longer well attached. Therefore, the lengthy cleaning process needed to be followed by equally detailed and critical stabilization treatments, including the resetting of detached tesserae; the infilling of interstices, or gaps between tesserae (shown here); infilling of lacunae; and the grouting by injection of below-surface voids.

Photo: Elsa Bourguignon, 2002.

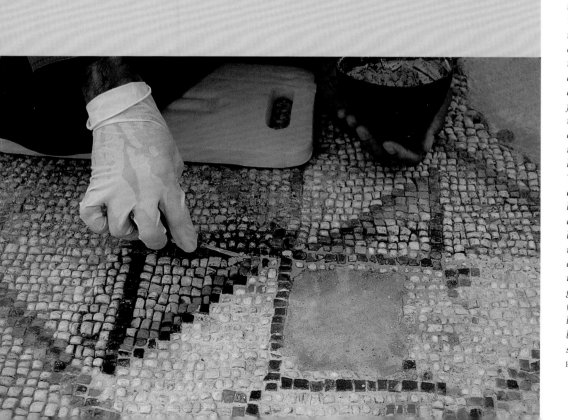

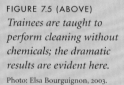

136

FIGURE 7.8
*Technician trainees
receiving assignments in
mosaic documentation
at the Great Baths of
Maktar.*
Photo: Elsa Bourguignon, 2003.

were affixed to the new supports and recon-
nected. The reconstructed panel was then
either exhibited or placed in storage. All of
these operations were performed without
any sort of documentation. Rare—very
rare—are the photos, or even drawings,
illustrating these operations, which might
have allowed us to determine which parts of
the tableaux were restored.

Techniques evolved in the early 1950s,
when cement and iron were used to build
new supports for the removed mosaics. This
development allowed the detachment of
more mosaics, including geometric and flo-
ral ones, which were most often left in the
storage facilities of their respective sites,
although sometimes the panels were returned
to their original locations. This situation
lasted for several decades. Removal, which
was almost always the rule, was considered
the best form of conservation. When the
pavements were not removed from their set-
tings, they were stabilized with cement by
workers whose task it was to maintain the
remnants and restore them with the available
resources, which were very limited.

These practices began to change just
over thirty years ago, when an international
movement to preserve ancient mosaic trea-
sures was initiated. Specialized international

institutions began focusing on the problems
inherent in the conservation of our shared
mosaic heritage. A scientific study of preser-
vation techniques was undertaken. New
techniques were developed and disseminated
as a means of ensuring better mosaic preser-
vation. Mosaic conservation specialists
began to speak out, particularly via the Inter-
national Committee for the Conservation of
Mosaics (ICCM), to the countries that held
major mosaic collections, encouraging them
to enhance the protection of their heritage
by using more appropriate techniques and
materials.

In Tunisia, which was one of the coun-
tries that undertook the weighty task of
producing the *Corpus des mosaïques de la
Tunisie,* professionals started to become
aware of the problems of conservation, par-
ticularly when mosaics are left in situ.
Thenceforth, it was understood that there
was a need to address the problems of the
mosaics that were deteriorating season after
season, particularly after cleaning for study
and measurement. At the same time, there
was a dawning awareness of the damage
caused by the routine use of cement for in
situ stabilization as well as for the support
of detached mosaics.

The task of implementing a sound policy for the conservation and enhancement of our mosaic heritage has been a very long and slow process—and results have not always been spectacular. This conservation policy requires the creation of appropriate structures and the training of qualified personnel to manage the thousands of pavements distributed throughout the country's sites, museums, and storage facilities. Finally, this new way of treating mosaics requires a profound change in the mind-set of archaeologists, site supervisors, and technicians—undoubtedly the most difficult aspect of the process.

The development of a preservation strategy certainly requires political will. It also requires extensive material resources, which are not always easy to come by in a developing country such as Tunisia. Broad regional and even international cooperation is essential to the process of the conservation and enhancement of our mosaic cultural heritage. More than ever, it is clear that mosaics constitute an invaluable and vulnerable part of our universal cultural heritage. The protection of this cultural heritage requires cooperation with specialized international institutions, such as ICCROM (International Centre for the Study of the Preservation and Restoration of Cultural Property) and the Getty Conservation Institute. Such cooperative efforts will not only allow greater in-depth research and implementation of new conservation techniques; they will also provide mentoring for Mediterranean countries that want to develop expertise in caring for their mosaic assets. This mentoring ranges from general brainstorming to the formation of multidisciplinary teams capable of managing mosaics in their various settings, trained in a manner responding to the realities of the different countries (FIGURE 7.8).

FIGURE 7.9
Trainees are given instruction in in situ conservation techniques at the House of the Nymphs, at Nabeul, before beginning their own work.
Photo: Elsa Bourguignon, 2003.

With the collaboration of the Getty Conservation Institute, the Tunisian cultural heritage institute, the Institut National du Patrimoine de la Tunisie, is developing a conservation strategy emphasizing the training of on-site personnel entrusted with the task of stabilizing and maintaining pavements in situ (FIGURE 7.9). This action represents a first step toward a global solution for the problems of conservation, which will require additional resources and supervisors. There has already been an effort to train conservators who will soon supervise the teams of mosaic technicians that the Getty Conservation Institute is instructing in the principles and practices of conservation. The Tunisian experiment in the conservation of its mosaic heritage, which began just a few years ago, appears to be on the right track. Above all, it is practical and suited to reality, with all of its strengths and weaknesses. The task ahead will no doubt present many challenges. Nevertheless, an appreciation of the value of these mosaic treasures has fostered a profound desire to preserve them for the enjoyment of future generations.

Acknowledgments

Suggested Reading

Ben Abed, Aïcha, ed. *Stories in Stone: Conserving Mosaics of Roman Africa.* Los Angeles: J. Paul Getty Museum/Getty Conservation Institute, 2006.

Ben Abed-Ben Khader, Aïcha, ed. *Image in Stone: Tunisia in Mosaic.* Paris: Ars Latina, 2003.

Dunbabin, Katherine M. D. *The Mosaics of Roman North Africa: Studies in Iconography and Patronage.* Oxford and New York: Oxford University Press, 1979.

_____. *Mosaics of the Greek and Roman World.* Cambridge and New York: Cambridge University Press, 2001.

Ennaifer, M. *La civilisation tunisienne à travers la mosaïque.* Tunis: STD, 1970.

Ennaifer, M., H. Slim, L. Slim, and M. Blanchard-Lemée (text) and G. Mermet (photography). *Sols de l'Afrique Romaine.* Paris, 1995.

Ling, Roger. *Ancient Mosaics.* Princeton, N.J.: Princeton University Press, 1998.

Yacoub, M. *Splendeurs des mosaïques de Tunisie.* Tunis, 1995.

We are extremely pleased to publish this book on the remarkable cultural heritage of Tunisia, in particular its Roman mosaics—both in museums and in situ—and the importance of caring for this precious resource for future generations.

We are grateful to our friend and colleague Aïcha Ben Abed, director of monuments and sites for the Institut National du Patrimoine (INP), for her continued work in the conservation of Tunisia's cultural heritage. Aïcha's vast knowledge, experience, and dedication to the preservation of the mosaics of her country make her the perfect author for this book.

Our work with Aïcha began in the early 1990s when she participated in the Getty Conservation Institute (GCI) course on conservation and management of archaeological sites in Cyprus. She has since become the driving force behind the Tunisia component of the GCI's Conservation of Mosaics in Situ project, which has focused on ongoing technician training and capacity building to ensure the long-term care of the country's mosaics.

Our partners and colleagues in Tunisia, including His Excellency Mohamed El Aziz Ben Achour, minister of culture and heritage protection, and Mohamed Beji Ben Mami, director general of the INP, have generously supported our work in Tunisia over the past decade. We would also like to thank the staff of Tunisia's Agence de Mise en Valeur du Patrimoine et de Promotion Culturelle (Cultural Heritage Improvement and Development Agency) for their invaluable assistance.

We would like to acknowledge the many INP staff members who have contributed to the GCI/INP mosaics initiative, including Fathi Bejaoui, director of inventory and research; Ridha Boussoufara, site director at Hergla; Taoufiq Redissi, site director at Utica; and Lotfi Cherif,

administrative assistant. Our thanks also to the mosaic trainees, who have shown pride, professionalism, and commitment to their work in the preservation of Tunisia's cultural heritage.

Tunisia's museum and site directors and their staff members opened their sites, doors, and archives, thereby allowing us to share their heritage with the rest of the world.

We are grateful to the GCI's Conservation of Mosaics in Situ team, present and past, including Jeanne Marie Teutonico, associate director, programs; Martha Demas, project leader; Thomas Roby, project manager in Tunisia and a contributor to this volume; Françoise DesCamps; Kathleen Louw; and training consultant Livia Alberti; and former GCI team members Elsa Bourguignon, Bettina Lucherini, Gaetano Palumbo, and Francesca Piqué. All have worked with dedication and professionalism with our Tunisian partners over the years.

This book would not be possible without the guidance of Kristin Kelly, assistant director, and Cynthia Godlewski, senior project manager of the GCI's dissemination and research resources department, who saw the project through to publication. We would also like to acknowledge the expert hand of Tevvy Ball, book and series editor; Sharon Grevet, who translated the manuscript from the French; Sylvia Lord, who copyedited the manuscript; Bruce White, whose photography beautifully supplemented the author's and archival images; Vickie Sawyer Karten, book and series designer; and Anita Keys, production coordinator.

Timothy P. Whalen
Director
The Getty Conservation Institute

I would like to express my gratitude to the staff of the Getty Conservation Institute for the high quality of their collaboration in the conservation of cultural heritage in Tunisia, in particular the conservation of mosaics. I would especially like to acknowledge Timothy Whalen, who from the beginning believed in our training projects and ceaselessly supported our work in mosaics conservation. My special thanks also go to Jeanne Marie Teutonico, who oversaw our projects with constant friendship and consummate skill.

I would like to acknowledge the fine work of all the members of the teams who carried out training programs on site, under the capable direction of Tom Roby. I would also like to thank Kristin Kelly, who entrusted me with the task of writing this book. It was through Kris that I

had the privilege of meeting and working with my editor at Getty Publications, Tevvy Ball, to whom I am grateful for both his personal kindness and admirable professional skill.

My heartfelt thanks go to all my colleagues at the INP, along with everyone else who has believed in our project to conserve Tunisia's mosaic treasures. I must thank my good friend Roger Hanoune, who kindly consented to read and comment on the original manuscript. Finally, my gratitude goes to Nadim, Ali, and Selma Afakh, who day after day gracefully tolerated their mother's changing moods. Thank you for everything.

Aïcha Ben Abed